This book is to be returned on or before
the last date stamped below.

THE ART OF
GRAHAM
SUTHERLAND

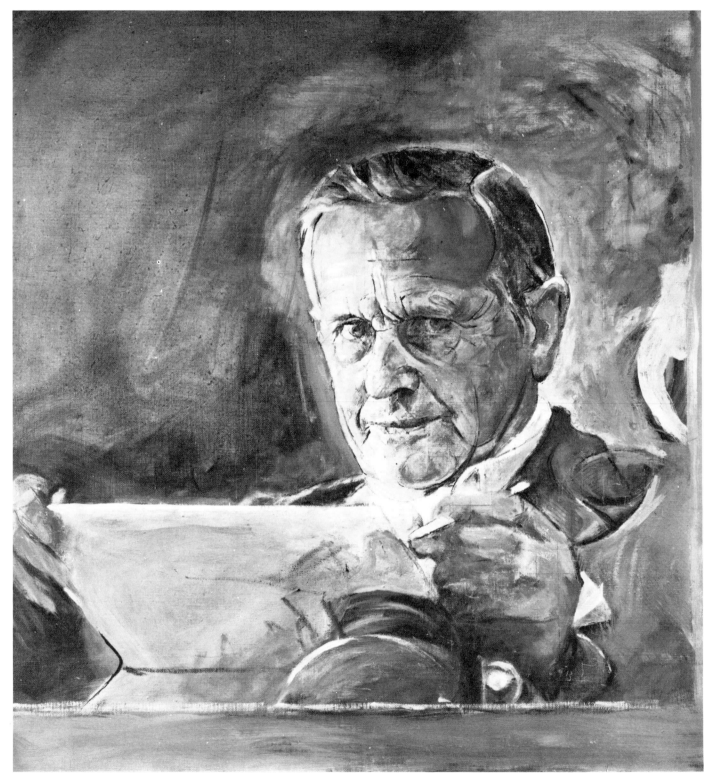

FRONTISPIECE *Self-portrait*. Canvas; 52.5 × 50.5 cm (20⅝ × 19⅞ in.). Signed and dated 1977.
National Portrait Gallery, London. Sutherland's first painted self-portrait, done when he was seventy-three. He chose to depict himself in his most characteristic posture, sketchbook in hand, scrutinizing the visible world.

JOHN HAYES

THE ART OF
GRAHAM
SUTHERLAND

PHAIDON · OXFORD

Phaidon Press Limited, Littlegate House, St Ebbe's Street, Oxford, OX1 1SQ

First published 1980
© Phaidon Press Limited 1980

British Library Cataloguing in Publication Data
 Hayes, John, *b. 1929*
 The art of Graham Sutherland
 1. Sutherland, Graham
 I. Title
 II. Sutherland, Graham
 759.2 ND497.S95

 ISBN 0-7148-2035-0

Printed in Great Britain by Jolly & Barber Ltd, Rugby

PREFACE

Although a number of publications have appeared recently, devoted to different aspects of Sutherland's art – his graphic work, his war drawings, his own statements about his painting – and a biography is in preparation, the only general survey in print is that by Santesi (1979). Douglas Cooper's authoritative work, to which it will be obvious that I am deeply indebted, not only for the precision of its research and the wealth of information deriving from the artist, but for its characteristically searching insight into Sutherland's style, appeared nearly twenty years ago, in 1961, and is no longer available; Francesco Arcangeli's more recent book, chiefly useful for its copious colour illustrations, is also out of print. The present study is intended to fill this gap. Its aim is expository rather than critical: to provide a clear and balanced account of Sutherland's career and achievement, whenever possible using the artist's own words, and, in the selection of plates, in general chronologically arranged, to elucidate both Sutherland's development and the constancy of his vision by means of a number of juxtapositions of works of different periods, an approach not previously adopted. It is for later studies to set Sutherland more fully within the context of his time.

In 1961 Cooper declared roundly that 'Graham Sutherland is the most distinguished and the most original English artist of the mid-20th century.' By this he meant that 'no other English painter can compare with Sutherland in the subtlety of his vision, in the forcefulness of his imagery and in the sureness of his touch. Also there is none whose sensibility and inspiration are so unmistakably and naturally English, yet whose handling and technical approach are so authoritative, modern and European.' Sutherland is now in his later seventies, and his energy and his powers remain undiminished. His aquatints, the *Bees*, for example, published in 1977, are remarkable not only for their technical virtuosity but for their sustained invention. Yet, since the time of the Coventry tapestry – and not only because he lives in France – Sutherland has to some extent fallen out of the reckoning in Britain and finds comparatively little favour among English critics and writers on contemporary art. It is hard to believe that no comprehensive exhibition of his painting has been held in England since Coronation Year, 1953. He is valued far more on the Continent, and especially in Italy, where the last great retrospective of his work was held in Turin in 1965. The reasons for this may be less to do with Sutherland than with recent developments in British art. But, in either event, a reassessment by his own countrymen is long overdue. Some of Sutherland's most recent paintings are here published for the first time, and the reader is enabled to evaluate the work of the last two decades (the period since Cooper wrote) within the context of his development as a whole.

In the course of preparing this book I have incurred a number of debts, which I gratefully acknowledge here. My primary debt has been to other writers on Sutherland, most notably, as I have already indicated, to Douglas Cooper. David Breeden, James Kirkman, and Gilbert

Lloyd and his colleagues at Marlborough Fine Art have been kind in lending me precious transparencies and photographs and in giving me other assistance. In Italy, Pierpaolo Ruggerini, Giorgio Soavi and Gianni Tinto have been exceptionally generous in similar ways. To Pierpaolo and Marzia Ruggerini, and to Gianni and Rosanna Tinto, close friends of Sutherland, I wish to express particular thanks not only for arranging special photography but for sharing their knowledge with me and for warm and memorable hospitality. I am most grateful to a number of English private collectors for showing me their pictures, and to my colleagues in museums and galleries for their helpfulness. Joseph Darracott showed me the War Artists' files. Paul Drury, Milner Gray and Dean Walter Hussey have kindly discussed particular problems with me; to others, who have helped me with specific information, and whose names are therefore acknowledged in the appropriate notes, I am equally beholden. At Phaidon Press Simon Haviland has watched over the book with characteristic sympathy and concern for both scholarship and presentation, while Stephanie Hall has been the most patient, sensitive and enthusiastic of editors. Once again Mollie Luther has typed, impeccably, a manuscript which would have defeated anyone else.

My principal debt, of course, is to Graham Sutherland himself, and to his wife, Katharine. Without their initial confidence I would never have contemplated writing; without their sustained encouragement I could not have written. To many kindnesses of a personal nature Graham Sutherland has added that of answering a questionnaire and reading the draft of my text, providing me with much additional information at this stage and saving me from various mistakes of fact and interpretation (the errors that may remain are my responsibility). What value this book may possess lies largely in the artist's own statements and emendations.

I had admired Graham Sutherland's work since I was an undergraduate; I never dreamt at that time that I would ever meet him. In 1974 I did. I enjoyed the rare privilege of working closely with him for two years on the exhibition of his portraits held at the National Portrait Gallery, and the exhilaration of this experience – continually stimulating not only intellectually and visually but in ways which must increase any art historian's general understanding immeasurably – has continued without interruption during the preparation of this study. I hope that this modest contribution to the growing literature on Sutherland will be some token of the gratitude I feel for so much so freely given.

J.H.
January 1980

Graham Sutherland died in London on Sunday, 17 February. Until the last few weeks of his life he had been hard at work, principally on portraits, and, with the intensive labour involved in the production of the *Apollinaire* aquatints behind him, was planning actively for the future. As always, his principle was 'to obtain the greatest possible perfection at almost any inconvenience & wear to [himself]'. Sadly, both this book and the exhibition being planned by the Tate Gallery must now be in the nature of memorials to one of the greatest artists of our time.

J.H.
April 1980

INTRODUCTION

Graham Sutherland was born in London on 24 August 1903, the son of a civil servant at the Board of Education.[1] He spent his boyhood in the prosperous outer suburbs of South London, first at Merton Park, later at Sutton; holidays were spent at Littlehampton, and after the war his father built a house near there in the pretty Sussex village of Rustington.[2] Nearly five years older than his brother Humphrey – the distinguished numismatist, formerly Keeper of the Coin Room at the Ashmolean Museum – and ten than his sister Vivien, his early life proved solitary; 'I was thrown on my own resources a good deal . . . we each made a sort of separate existence.'[3] Without wishing to exaggerate any affinity there might be with the childhood of Ruskin, who was, in any case, that very different thing, an only child, it is worth remarking that the effects on Graham's visual imagination were similar. He, too, became fascinated by geology and natural history. 'I got into the habit of looking at things closely – observing, analysing and drawing everything in the countryside.'[4] This practice, which dates most particularly from some holidays spent at Swanage, in Dorset, in the two years before the First World War,[5] became a lifelong passion and an essential nourishment to his imagination, without which Sutherland was acutely aware that his painting would soon decline into the vacuous or merely decorative. 'We are deceived if we work contrary to our inclinations or to nature.'[6]

In 1912 Graham was sent to a preparatory school in Sutton, but in 1914 he was transferred to Epsom College, where the educational bias was more towards science; in consequence, his four years there were much less happy ones.[7] His great solace remained drawing. In 1919 he followed in the footsteps of his uncle, an engineer and designer with the London, Midland and Scottish Railway. Earlier, his great-grandfather had been involved, amongst other enterprises, with the construction of the great market hall at Derby; and it was in the same town that Graham followed his uncle, who had by then virtually retired, at the Midland Railway works, where he spent a year as an apprentice. It would be wrong to suppose that Sutherland gained nothing from this experience; he was by nature assiduous, inquiring and alert, and not the kind of youngster who would have failed to profit even from an uncongenial apprenticeship. Undoubtedly he was impressed by what he saw around him; we may recall his own later words: 'I have always liked and been fascinated by the primitiveness of heavy engineering shops with their vast floors. In a way they are cathedrals. Certainly they are as impressive as most cathedrals I've seen and a good deal more

impressive than some.'[8] None the less, a year was sufficient to convince him, and his superiors – and to persuade his parents – that he was not cut out for a career in engineering, and he was allowed to go to art school. In 1921 he was entered as a student at the Goldsmiths' College School of Art at New Cross.[9]

Sutherland was at Goldsmiths' from 1921 to 1926.[10] Amongst his close friends there were Paul Drury, Bouverie Hoyton, and William Larkins, all etchers. He worked hard, taking full advantage of the varied teaching characteristic of a good academic school; he also continued to draw from nature. It was the encouragement of the Principal, an etcher and specialist in aquatint, that inclined him in the direction of specialization in engraving techniques.[11] This proved a practical decision, too, for the twenties were still the heyday of English etching. Processes always fascinated Sutherland, and the more subtle, complex and demanding they were, the more he was in his element. Lithography and aquatint were a major part of his output in the last years of his life; he had installed at Menton a separate and spacious atelier for printmaking, and always liked to undertake the arduous work of operating the printing press himself. At Goldsmiths' the instruction, first under Malcolm Osborne and then from Stanley Anderson, was desultory and academic.[12] But he met the recognized master of the medium, F. L. Griggs, a superb technician who went out of his way to give him advice, and it was this fruitful relationship, which soon grew into friendship, that led Sutherland to refine and perfect his technique.[13] Soon he acquired an enviable reputation for himself in the small, tight-knit world of engravers and print collectors. From 1923 his prints were published by the Twenty-One Gallery, and he had his first one-man show there in 1925; in the same year he was elected an Associate of the Royal Society of Painter-Etchers and Engravers. He was well set on his career.

After leaving Goldsmiths', Sutherland taught an evening class one night a week at Kingston, and then, in 1928, the year of his second successful show at the Twenty-One Gallery, he was invited to teach etching and engraving at the Chelsea School of Art. Also during these years there occurred two connected events of profound importance in his personal life, in 1926 his conversion to Roman Catholicism, and, the following year, what Sutherland describes as 'the only *crisis* in my life which was really significant.'[14] At Goldsmiths' he had met, and fallen in love with, a beautiful and spirited Irish girl. On 29 December 1927 he married Kathleen (Katharine) Barry (Fig. 1), who was to give up her own career in fashion to further that of her husband.[15] The young couple first lived at Farningham, in Kent, that part of the Weald so indissolubly associated with Samuel Palmer, and settled in what was to remain their English home, the White House at Trottiscliffe, a village seven or eight miles away from Farningham, in 1936.[16]

Sutherland's early drypoints and etchings display a considerable range of aesthetic interests and are influenced both in subject-matter and in style by masters as diverse as Dürer, Rembrandt, Millet, Meryon and Whistler.[17] Their effects are virtuoso, dramatic and, to some extent already, romantic in feeling. In *Sylphides*, his first print,[18] the brilliant effect of incandescent light flooding the stage is achieved by the intensity of the surrounding blacks. A more subtle, but none the less powerful, chiaroscuro is used to control the design in *Barn Interior II*,[19] where, as in his recent *Conglomerates* (Plate 137), Sutherland set himself the task of compressing an immense variety of shapes into a small and shallow space. This composition is a *tour de force*. In *The Black Rabbit* (Plate 1), a view of the Arun taken from the slopes of Arundel Park, one of Sutherland's most beautiful early etchings, the detail is subordinated to the splendid masses of the trees

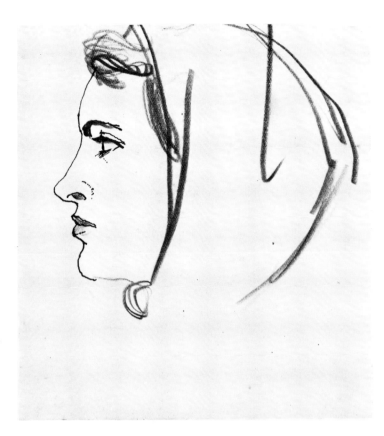

Fig. 1. *Study of Kathleen (Katharine) Sutherland.* Pen and ink and pencil; 11.4 × 11.1 cm (4½ × 4⅜ in.). About 1938. Mrs Graham Sutherland. One of the few surviving portrait studies dating from the pre-war years

and the dominating rhythm of the winding road and river. A compelling sense of mass and weight, always important to Sutherland, is shown in such subjects as the half-thatched cottage in *Number Forty-Nine*,[20] a print which also displays his love of surface textures and was singled out for praise by contemporary critics.[21] In a totally different vein, taut, springy line and impeccable placing on the sheet are the means of suggesting the movement of the two greyhounds speeding across the open fields in *Coursing*.[22] Vertiginous perspectival effects are explored in *Waterloo Bridge* (Plate 51), and, in two prints of 1924, *Cudham, Kent* and *Barrow Hedges Farm*,[23] the romantic effect of light from the setting sun breaking through the sinuous branches of deliberately stylized trees.

These last two designs are a premonition of an emphatic and, on the visual evidence, unexpected change of style which marked the next few years. Sutherland had been bowled over by his first sight of an etching by Samuel Palmer – 'I was amazed at its completeness, both emotional and technical'[24] – and from 1925 to 1928 he developed a mannered, dreamlike, pastoral romanticism which derived from Palmer's 'visionary years', the principal influence on the work of his friend and mentor F. L. Griggs. 'My feeling . . . was partly a bid for independence from the stereotyped Seymour Haden etc. engraving tradition of the school, which caused in me a bias towards heavily worked plates – partly also, since I liked Palmer drawings of the early few years . . . because as a young man I was drawn to a strongly romantic and, so it seemed, independent approach to nature from which I was always drawing.'[25] Sutherland's absorption in engraving techniques and the variety of the effects he could achieve in this exacting medium, together with the intensity of his feeling for nature, circum-scribed as it was by aspects of the English scene and dominated for the moment (as it was so often) by romantic leanings, makes it easier to understand why, inquisitive and usually so open to every sort of stimulus, he was unreceptive, in the 1920s, to modern art. For the moment he was set on a deep but narrow course.

Clive Gardiner, later Principal of Goldsmiths', and remembered by Sutherland as a really great teacher, whom, with Drury and Larkins, he assisted on his large, Léger-like mural decorations for the British Empire Exhibition at Wembley in 1924, introduced him to the work of Cézanne, Matisse and other painters of the modern French school, but he showed no interest – indeed, as Douglas Cooper records, 'he did not like what he saw.'[26] The 'fragmentary analyses' of Cézanne, the movement towards abstraction, colour harmonies for their own sake, distorted forms and the intellectualism and subtleties of cubism as yet meant nothing to Sutherland; cubism never did, except perhaps indirectly. To a young romantic, however, expressionist tendencies with an associational meaning were quite another matter, and Palmer he somewhat enigmatically described as 'a sort of English van Gogh'.[27] The strangely pulsating terrain, simplified, symbolic forms (so different from the crowded naturalism of his earlier work) and equally stylized effect of the sun's rays in Sutherland's *The Village*[28] show us something of what he meant by this analogy. The dignified villagers, beautifully thatched cottages and magical effects of light in the etchings of this period reflect an idyllic view of English country life almost as part of a divine order which goes back to the late eighteenth century. 'The day's last light falling gently upon the thatched roofs, the richly-fruited trees, the hop-poles ripely burdened, the sheep in the fold, the quiet plough, and all happening in harmonious design', so Malcolm Salaman described *Lammas* (Plate 2).[29] Of the drawings and gouaches Sutherland also did at this time one critic wrote that they have 'a kind of Palmeresque charm, but they mostly suggest preparations for etchings or wood-engravings in the Palmer technique'.[30] There is apparently record of no more than one of these works: a gouache of deserted and overgrown cottages (Plate 5) which probably dates from about 1928, since it is closely related in the handling of detail to such etchings as *The Meadow Chapel* of that year,[31] but links nevertheless more with the picturesque of *Number Forty-Nine* than with Sutherland's current preoccupations in his printmaking. 'How far', continued Salaman in his article of 1927, 'will the Palmer influence carry the art of this brilliant young etcher, and in what direction and in what manner will his undoubted gifts develop their complete independence of expression?'

It was indeed through the symbolic, archaizing and stylized forms, and the method of isolating, exaggerating and illuminating those forms, characteristic of the Palmeresque, that Sutherland developed his own highly personal style in the period 1929 to 1932. In the prints of these years the landscape is charged with a new force: ground undulates as if in response to some inner tension, the tall, slender trees in his woodland scenes possess a brittle life of their own, the powerful chiaroscuro seems to herald some extraordinary drama. Individual forms assume a new potency. In *The Garden* (Plate 6), a work which shocked the conventional, a gigantic rose bush is the solitary image, what Sutherland would later term a 'presence', its mystical, unearthly quality emphasized by the unnaturalistic, de Chirico-like foreshortening of the wall behind and elongation of the building in shadow on the left. The hollow oak which dominates the composition of *Pastoral*[32] is a strongly anthropomorphic form, the earliest in his work, which presages the *Association of Oaks* of 1940 (Plate 91). The cottage in *Cottage in Dorset, 'Wood End'* (Plate 4) seems to be engulfed in some terrifying movement, so dramatic are the perspective lines. The astonishing vitality, and ultimate mystery, of these remarkable etchings foreshadow the mature Sutherland.

Ironically, however, this period marked a watershed of a different and disastrous

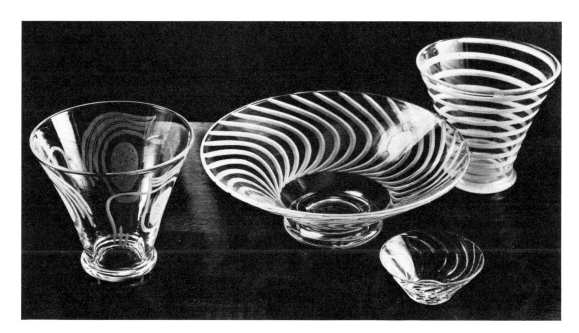

kind. In 1929, following the Wall Street crash and its effects on the world economy, the hitherto flourishing market for prints (to a large extent American) collapsed overnight. No editions were printed of the masterly *Pastoral* (1930) and *Oast House* (1932).[33] The hard-won experience of a decade was suddenly of no account. In 1932 Sutherland switched to the teaching of composition and book illustration at Chelsea, and, in order to supplement his income, engaged more seriously in commercial work – from glass-ware and ceramics to postage stamps – but notably in poster design for companies with such artistically enlightened direction as Shell-Mex and the London Passenger Transport Board.[34] In this broadening out he was at one with every avant-garde artist of the time. Sutherland always showed an ability to respond to a new challenge, and he continued to enjoy work on a decorative plane, designing tapestries, book-jackets, table-tops and other objects with spontaneity and flair. But, more important, it was at this time of professional crisis – a time, too, of deep sadness in his personal life – that he turned, for the first time, to painting. He was now almost thirty.

Sutherland had been visiting Dorset, the county where he had been inspired to draw so diligently from nature as a young boy of ten, every year since 1928, either in the spring or summer, and continued to do so until 1933.[35] The earliest of his extant oil paintings is a Dorset scene, and it is in an entirely different idiom from his prints and gouaches. *Farm in Dorset*, done in 1932 (Fig. 5), is an exact, but somewhat laboured, transcription of a perfectly ordinary stretch of country lane with a farmhouse on one side and a barn and pond on the other. Its ancestry is the Constable sketch, and it is evident that Sutherland had a single aim in mind: the mastery of an unfamiliar medium. This is confirmed by his later destruction of all the other paintings he did between 1931 and 1934.[36] Their original function as exercises – 'an attempt to train myself to register as accurately as I could "values" of tone & colour'[37] – is plain.

In 1933 Sutherland spent some time in Cornwall, and in the spring of 1934 he first visited Pembrokeshire.[38] Here at last his imagination found its true home. 'From the first moment I set foot in Wales I was obsessed.'[39] It is apparent from his repeated visits to Dorset that Sutherland was the kind of artist who depended for his inspiration on a searching scrutiny of a familiar landscape with a particular appeal. His vision was sharply focused. He was also a perfectionist. He returned again and again 'to pin down

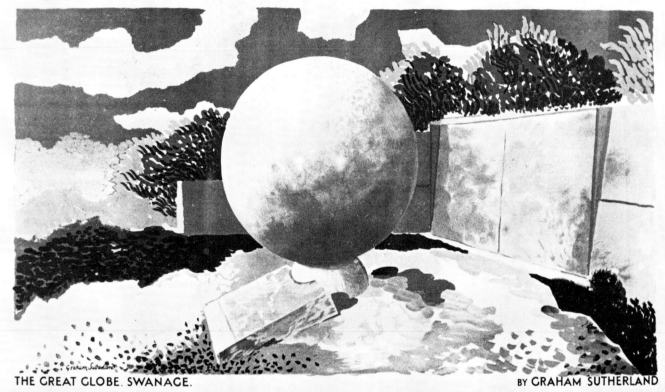

EVERYWHERE YOU GO

THE GREAT GLOBE. SWANAGE. BY GRAHAM SUTHERLAND

YOU CAN BE SURE OF SHELL

the essence' of a locality. And he did not find the initial stimulus he needed everywhere. Thus, in Gloucestershire, for example, magnificent country on the edge of the Cotswolds where he spent the first year of the war, he discovered nothing he wanted to draw. As his friend Edward Sackville-West has said: 'That so few kinds of landscape are of any "use" to him gives the measure of his intransigence as an artist, and lies also at the root of his absolute originality.'[40] Pembrokeshire was a constant source of inspiration. He spent each summer there until the war, was able to revisit it during the war years, and returned every year from 1967 onwards.

Sutherland was a deeply questioning and self-analytical artist, and he explained movingly and most eloquently what Pembrokeshire meant to him as a painter during the 1930s in an open letter to his friend and patron Sir Colin Anderson, published in *Horizon* in 1942.[41] It is worth quoting extensively from this statement because it is exceptionally revealing of the innermost processes of Sutherland's pictorial imagination and embodies the core of his thinking about his art. 'It was in this area', he wrote, 'that I learned that landscape was not necessarily scenic, but that its parts have an individual figurative detachment.' Those parts took on meaning only in relation to man and his imprint on the country, always central to Sutherland's concept of landscape. 'Farms and cottages – glistening white, pink, and blue-grey, give scale and quicken by their implications our apprehension of the scene. . . . The astonishing

...*From field to field*

Fig. 3 (left). *The Great Globe, Swanage*. Poster designed for Shell-Mex Ltd. 1932

Fig. 4 (right). *From Field to Field*. Poster designed for the London Passenger Transport Board. 1936

fertility of [the] valleys and the complexity of the roads running through them is a delight to the eye. The roads form strong and mysterious arabesques as they rise in terraces, in sight, hidden, turning and splitting as they finally disappear into the sky. To see a solitary human figure descending such a road at the solemn moment of sunset is to realize the enveloping quality of the earth which can create, as it does here, a mysterious space limit, a womb-like enclosure – which gives the human form an extraordinary focus and significance. . . . Such country did not appear to make man appear little as does some country of the grander sort.' 'Can you imagine', he asked elsewhere, 'anything more boring than mountain gorges?'[42] Sutherland goes on to describe other configurations and imagery that excited his imagination. 'The deep green valleys and the rounded hills and the whole structure, simple and complex . . . the high overhanging hedges by the steep roads which pinch the setting sun, mantling clouds against a black sky and the thunder . . . phantom tree roots, bleached and washed by the waves . . . the twisted gorse on the cliff edge, such as suggested the picture, "Gorse on Sea Wall" – twigs, like snakes, lying on the path, the bare rock, worn, and showing through the path . . .'

'It became my habit to walk through, and soak myself in the country.' Then, he found, certain shapes or forms would dominate others, 'as if in response to some internal need of the nerves',[43] 'rare and hidden forms'[44] that might engage his attention one

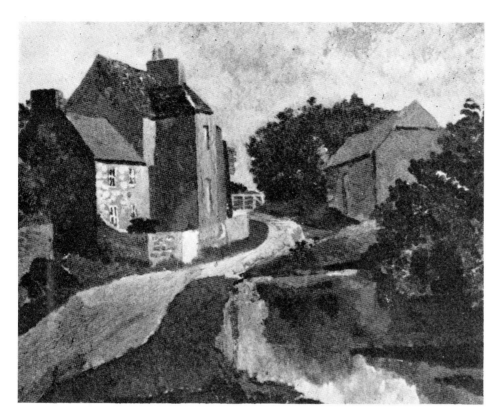

Fig. 5. *Farm in Dorset*. Hardboard; 50.2 × 60.6 cm (19¾ × 23⅞ in.). 1932. Ownership unknown

day and be totally lost to him when he passed the same way on the next. 'It was only at the original moment of seeing that they had significance for me.'[45] These were the forms that really started him off. 'Since 1934, I have used sketchbooks . . . Firstly, as a means of planning several versions in miniature of the ideas for the layout of a projected painting. Secondly to make drawings . . . with no apparent purpose in sight, except to follow the relationships between one form & another of the things which struck me. Such work can unlock, quite suddenly the door to an idea which *might* become a painting.'[46] 'The overall activity of making these notes . . . is enchanting to me and exciting. One feels one has no responsibility (as one has in painting) – or if one has, only to these so called inanimate objects; they do not press me. There is simply the fascination of things seen, and trying to understand the principles of what one sees.'[47]

Sutherland did not paint in Wales. 'At first, I attempted to make pictures on the spot. But soon I gave this up.' 'There were no "ready-made" subjects to paint. The spaces and concentrations of this clearly constructed land were stuff for storing in the mind.' He found that he could express what he felt about this 'highly charged' landscape, country where he had 'an emotional feeling of being on the brink of some drama', only in retrospect – Wordsworth's emotion recollected in tranquillity – and only by paraphrasing what he had seen. The process of gestation, comparable with the course followed by the imaginings of Blake and Palmer, remained unchanged over thirty years, as his self-analyses show. 'The parts of the scene, as they reach [the] mind, lose their normal contiguity, the isolated forms their identity, and all become absorbed in the reservoir of the subconscious mind out of which emerge the reconstructed and re-created images.'[48] 'In the studio, I remember; it may be an hour ago or years, and I react afresh. The images dissolve; objects may lose their normal environment and relationship. Then things seem to be drawn together and redefined in the mind's eye in

a new life and a new mould – there has been a substitution, a change. But I feel this to be valid only in so far as the process of digestion has preserved in the substance of my material – paint and canvas – the sensation of the original presence, in its new and permanent form.'[49] Or, differently: 'An idea, at the most unlikely moment, wells up in the mind . . . I cannot tell, I do not know why or how it happens. It arrives . . . But then the *mind* must take a hand and the rest of the time between that first inspiration and the completing of the work is a question of putting what intelligence one has to the task of governing and controlling and refining that which has been pure inspiration into something which works and which becomes a picture; at the same time preserving the first consciousness of the idea.'[50] This intellectual process of governing and controlling and refining does not necessarily imply definition, in the sense of making an idea explicit. Sutherland regarded a certain obscurity of imagery as an essential element in the effect which a picture may have in heightening the emotional response of the spectator. 'Coleridge said that poetry gives most pleasure when generally and not perfectly understood . . . So in painting it might be argued that its very obscurity preserves a magical and mysterious purpose.'[51] In portraiture as much as in landscape he was 'drawn towards a paraphrase in some degree or other in order to display more vividly the inner life and mystery of the subject'.[52]

The material with which Sutherland filled his Welsh sketchbooks consisted of such subjects as he has described: craggy or softly rounded hills, roads and valleys winding through the landscape, jagged rocks, cairns, interlocking stones, damp tree roots, the branches of a blasted tree. Many were later worked up into larger watercolours or gouaches, some of which – like *Association of Oaks* (Plate 91) and *Midsummer Landscape* (Plate 38) – are finished compositions in their own right. Sutherland's respect for the inner meaning of his original notations is shown by the grid system which he almost invariably employed to keep scale.[53] Fewer oil paintings seem to survive from this period. But those that do exhibit a startling originality of vision – a vision almost wholly unrelated to the world of Sutherland's etchings of the beginning of the decade – and an increasing freedom, sureness and sense of structure. As a professional painter Sutherland was treading a lone path. The English response to abstraction and surrealism, the two movements which dominated European art at this time, was the realism of the Euston Road School;[54] and it was his friend Paul Nash, whose work he greatly admired, whose example encouraged him in his own outlook and 'to think of certain objects in nature as being sanctioned as fit and possible subjects for a painter'.[55] In 1938, at the suggestion of Sir Kenneth (now Lord) Clark, the Rosenberg and Helft Galleries offered him his first one-man show; Clark (Fig. 8), who had acquired his first Sutherlands in 1935,[56] wrote a short preface to the catalogue and Raymond Mortimer described Sutherland, in a review, as 'an arrival', an artist who 'takes his place among the most arresting painters of his time'.[57]

In the Welsh drawings the instrument of Sutherland's purpose was a pen line like a 'tough thread of black cotton',[58] limp and variable rather than taut, as it had been in his drypoint *Coursing*, precisely because delimiting and descriptive of new and strange forms of which he sought to grasp the essence. As Robert Melville put it, 'he has had to be on guard against his talents and the pride of hand that could so easily make firm, precise, plausible inventions. Instead, he turns, with all his nerves exposed, to watch living substance.'[59] None the less, it is true, as he has said himself, that he 'tended to make the paraphrases at once – my first drawing was a paraphrase of what I saw'.[60] In

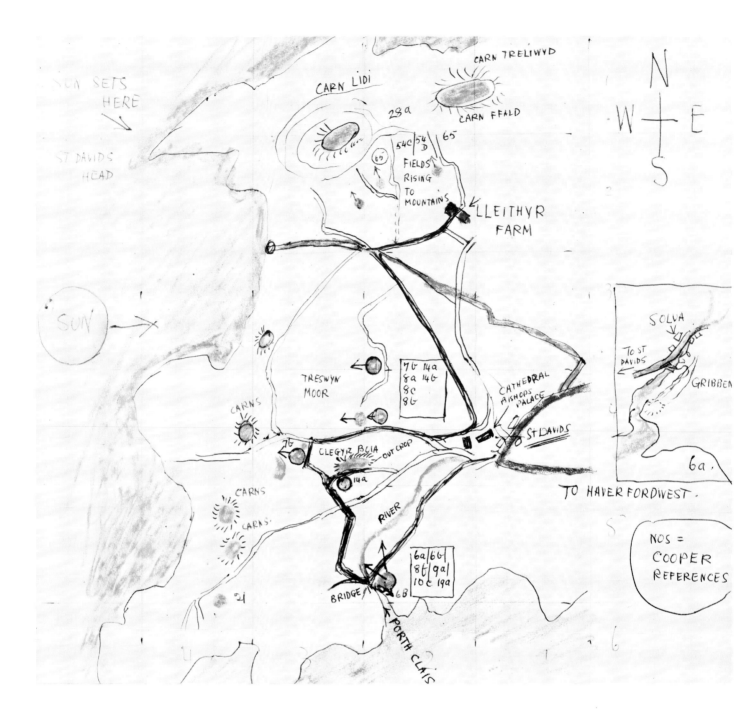

the paintings Sutherland's agent was not line but colour, apparently arbitrary but in large measure derived from his romanticizing of natural phenomena, in other words, expressionist rather than abstract. Sunset was a recurrent theme, and objects glow mysteriously in its radiance. 'The coloured patches which streak the surfaces give emphasis to the form and variety to the eye.'[61] Light had absorbed Sutherland since the days of his earliest experimental prints, and he wrote of Pembrokeshire: 'the quality of light here is magical and transforming', describing a specific scene, where he speaks of 'the exultant strangeness of this place', in a memorable passage: 'the left bank as we see it is all dark – an impenetrable damp green gloom of woods which run down to the edge of low brackish moss-covered cliffs – it is all dark, save where the mossy lanes . . . which dive down to the opening, admit the sun, hinged, as it were, to the top of the trees, from where its rays, precipitating new colours, turn the red cliffs of the right hand bank to tones of fire. Do you remember the rocks in Blake's "Newton" drawing?'[62]

To the extent that Blake and Palmer remained a source of inspiration in the late 1930s, it was no longer for their pastoral and religious symbolism, but for the boldness of their imagery and the richness and subtlety of their colour, colour productive of 'the texture and form that we associate with the uncontrolled blots on French marbled papers'.[63] *Mountain Road with Boulder* (Plate 40), with its rich scheme of reds, pinks, yellows and dominating orange against the evening sky, is a superb example of this romantic precipitating of new colours, as it is of Sutherland's magnification of the shapes and forms which emerged from his subconscious and also – if we turn to the rapid descent of the road, as if 'on the brink of some drama', over a hillside unseen – of his sense of the mystery inherent in the configurations of the Pembrokeshire landscape. In parenthesis it may be noted that Sutherland was quite capable of using his original drawings for different purposes. His mind always operated, with perfect ease, on many levels. In this case his sketches had served as a design, executed earlier in 1940, for a backcloth for the ballet *The Wanderer* (Plate 41). Here the palette is subdued instead of fiery; the coloured patches do not give emphasis to the form (necessarily in a decorative work); and the boulder is not three-dimensional, not the 'presence' of an almost threatening, even superhuman, kind it became in the work he conceived later.

Presences, shapes charged with an expressive vitality far transcending their own organic nature, are perhaps the most notable feature of Sutherland's paintings of this period; and, in considering this aspect of his creativity, we should cast our minds back for a moment to the fantastic rose which dominates his etching entitled *The Garden*, of 1931 (Plate 6). The creation of significant 'presences' had always preoccupied Sutherland. 'The unknown is just as real as the known, & it must be made to look so. I want to

Fig. 6 (left). Map of St David's Head, Pembrokeshire. Pen and ink, chalk and pastel; 28.5 × 32 cm (11¼ × 12⅝ in.). 1969. Private collection, Milan. The map was drawn by Sutherland to indicate the sources of many of his early Welsh pictures. The numbers refer to the illustrations in Douglas Cooper's monograph

Fig. 7. Map of the Milford Haven Estuary at Sandy Haven, Pembrokeshire. Pen and ink, chalk and pastel; 22.5 × 17.5 cm (8⅞ × 6⅞ in.). 1969. Private collection, Milan. A more detailed map of a particular area, drawn by Sutherland to indicate the sources of some of his early Welsh pictures, notably *Entrance to Lane*. The numbers refer to the illustrations in Douglas Cooper's monograph

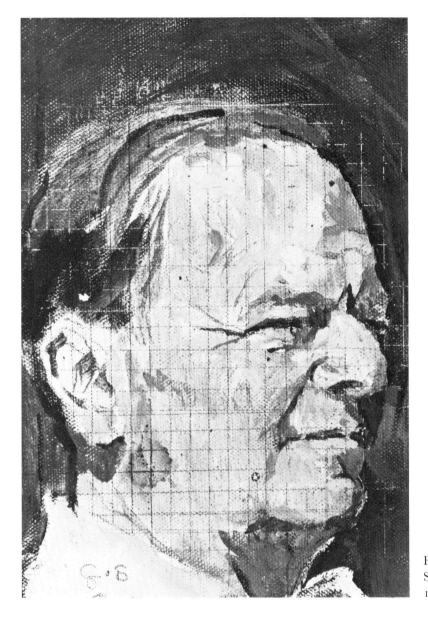

Fig. 8. *Study for a portrait of Kenneth Clark* (Lord Clark of Saltwood). Canvas; 14.5 × 10.3 cm (5$\frac{11}{16}$ × 4$\frac{1}{16}$ in.). 1962. National Portrait Gallery, London

give the *look* of things to my emotionally modified forms.'[64] And as Kenneth Clark wrote: 'These objects have no material existence. And yet they convince us that they could exist.'[65] The forms in the large watercolour *Hollow Tree Trunk* (Plate 31) or the painting *Tree Trunk Sprawling*[66] seem to describe the shape of an animal or a large bird, and to impress us with a sense of impending movement; the two oaks in *Association of Oaks* (Plate 91) are more than half human. 'It is not a question so much of a "tree like a figure" or a "root like a figure"', Sutherland says, 'it is a question of bringing out the anonymous personality of these things; at the same time they must bear the mould of their ancestry. There is a duality: they can be themselves and something else at the same time. They are formal metaphors.'[67] Here we are reaching out towards the very fundamentals of Sutherland's art, the vision of all created things which reflects a pantheistic attitude towards the world rooted in his unshakeable, but carefully pondered, religious convictions. 'All human effort falls short of the divine law, which compels unconditional reverence. But through the closest scrutiny & observation we may work parallel to the invisable [sic] order & perhaps catch a reflection of it.'[68] It is symptomatic of this mode of vision that he should constantly be aware of relationships

between great and small, 'how an infinitely small form at the foot of a tree is reproducing, in miniature, the whole structure of the surrounding landscape.'[69]

Even the very earliest of Sutherland's 'conceptual' Welsh paintings are already striking, the paint thickly and boldly applied, as in most of Sutherland's work until more recent years; but in composition they are somewhat tentative and uncontrolled, their deeply felt images not yet fully resolved into pictorial art. In *Welsh Landscape with Roads* (Plate 17), painted in 1936, unity is achieved by means of tone. *Red Tree* (Plate 25), of the same year, richly and loosely brushed, dramatic in its scarlet setting and background, was the starting point for a bold abstract composition more closely related to his poster art (Plate 26), and it was probably the modernity of pictures of the latter description that led Sir Roland Penrose to invite Sutherland to contribute to the International Surrealist Exhibition in 1936.[70] But the pictures he sent were not landscapes; they were in essence *jeux d'esprit*[71] and in no way surrealist; he was unsympathetic to the movement as such, and he gained little, except an admiration for Picasso and Miró, from the experience of the exhibition.[72]

There were, however, aspects of modern art which now attracted Sutherland. From at least the mid-1930s he was fully aware of trends on the Continent from *Cahiers d'Art* and other periodicals,[73] and he was deeply moved and impressed when Picasso's *Guernica*, and the preparatory studies for it, were exhibited in London, ironically perhaps, in October 1938, the month after the Munich agreement.[74] *Guernica* demonstrated, with an urgency which he was soon to emulate, precisely what he was trying to achieve in his own painting. 'Picasso's *Guernica* drawings seemed . . . to point to a way whereby – by a kind of paraphrase of appearances – things could be made to look more vital and real. The forms I saw in this series pointed to a passionate involvement in the *character* of the subject whereby the feeling for it was trapped and made concrete. Like the subject and yet unlike. Everything I saw at this time seemed to exhort me to a greater freedom . . . Only Picasso, however, seemed to have the true idea of metamorphosis whereby things found a new form through feeling.'[75] In spite of this enthusiasm, Sutherland never travelled outside Britain at this time. A visit to Paris might have seemed obligatory for any young English painter set on an independent course; perhaps, at this stage in his artistic development, Sutherland felt Paris threatened the independence of his thinking, but to a large extent it may simply have been an ingrained insularity inherited from his family.[76] At any event, he was not interested in going.[77]

The paintings of the later 1930s show a growing tendency towards the use of abstracted shapes and areas of broad, flat, sometimes comparatively undifferentiated – rather than broken, textured – colour, and an ever-increasing nobility or dynamism of form. Comparison of a watercolour and a painting of the same subject is instructive from this point of view, all the more so if, as in the following case, the painting was executed earlier than the watercolour. In *Sun Setting Between Hills* (Plate 22) the still recognizable components of the hillsides, rocks and fields and hedges, are gradually dissolving into blacks and greys. In *Welsh Mountains* (Plate 21) the forms and contours are simplified and smoothed out into almost abstract shapes, fields and hilltops receiving due emphasis from a certain sharp angularity which became a characteristic of Sutherland's underlining of a compositional idea. The design in this form has an undeniable nobility and firmness of structure: 'for me it is always a question of starting with the concrete & recreating something more concrete.'[78] The well-known *Entrance to*

Lane, in the Tate Gallery (Plate 36), which developed from a series of complex studies of a lane shrouded by high hedges and an overhanging bough, is equally bold in design, though lyrical and rhythmical (the rough shape of the bough has disappeared) rather than dramatic; angularity of form is evident only in the foreground shadows. Even the abstracted image which came into being as *Red Monolith* (Plate 28) gained immeasurably in strength between gouache and painting: the imperceptibly 'faltering' contour of the left side, in particular, has an immense power, as of a strung bow.

The same monolithic structure was used to equally telling effect, rising sheer above the rocks, in *Gorse on Sea Wall* (Plate 33); it is not without significance that Robert Melville, a critic deeply responsive to Sutherland's work, should have described this sombre presence, and the gorse clambering about it, as 'a grave and noble portrait'.[79] In *Red Monolith* colour could legitimately be deployed for purely aesthetic purposes. The colour in *Gorse on Sea Wall* is also to a large extent arbitrary, the sky occupying over half the canvas being divided into areas of yellowish-green and crimson-lake which surmount the inky blackness of the sea; the picture space is correspondingly shallow. The root forms which are the subject of *Midsummer Landscape* (Plate 38) have been composed into an image of a wholly different kind, a creation resembling some extraordinary denizen of the sea, vibrating with energy, that seems to rotate wildly over the landscape. Similarly anthropomorphic, and equally dynamic, are the monstrous but majestic *Green Tree Form* (Plate 39), Sutherland's largest canvas to date (1940), and the fearsome *Blasted Oak* (Plate 42), its roots bared and claw-like. These works are highly expressionist in character, and must owe much to his study of *Guernica*.

Some of the finest and most elaborate of the Welsh landscapes were painted during the freezing first winter of the war, when the Sutherlands were offered hospitality, away from the potential danger zone of Kent, at Tetbury House, Gloucestershire, which had been rented by their close friend and patron, Kenneth Clark. These pictures were exhibited at the Leicester Galleries in May 1940. Clark was Chairman of the War Artists Advisory Committee, a body he had set up to commission pictorial records of every aspect of wartime activity, records similar to those commemorating the First World War, housed in the (then) newly founded Imperial War Museum; he now asked Sutherland to become an official War Artist, and Sutherland at once accepted.[80] Apart from his commercial work, this was the first time Sutherland had worked to commission; the thoroughness of his art-school training and his natural gifts ensured competent results, but one might not have expected an artist with a vision so intensely personal to have responded creatively to the range of assignments allotted to him.[81] That he did was due partly to his fascination, first awakened twenty years before in the railway works at Derby, with machinery and machine-power, but, above all, to his passionate feeling for, and sympathy with, human endeavour and human suffering; it is significant that the figures in his wartime pictures, real people now, are invariably vitally conceived, whereas, in spite of the fact that the figure was always central to Sutherland's imagination, those single, oddly usually running, figures with which he peopled his Welsh landscapes, to give scale and some sense of 'the imprint of man', are, as Douglas Cooper rightly pointed out, pasteboard, no more than mannequins.[82] Of the places to which Sutherland was sent, it was the newly reopened tin mines[83] and the foundries, rich in effects for any painter of a romantic disposition, that especially quickened his visual imagination.

The first important assignment he was given was to record air-raid damage in

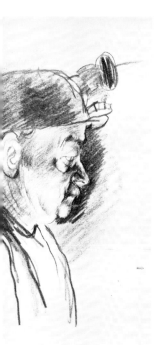

Fig. 9. *Study of a Tin Miner*. Pencil; 22.9 × 13.7 cm (9 × 5⅜ in.). 1942. Mrs Graham Sutherland

devastated Swansea.[84] His drawings were firmer, more incisive, than anything he had done since his early printmaking days, but they were as highly charged as his studies of the Pembrokeshire landscape. 'It's the force of the emotion in the presence of such a subject which determines and moulds the pictorial form that one chooses . . . the forms of ruin produced by a high explosive force have a character of their own . . . One day one will feel moved by the purely explosive character of one's subject and wish to get rid of this sensation in a picture. At another time, the sordidness and the anguish implied by some of these scenes of devastation will cause one to invent forms which are the pictorial essence of sordidness and anguish – dirty-looking forms, tormented forms, forms which take on an almost human aspect, forms, in fact, which are symbols of reality, and tragic reality at that. . . . In either case . . . the forms which the artist creates . . . will transcend natural appearances.'[85]

Sutherland's wartime pictures – even the rapid and direct, rough chalk and gouache drawings done on the spot – are indeed less naturalistic than they often appear at first sight. He vividly remembered the origins of his fine portrait sketches of tin miners: they were done on the way up to the surface in order to distract them from their natural desire to look through his portfolio of studies made below and save him the embarrassment of their total incomprehension.[86] The evocative womb-like conception, based on the strata of the tunnellings, of his magnificent *Tin Mine: A Declivity* (Plate 48), rich in subtly textured, romantic reds, oranges and yellows, is a case in point. His sense of colour was still in the tradition of Blake and Palmer, and some of his compositions revert, almost instinctively, to the ideas of his Welsh landscapes. 'The paintings I made as a War painter were influenced by the vocabulary of forms, which I had observed in natural objects'.[87] His initial study of twisted girders[88] has a generic likeness to the root form in *Midsummer Landscape* (Plate 38), as does the rearing shape like that of a wounded animal in his large gouache worked up from studies of a fallen lift shaft (Plate 47) to the fallen tree trunk in *Green Tree Form* (Plate 39). His early love of perspectival effects, and the use of brilliant yellows against an eerie darkness, effectively dramatized the desolate façades – all that remained – of rows of ruined houses in *Devastation: East End Street* (Plate 52): 'they were great – surprisingly wide – perspectives of destruction seeming to recede into infinity and the windowless blocks were like sightless eyes.'[89] In *Tapping a Steel Furnace* (Plate 56), one of his most powerful wartime compositions, both the sharpness of the perspective and the poses of the deeply felt figures inescapably remind one of Tintoretto. *Devastation: City, Twisted Girders* (Plate 49) is a beautifully rhythmic design based on the tensile strength of great metallic forms; his towering *Hydraulic Press, Woolwich* (Plate 59), done at Woolwich Arsenal, is perhaps his noblest image of this period, an equivalent to the 'presences' of the Welsh landscapes.

The subjects with which Sutherland was confronted also included devastated factories – the complex studies of bits of machinery in a garment factory that had been gutted, 'their entrails hanging through the floors',[90] anticipate his quasi-mechanical constructions of a decade later – iron foundries, limestone quarries and open-cast coal production. Sutherland was anxious to go to the Russian front – it would have been his first journey abroad – but the war artists were regarded by the Ministry of Information as too precious for such adventures;[91] he did go to France, however, in very uncomfortable conditions, following the landings in Normandy in 1944,[92] and his studies of wrecked locomotives and goods trains at Trappes (Plate 58), virtually his last work as a war artist, resulted in one of his most distinctive compositions – and one of his few large

oils – of the war period.[93] These subjects, and his sketches of the flying-bomb sites at St Leu d'Esserent, display a wholly new breadth and force of handling which was already being reflected in such imaginative landscapes as he found time to paint in 1944.

In February 1944 Sutherland was present at the unveiling of Henry Moore's *Madonna and Child* in the north transept of St Matthew's, Northampton.[94] The vicar, Canon (now Dean) Walter Hussey, one of the most remarkable contemporary ecclesiastical patrons of music and art, a man never content with anything but the best, and an admirer of Sutherland's, invited him to paint an *Agony in the Garden* which would fill the space on the opposite wall. The proposal was surely as surprising as it was inspired.[95] Sutherland was not a figurative painter, though the figure meant much to him. But he had an adventurous disposition: 'I have never disliked working outside my normal scope and it interests me to try and solve new problems.'[96] Perhaps because of the experiences of the war, he 'had wanted for some time to attempt a Vision of the Crucifixion' and when, after a short conversation, he was able to persuade Hussey to substitute this subject, he accepted the commission.[97] The canvas was to be on a scale quite new to him, he had never painted the human figure life-size, and he had not attempted a religious subject since he had entered for the Prix de Rome in 1925.[98] Moreover, as he wrote a few years later, 'we have got out of the habit of working for a specific place, and for a patron, and this gives rise to complexes and psychological inhibitions.'[99] These hazards he was fully prepared to accept.

For Sutherland the Crucifixion symbolized 'a duality which has always fascinated me. It is the most tragic of all themes yet inherent in it is the promise of salvation. It is the symbol of the precarious balanced moment . . . It is that moment when the sky seems superbly blue – and, when one feels it *is* only blue in that superb way because at any moment it could be black . . . and on that point of balance one may fall into great gloom or rise to great happiness.'[100] This duality was, of course, especially relevant in 1944. Characteristically, he approached the commission – when he was free of his war work – with diffidence and infinite patience, pondering the numerous possibilities that presented themselves with an unhurried deliberation. To avoid superficiality in a subject painted by so many of the great artists of the past was not easy. At one point his mind 'became preoccupied with the idea of thorns (the crown of thorns) and wounds made by thorns',[101] and inspiration came to him in the same way as it did in his landscape work, from the 'hidden' forms in nature. 'In the spring of the following year [1945] the subject was still very much in my mind. So far I had made no drawings – and I went into the country. For the first time I started to notice thorn bushes, and the structure of thorns as they pierced the air. I made some drawings, and as I made them, a curious change developed. As the thorns rearranged themselves, they became, whilst still retaining their own pricking, space-encompassing life, something else – a kind of "stand-in" for a Crucifixion and a crucified head.'[102] 'Only the rhythms which I seemed to want were recorded and the rest left out. I shall never forget the thrill of seeing these "heads" actually present.'[103] During 1945 and 1946 Sutherland was obsessed by this revelation, and painted a whole series of thorn pictures: thorn heads supported on narrow, usually triangular, necks (Plate 69) and thorn trees in which the complexity of forms 'pricking out points in space in all directions'[104] is only held together visually by the firm, tubular trunks on which the branches are poised, a pair of balanced verticals forming an edifice like a rustic gate.

It was instinctive for Sutherland to consider, for his rendering of the Crucifixion, a

're-created' image as evocative as his thorn heads, a 'substitution' which, as in his landscapes, would make the concrete yet more concrete. 'I did . . . a number of "essays" . . . as an exercise, and some of the drawings which exist might give evidence of my thoughts in that direction. . . . I would have liked to make a more "detached" less naturalistic rendering. But two things deterred me: (1) I felt, rightly or wrongly, that since I was designing for a Christian "*culte*" the final form must be immediately intelligible and within the tradition. (2) I felt that certain overtones might be lacking if my rendering approached a technical detachment.'[105] Thus, as he did a few years later in his approach to portraiture, when a similar choice confronted him, he opted for a 'naturalistic' rather than a 'modern' solution.

It was at this time that Sutherland saw photographs of the victims of the concentration camps at Auschwitz, Belsen and Buchenwald, which reminded him of the Crucifixions of Grünewald; these photographs, and the tortured visions of Grünewald, now influenced his thinking.[106] In 1924, when he etched his *Cain and Abel* plate,[107] he had similarly looked back to the world of early-sixteenth-century German expressionism. The first drawings (Plate 70) and small oil study[108] for the Northampton Crucifixion depict an emaciated body stretched beyond breaking point, the head faceless and deprived of its humanity, the tautness of the elongated arms emphasized by the closeness of their position to the slender vertical of the Cross. Especially in the drawings, this was a horrifying image, too much so to convey any message of salvation. One may recall, in this context, the monstrous, distorted head in torment (Plate 63) which Sutherland drew at this time, an image originating in his observation of a stone.

In the second design (Plate 71) the Cross is differently conceived and consists of great planks of wood with the cross-bar no longer short and curving downwards but fully as long as the upright, while abstract, rectangular shapes, rather than the suggestion of a wall, make up the background; this was the setting for the figure finally adopted. The slightly rhythmical treatment of the body, with the abdomen protruding, Christ seen writhing in the agony of death, is reminiscent of Cimabue and early Italian representations of the theme; the forms are more generalized, and the emaciated arms and over-life-size hands more schematically expressionistic, closer to Picasso; the crown of thorns is a dominant feature. Similarly influenced by Picasso, notably in certain distortions and in the agonized head of the Magdalen violently thrown back, is a *Deposition* (Plate 75) which Sutherland painted shortly after the *Crucifixion*, perhaps to exorcise his ideas about a 'less naturalistic rendering'.

In the finished work (Plates 77, 78) the body is limp and the pose frontal, the legs placed further apart (unusual in the iconography) to give greater strength to the lower part of the design, and, though the ribs still project sharply, the handling is softer and shadows lend substance to the forms.[109] The background colour, 'a bluish royal purple, traditionally a death colour – was partly dictated by certain factors already in the church': the level of daylight and the light creamish-yellow Bath stone. 'I would have liked to paint the Crucifixion against a blue sky – a blue background. The thorns sprang from the idea of potential cruelty – to me they *were* the cruelty; and I attempted to give the idea a double twist, as it were, by setting them in benign circumstances: blue skies, green grass, Crucifixions under warmth – and blue skies are, in a sense, more powerfully horrifying.'[110] Though the setting in the church was, from Sutherland's point of view, 'only moderately sympathetic',[111] it was characteristic of his deep concern for the relationship between painting and setting that 'he worked for ten days

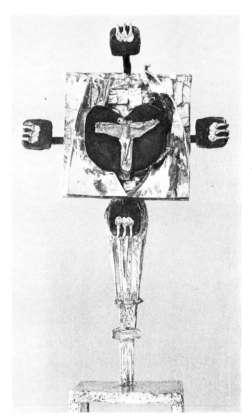
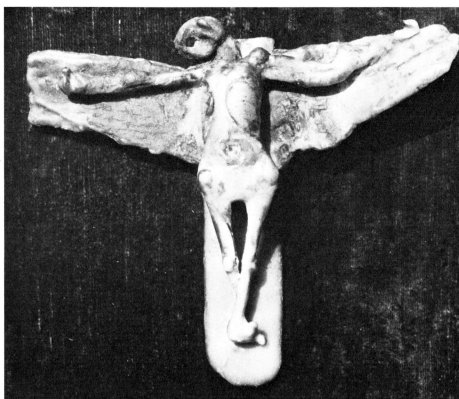

Fig. 10. Cross originally commissioned for the high altar of Ely Cathedral. Silver, the crucifix and fingers gold; height 106.7 cm (42 in.). 1964. Mr and Mrs Emery Reves

in the church before the ceremony of unveiling, adjusting the tones to suit the new conditions of light.'[112] There can be no doubt that the Northampton *Crucifixion* is one of the finest religious works of the twentieth century, 'profoundly disturbing and purging'.[113] Largely because there is no group of mourners at the foot of the Cross, as had been envisaged at first – no Virgin Mary, Mary Magdalen or St John – and in spite of the little railing painted round the feet, the spectator is himself drawn into the tragedy, enveloped and hypnotized by the anguished yet noble figure of the Redeemer.

Sutherland's landscapes of this period are much bolder, and far looser, than his work of five years earlier. One has only to contrast his *Horned Forms* of 1944 (Plate 65), reminiscent of Picasso's admittedly more playful *Baigneuse* of 1927,[114] with the *Midsummer Landscape* of 1940 (Plate 38). Line is thicker, more forceful and dramatic; colour is brighter, more arbitrary, and more varied; natural forms are more generalized, even vestigial, little more than symbolic of roads or fields or woods; shallow and flattened compositions, with a decorative emphasis on the picture plane, become more common. *Triple-Tiered Landscape* of 1944 (Plate 61) is an excellent example of these qualities, which Sutherland described as a clarification of his art.[115] In the similarly constructed *Landscape with Fields*[116] the loosely drawn pyramid of stooked corn becomes a towering presence in the foreground. Images remain anthropomorphic, but the forms he uses are infinitely stranger. For example, studies of bits of branch containing an unusual knot in the wood (Plate 66), first developed into a staring tree form (Plate 67), are finally transformed into those weird but haunting large-scale canvases entitled *Chimère*, or

fantasy (Plate 68). The abstraction, the distortion, the angularity, as well as the decorative harmonies of line and colour, in these works, are closer to the visual world of modern French painting than they are to the romanticism of Sutherland's own style of the 1930s.

In 1947 Sutherland first visited the South of France; he spent four or five months at Villefranche, and in November met Picasso and Matisse.[117] Picasso he now saw fairly regularly over the next ten years.[118] He returned each year to the Riviera and in 1955 bought a house in the hills above Menton. 'I love the sun. I like *working* in the sun. I always have done. . . . It is life-giving.'[119] Objects are 'more alive, more thoroughly and mysteriously themselves when I find them in sunlight.'[120] What is remarkable is that Sutherland's change of style preceded these events, which, as Douglas Cooper wrote, seemed like 'the logical fulfilment of a spiritual need'.[121] 'I think that I made a major step forward', Sutherland explained, 'three years before I started going to France regularly. Even before I went abroad, I owed a profound debt to both Picasso and Matisse.'[122] 'Critics have said that my colour became light (and acid!) after I started to work in France! . . . if they had bothered to enquire, I could have shown them pictures painted in 1944 which were very bright and light in colour.'[123] 'I do not attribute the increase of colour', he added, 'to seeing more contemporary art, but rather to the feeling of a need to clarify and lighten at that time. Colour gradually became important to me and I found I could use it emotively and arbitrarily.'[124] 'When I did start working in France, in 1947, I must confess that I did wonder how I had come to anticipate, by this lightening of key, the clarity of the steady southern light.'[125]

For the next twenty years, when he lived chiefly in France, Sutherland derived most of his pictorial ideas from the Riviera. The rich, moist and varied countryside of Pembrokeshire, which had nourished his imagination for over a decade, was replaced on the one hand by the arid plateaux and mountains of the Alpes Maritimes, spectacular landscape which would have appealed to Turner – 'I was intimidated by the immensity of it'[126] – and on the other by the exotic and gaudy trees and plants of the Mediterranean seaboard which he was able to study all around him but notably in the tropical gardens of the Musée de l'Ile de France on Cap Ferrat.[127] Both the character of the landscape and its forms and the clarity of the Mediterranean light inclined Sutherland even more towards a decorative style of painting and away from landscape painting as such towards a type of composition in which the 'presences' he had tended to evolve in his landscapes became, as Cooper pointed out, virtually still-life objects.[128] This process was already apparent in such works as his *Study of Corn* of 1945[129] and, of course, the thorn trees and heads; he had already been painting conventional still-life arrangements with apples,[130] while his two versions of *The Lamp* of 1944 (Plate 60),[131] close to Picasso in their boldness both of line and colour, are amongst his most successful pictures of this period.

The Riviera motifs which dominated his picture-making in the late 1940s were ones close at hand, vine pergolas and palm palisades. The former he composed into designs as complex as his thorn trees;[132] the latter he compressed into vigorous, sharp forms in which, however, the barbed branches upon which he concentrated his attention were somehow less malevolent in intent than his thorns, their essentially decorative purpose underlined by his experimentation with different background colours, here a startling red, 'like the sound of a trumpet',[133] there a subdued brown (Plates 72, 73). 'Colour

Fig. 11. Study of the *Crucifixion* for the Ely Cross. Wax. 1964. Mr and Mrs Emery Reves. This little figure was one for which Sutherland had a particular affection

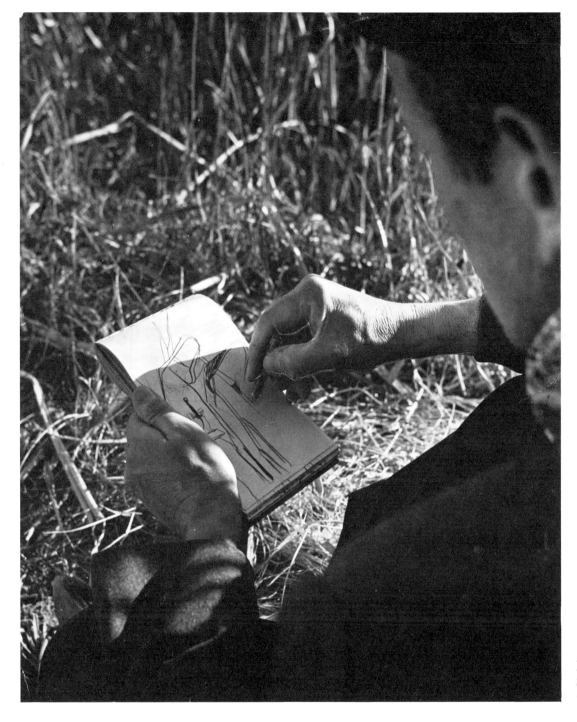

can create form; it can also create a mood; it is fascinating to make complete changes of colour in the background of a painting and see how the whole atmosphere changes.'[134] Many of the forms which he chose – pomegranates, gourds, roses, hanging maize[135] – presupposed a decorative, even lyrical, approach: his drawings of datura plants (Plate 79) are exquisite, his *Apple Bough* of 1955[136] a masterpiece of rhythmical design. The curvilinear, serpent-like *Turning Form* (Plate 112), derived from his studies of roots and maize, is once again anthropomorphic, and Sutherland began to be preoccupied at this time with magnified representations of such insects as the mantis and the cicada which, like his tree roots of 1939–40, he transformed into images of an almost human character (Plates 82, 83). Perched on stone walls which assume the role of plinths, these insects

have an undeniable grandeur, in this respect anticipating Sutherland's more recent studies of bees; they also adumbrate, as do the *Organic Forms*, similarly poised,[137] and the *Root Form, Green Background*, supported on three pedestals,[138] both executed in the same year as the *Cigales*, 1948, the most important series of pictures which occupied him from 1949 until 1953, and which ran parallel to, and were in some degree a preparation for, his early experiments in portraiture – the *Standing Forms*.

This period Roberto Tassi has rightly described as one of the most 'powerful and original' in Sutherland's career.[139] In 1950 he was commissioned to paint a mural, *The Origins of the Land* (Plate 94), for the 'Land of Britain' pavilion at the Festival of Britain, which took place on the South Bank in the summer of 1951. In this symbolic work his forms could legitimately become presences: the pterodactyl and root forms represent the process of fossilization beneath the earth's surface and the array of rocks the eroding process above, while Man, in the shape of a standing form, is shown looking on. This huge canvas, the largest he had ever painted, was at once a summation of his post-war decorative style and an intimation of the sculptural figure style he was developing[140] – and it made Sutherland widely known in Britain. At the beginning of the following year, 1952, he accepted the most important commission of his life, the *Christ in Glory* to be woven in tapestry for the east wall of the new Coventry Cathedral. This period was also one in which Sutherland was achieving an international reputation. He had had successful one-man shows in New York in 1946 and 1948,[141] and well-known American collectors, such as Stanley Marcus and Wright Ludington, were buying his work. In 1952 he was given a retrospective at the Venice Biennale, which went on to the Musée National d'Art Moderne in Paris. 'Perhaps', wrote Kenneth Clark, 'no other English painter since Constable has been received with so much respect in the critical atmosphere of Paris.'[142] One of the largest and most monumental of his standing forms was purchased for the French national collection, and now hangs in the Centre Pompidou.

Robert Melville, writing in 1950, before the astonishing achievement in figure painting, notably portraiture, of the last thirty years, held that Sutherland had 'never been entirely happy with the figure';[143] and it is certainly true that, if one sets aside such brilliant, impressionistic sketches as *The Laughing Woman* (Plate 86), the post-war figure compositions, *Woman Picking Vegetables* or *Woman in a Garden*,[144] are among his least inspired. 'The act of depicting human figures', Melville continued, 'before he can find the means of integrating them with his vision is fraught with some danger . . . he will have to *find* the figure, and not search for it. He will have to come across it by chance . . . and observe it with the passivity which has allowed him to mark the other forms of his choice with the imprint of total recognition.'[145] As Sutherland himself said: 'New directions arrive with stealth – out of the blue.'[146] In this case we happen to know precisely what started him off. 'The standing forms stemmed from seeing figures in gardens – half hidden in shade. At the time, I wanted to try and do forms in such a setting which were not figures but parallel to figures – figures once removed.'[147] The massive *Standing Form against Hedge* of 1950 (Plate 90), composed largely of mechanically inspired shapes, is one of the earliest important examples of these paintings, works which were met with incomprehension by a public then coming to accept Sutherland's modernity. 'People ask about my "Standing Forms". What do they mean?' The artist answered this question in the course of a talk on the BBC Third Programme broadcast at the time of the Festival of Britain: since the passage is unusually revealing about the

creative introspection and obliqueness of Sutherland's processes of mind, it deserves to be quoted in full. 'They do not of course *mean* anything. The forms are based on the principles of organic growth, with which I have always been preoccupied. To me they are monuments and presences. But why use these forms instead of human figures? Because, at the moment, I find it necessary to catch the taste – the quality – the essence of the presence of the human figure: the mysterious immediacy of a figure standing in a room or against a hedge in its shadow, its awareness, its regard, as if one had never seen it before – by a substitution. I find at the moment that I can make these qualities more real to myself in this way. It happens that I find these organic forms best for my purpose. They themselves are emotionally modified from their natural prototype. They give me a sense of the shock of surprise which direct evocation could not possibly do. Also, in these pictures, I am trying to return these forms after drastic rearrangement and emotional and formal modification to the field of purely visual response – to throw them back, as it were, into the original cradle of impact.'[148]

In these pictures Sutherland sought to explore every aspect of the figure, and he posed it in every kind of setting: in bright sunlight, in a sunlit interior, in shadow, against reeds and foliage;[149] he explored the potential majesty of its form, in presences like Egyptian sculpture (Plate 93), and, at the other extreme, painted carcass-like shapes (Plate 92), 'totems of anguish', in Roberto Tassi's phrase,[150] which are reminiscent, both in their handling and in their sense of degraded and decomposing flesh, of the work of his close friend Francis Bacon: a painter, Sutherland believed, 'cannot . . . avoid soaking up the implications of the outer chaos of twentieth-century civilization. By that token tragic pictures will be painted – subconsciously perhaps, and without necessarily having a tragic subject.'[151] The variety of the images which Sutherland drew from the recesses of his mind for the composition of his standing forms is best exemplified by *Three Standing Forms in a Garden* (Plate 89): here the lower part of the figure on the left is derived from bamboo roots not unsuggestive of the burnt-out paper rolls he had drawn in the blitz, and the upper part from a combination of metallic and root forms; the torso of the central figure seems to be an abstraction of stooked corn, the head again metallic in its sharpness; and the figure on the right, which is almost human in appearance, is based on gourds and hanging maize. In such an invention it is possible to observe quite clearly the process of formal modification by which Sutherland returned 'to the field of purely visual response' these mysterious, contrived but none the less powerful, substitutions for the human figure he found it necessary to stalk in so oblique a fashion.

At the same time as he was composing these strange and often alarming figures, he was making a particular study of the head. Some stones he had come across in a dry river-bed at Tourettes-sur-Loup suggested to him the shape of a human head (Plate 96), and a number of powerful images were evolved from this source.[152] In other, more skeletal heads set against bougainvillaea (Plate 85), apparently inspired by the same *objets trouvés*, he seems to have been exploring the relationship between the tensions in the human head and those inherent in precision machinery. Certain images were derived from the thorns with which he had become obsessed in 1945–6; these were set within an oval frame suggestive of a head and supported upon a metallic base in place of shoulders (Plate 84).

When Sutherland departed from these substitutions, and attempted compositions such as *Path through Plantation* and *Men Walking*,[153] in which actual figures were

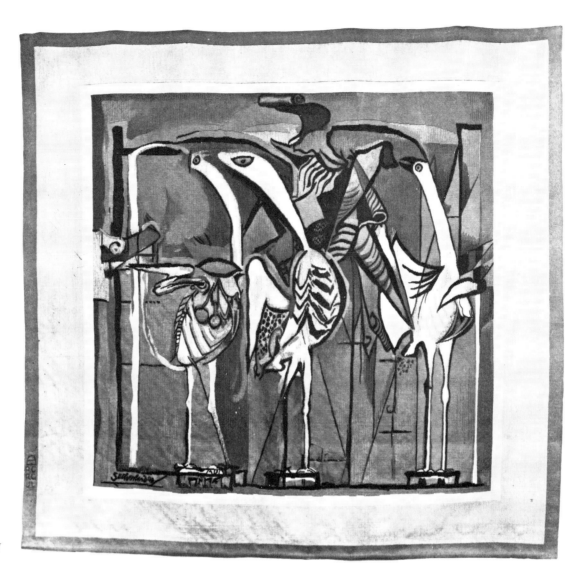

Fig. 13. *Wading Birds.*
Tapestry designed for
the Edinburgh
Tapestry Company;
195.6 × 199.7 cm
(77 × 78⅝ in.). 1949.
Vancouver Art Gallery

introduced, the result was less effective, reminiscent of the 'mannequins' of his Welsh landscapes. It was only when the figures were participants in a drama not of his own imagining, as in his *Christ Carrying the Cross* of 1953 (Plate 103), that they attained the potency born of deep feeling; this is crucial to our understanding of Sutherland, and helps to explain both his need to express himself in terms of the standing forms and much of his later development. 'The feeling one has – if it is strong enough – generates its own technique which will express it. If the feeling is not strong, the technique will be weak.'[154] Sutherland found what he was searching for in portraiture, far from a sideline in his work, as has sometimes been suggested.[155]

Portraiture was a genre with which Sutherland had experimented as a student[156] but since totally abandoned except for occasional, and often very accomplished, pencil sketches; none the less, it continued to attract him.[157] Shortly after settling in the South of France he became acquainted with Somerset Maugham, and one day in 1948 casually remarked to a mutual friend that, had he been a portrait rather than a landscape painter, Maugham's remarkable head and personality were of precisely the kind that would have excited his pictorial imagination.[158] Characteristically, Maugham responded to this implicit challenge, and invited him to do his portrait:

Sutherland replied, equally characteristically, that 'if it can be regarded purely as an experiment I would very much like to try'.[159] 'Perhaps', he explained a few years later, 'one of the reasons why I have recently tried to do portraits is that it is possible that I feel the need to narrow the gap between my 'stand in'' monuments and the real human animal. I cannot say for certain.'[160]

The portraits 'have in some ways remained – experiments – studies akin to the studies I would make in front of any object';[161] just as in his landscapes and 'still-lifes', Sutherland's aim was to probe, to pin down the essence of his subject. He could have achieved this by following the example of Picasso, whose distorted portraits he greatly admired for their strong likenesses, 'psychological truth' attained 'by unlikely means';[162] indeed, this is the course he might have been expected to adopt, for it would have been in line with his metamorphosis of landscape or insect forms, making the real more real. In fact his approach was quite opposite and, as in all his work, carefully determined. The human head he regarded as 'obscure enough', and in his view it would have been unhelpful, therefore, 'to put too much distance between the subject and the spectator'. 'With unfamiliar things, I am interested in pointing out their nature, and indeed their very presence, by a system of comparisons or parallels: reality told in a different way. In other words I am attempting to announce something that nobody looks at. But as far as people ever really look at anything, they *do* look at faces: and as the human head is interesting enough to me also I try to understand its essence by more direct means.'

Thus likeness has always been essential to Sutherland's portraiture: not, of course, superficial resemblance, 'the so-called ''speaking likeness'' of attempted imitation, but the likeness which is the result of an attempt to fuse all the characteristic directions, movements, and tensions of the head and body into terms of paint.'[163] Representation on the deepest level presupposes the closest scrutiny and analysis of externals – every apparently surface aspect and idiosyncratic movement of an individual; for, 'in falsifying physical truth you falsify psychological truth.'[164] 'If I understand enough of the forms I see, the rest follows.' Hence, at the outset of a commission, Sutherland would draw incessantly in front of the sitter, making notations principally of the head, its features and conjunctions of features, studying proportions, lineaments and complexion from different positions and under different conditions of light – notations that became gradually more immaculate as he got to know his sitter better. In the case of Churchill, where the hands were of especial significance – the sitter was always sensitive on this score – Sutherland made innumerable studies of these features (Fig 15). Characteristic expressions, movements, gestures were marked down, accurately and remorselessly. Sutherland was acutely conscious that 'everyone has their own aura' and yet that 'layer upon layer of wrappings cover . . . personality'. 'I have to be as absorbent as blotting-paper and as patient and watchful as a cat. . . . It is a matter of accepting rather than imposing. It is also an art of letting the subject gradually reveal himself unconsciously so that by his voice and gaze as well as by his solid flesh your memory and emotions are stirred and assaulted, as with other forms of nature.'[165] It is the rigour, intensity (not cruelty) and sympathy of this assimilative procedure that accounts for the extraordinary originality of Sutherland's portraits, as it did for the originality of his landscapes from the moment he set foot in Wales. When the portrait of Somerset Maugham (Plate 88) was first shown at the Tate Gallery in 1951 the public was shocked, even outraged, but there was also an awareness that the accepted

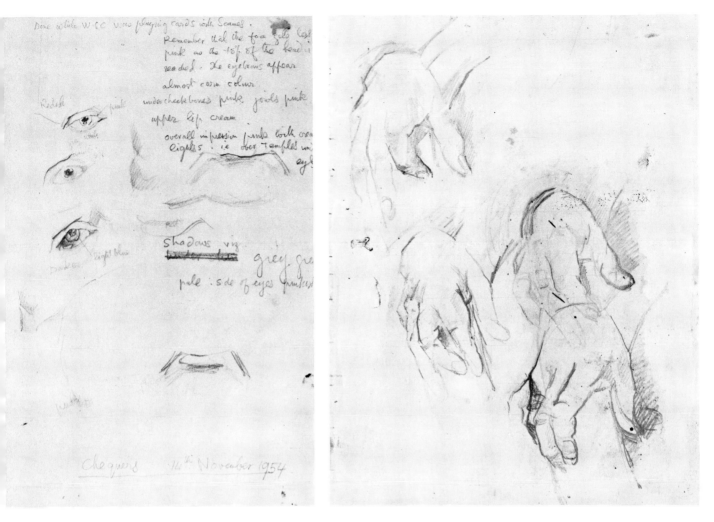

Fig. 14 (left). Studies of the right eye and mouth for the portrait of Sir Winston Churchill. Black chalk and pencil; 36.8 × 25.4 cm (14½ × 10 in.). Dated 14 November 1954. The Beaverbrook Foundation, Beaverbrook Art Gallery, Fredericton, New Brunswick

Fig. 15 (right). Studies of the right hand for the portrait of Sir Winston Churchill. Pencil and gouache; 36.8 × 25.4 cm (14½ × 10 in.). 1954. The Beaverbrook Foundation, Beaverbrook Art Gallery, Fredericton, New Brunswick

conventions of portraiture had been silently set on one side, and no longer possessed substance.

Sutherland painted fewer than fifty portraits in the course of thirty years. He did not like to undertake commissions that were not a stimulus to his painting.[166] In the first place, the physical element was important, and in a sense equivalent to the 'rare and hidden forms' he would find in landscape one day but not the next: for 'there are certain conjunctions of form and shape which for one's personality seem right. Why this is so – why one is astonished by these particular relationships, while others do not touch one, is a mystery.' But ultimately it was the personality that mattered, individuals whose complexity and depth of character and experience were a challenge to his powers of interpretation. 'I . . . find it immensely fascinating . . . to deal with people who have had pressures put upon them or who have had the character necessary to direct great enterprises. There are psychological overtones in such people which it is absorbing to try and render.' Above all, 'the last state of man holds for me the greatest interest. He has faced the responsibilities and temptations of life.'

With Somerset Maugham, as Douglas Cooper implies in a typically apt comparison, Sutherland 'began to see in the lines, forms and convolutions of a human face the same sort of expression of the process of growth and struggle as he found in the rugged surfaces and irregular contours of a boulder or a range of hills'.[167] An *objet trouvé* indeed.[168] He also saw in terms of line, as he was doing at this time in his palm palisades (Plates 72, 73). Sketches from life were followed by elaborate drawings of the head done in the studio, drawings which accentuated the folds, pouches and wrinkles of Maugham's remarkable face, and it is symptomatic of his understandable preoccupation with these 'picturesque' features that Sutherland should have traced the head onto the canvas, the first and last time he adopted this procedure. A similar, linear approach to his subject is apparent in the multiplicity of folds and creases in the clothes, but this tendency towards caricature, also evident in Sutherland's second portrait, that of Lord Beaverbrook, he subsequently eradicated from his style; the full-length of his old friend Edward Sackville-West, done in 1954, perhaps his masterpiece in portraiture, is at once painterly, muted and infinitely more subtle (Plate 106).

Sutherland always considered his overall conception as the most vital element to keep clear in his mind, and, accordingly, painted in the tranquillity of his studio, away from the sitter: 'form is more difficult [than colour or atmosphere] . . . I find it distracting to have somebody in front of me . . . You know how the idea of a person forms itself in your mind, generally quite clearly? And then, when you look again, you find so many other features that the original conception is obliterated.'[169] The early portraits are executed on unusually narrow canvases, similar to the compositions of his single standing forms, and they possess the same 'contained vitality',[170] an effect which Sutherland was also seeking in his *Christ in Glory* for Coventry (Plate 116). He was opposed to the informal, snapshot-like effects so carefully contrived by the Impressionists or by Degas, and he disliked being obliged by circumstance to truncate or cut his figures, though in the case of *Helena Rubinstein* (Plate 107) he did so for compositional reasons, and the immense power of the image depends precisely on this factor. 'I like the whole movement of a composition to be contained within the canvas, as though in a vacuum.' How a sitter himself posed was a determining element, for 'it is no good trying to impose a position. Each person has his own way of sitting down, crossing his legs, moving his hands.' Sutherland was at his best when the sitter composed himself, like Prince von Fürstenberg (Fig. 16; Plate 109), 'in such a way that the forms, while full of diversity, complexity and variety, yet have a rhythm which holds them all together . . . where the complexities are so dovetailed as to form a single – inevitable – movement . . . the maximum action in repose'.

Sometimes the composition of a Sutherland portrait is so rhythmic that it seems literally to spring from the sitter's shoes, as if from a generator. 'What I put in the background', often a system of abstract lines and rectangles, first employed in the *Sackville-West*, 'is usually to stabilize the movements.' The same system, used for exactly the same reason, is found in the head compositions, and the mechanistic, poised, hanging and swinging forms painted in the 1950s.[171] Background colour is arbitrary, but chosen 'very much with a view to the subject's own "colour". The face gives the clue.' Though Sutherland had a good memory for colour – 'the "baby" translucence of Churchill's skin or the parchment of Maugham was easy to remember'[172] – he customarily did oil sketches in front of the sitter, not only for the sake of marking down the nuances of tone and hue but for determining the whole colour scheme of a portrait.

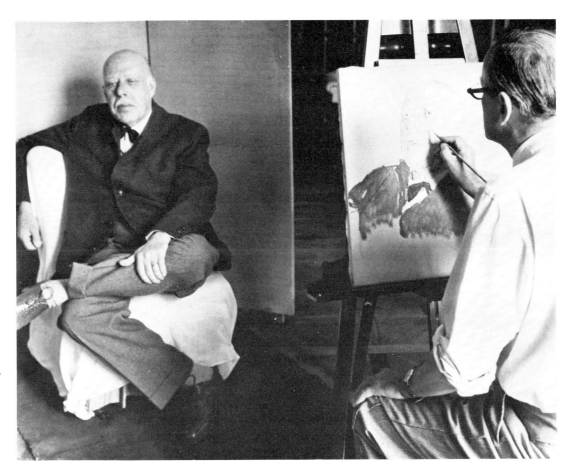

Fig. 16. Photograph of Sutherland making an oil sketch of Prince von Fürstenberg (see Plate 109) at Donaueschingen. 1958

Over the years the brushwork in Sutherland's portraits altered with the development of an interest in tone which was complementary to, and sometimes more important than, his linear description. Even in the *Adenauer* (Plate 121), where line remains crucial to the portrayal, it is the modulation of tints, arbitrary if considered as local colour, that effectively shapes the structure of the head; in such a portrait as the *Paul Sacher* the touch is the essential instrument of modelling (Plate 111). A similar development is discernible in his other work, and the gradations in tone which distinguish such subtle compositions as *Head III* or *La Petite Afrique III* (Plates 101, 98), painted in 1953 and 1955 respectively, should be contrasted with the emphatic use of line and colour characteristic of the 'still-lifes' of the late 1940s.

The central event in Sutherland's career, and the work for which he will be most generally remembered, is undoubtedly the Coventry tapestry, upon which he lavished the greater part of his energies for an entire decade, 1952–62. It was towards the end of this period that he was awarded the Order of Merit. The commission was inspired by the architect of the cathedral, Sir Basil Spence, who was determined that, if he won the competition, the tapestry which formed part of his design should be by Sutherland;[173] and it says much for the ecclesiastical authorities, for whom Sutherland's work meant nothing, not only that they agreed to his suggestion, but that they accepted, and laid down, that 'the artist-designer should be given great freedom in composition, colour, style, which will necessarily be of this generation.'[174] The subject itself was prescribed; it was not, as in the case of the Northampton *Crucifixion*, of the artist's own choosing. Christ the Redeemer was to be depicted enthroned in the glory of the Father, who was to be represented as light unapproachable: Christ's attitude, 'though serene, should

indicate His present active saviourhood of men on earth – e.g. He may be shown blessing, helping, ruling, giving the sacrament, especially drawing humanity up into Himself.'[175] The source of the iconography was the Book of Revelation, and the composition was to include, surrounding the throne, the four beasts (from early Christian times associated with the Evangelists) and the rainbow mandorla.[176] The image was intended to dominate the cathedral from behind the high altar, and to set the devotional mood in which the other features commissioned for the building were to play their part.[177]

In the first year or so Sutherland spent much of his time studying religious art and Christian iconography, to 'clear the ground', in much the same way as he had done in approaching his *Crucifixion*: 'I wanted to free myself from what had been done but, equally, to know what to free myself from, I had to look at it.'[178] From an aesthetic point of view, he realized that 'a single dominating figure is a very testing thing to do because it either becomes too symmetrical or it does not become symmetrical enough.' With regard to the image, 'I wanted the figure at least to have in its lineaments something of the power of lightning and thunder, of rocks, of the mystery of creation generally – a being who could have caused these things, not only just a specially wise human figure. My idea, then, was to make a figure which was a presence.' He was deeply impressed by 'the quality of pent-up force' which he found in the Egyptian sculpture in the Louvre and 'after much thought I felt I wanted to do a large figure like a Buddha or one of the Egyptian figures in the Valley of the Kings.'[179] Also, 'the feeling of a paraphrase or reconstitution of the stillness one sees in some of the Pantocrator heads or busts I did want to get.' 'All this time I was thinking that the figure must be at once remote and yet using gestures of to-day . . . One should of course make a new vocabulary not only of gestures which people use in ordinary life but also of religious gestures. People do clasp their hands in church, but they do a number of other curious things as well.' This apparent dichotomy, like his readiness to combine conceptual and naturalistic forms in his representation, brings us close to the heart of Sutherland's conception. Similarly, with the four beasts, Sutherland eschewed heraldic connotations, and sought to depict their natural characteristics: 'only through this demonstration of their nature do animals pay unconscious tribute to the power which created them.'

Given the breadth and essential simplicity of Sutherland's figure of Christ, the immense scale of the tapestry dictated a greater complexity in the design of the surrounding panels and a lively, broken treatment of the vast areas of green which composed the background. The change, from red sandstone to white plaster, in the proposed treatment of the walls of the retrochoir, which was not made until after the completion of the second cartoon, also affected these considerations, as it meant that Sutherland was able to use much brighter colour: the initial choice of stone had inevitably been a considerable restriction on the tonality, which the artist had visualized as 'a series of dullish green tones, rather like old velvet'. Sutherland evolved three distinct compositions, embodied in the cartoons which were submitted to the Bishop in 1953 and formally to the Reconstruction Committee in 1955 and 1957 respectively (Plates 114, 115); it was characteristic of his total integrity in face of such a work that twice he should recast carefully conceived designs which had been accepted by the authorities. The final maquette used by the weavers[180] was a modification of the third cartoon.

The tapestry was woven, in one piece, by the French firm which had done so much to revive the art of tapestry in the post-war years, Pinton Frères, at the Aubusson factory at Felletin. The specially dyed colours, which the artist examined with great care, were impeccable; and the twelve weavers worked from the cartoon and from full-scale photographic enlargements upon which Sutherland went over all the parts which he thought required clarification, seeking, among other things, to avert the danger that the craftsmen, conditioned to the boldness of Léger and Matisse, might simplify his complex, variable contours. Sutherland's absorption in the problems of the technique, and his close co-operation with the individual craftsmen, was typical of his working methods at all times. Both weavers and artist were fully occupied with the work for over two and a half years; the tapestry was finished in February 1962, and the cathedral was consecrated on 25 May. Unfortunately, Sutherland was not allowed, owing to the exigencies of the final timetable and the authorities' feeling that the work should be seen first at Coventry, to see the tapestry hung before it left France[181] – during the process of weaving only as much as was wrapped once round the roller, about two feet, was visible – but the effect had been superbly calculated and the tapestry commands the nave with the majesty for which the authorities had hoped. The image of Christ, given greater strength by the final modifications in the lower part of the drapery, amply possesses that compelling force, that 'great *contained* vitality', which was Sutherland's principal aim from the outset, but He is also dignified and serene, as had been stipulated, and in the countenance there is a measure of that tenderness for which Sutherland believed it unusually difficult to invent a valid pictorial equivalent.[182]

In 1954, soon after he had submitted his first cartoon, Sutherland became pre-occupied with intricate pictures of thorn trees and thorn crosses, as he had been at the time of the Northampton *Crucifixion*;[183] but the years during which the Coventry tapestry was constantly in the forefront of his mind were also ones in which a mood of lyricism and serenity tended to predominate in his 'nature' work. Perhaps this is not altogether surprising. In his *Apple Orchard* of 1955 (Plate 161) the swags of apples are gracefully poised against a muted background; the loose forms and tentative contours of his *Palm* of 1958, its setting reminiscent of the gaiety of Matisse (Plates 117, 118), are a far cry from the sharpness and the Picassesque breadth of line and colour harmonies of a decade earlier; the subdued colour and tonal relationships of his *Scales* of 1959 (Plate 124) are as subtle as a still-life by Sir William Nicholson. In such works as his *Petite Afrique III* of 1955 (Plate 98), delicate in colour, soft in treatment, the panels in the lower part of the composition seem even to provide an echo of those in the design of the tapestry.

In the 1960s, released from a long period of concentration on a single image and an unfamiliar technique, Sutherland developed a much more expressionist facture. This is most evident in such pictures as his vigorous and thickly painted *Mantis* (Plate 119), done in 1963, and the brilliant *Night Landscape* of 1965,[184] a veritable explosion of paint in a riot of colours, with a fiery red predominating. Complexity and verve of brushwork are also characteristic of the masterly *Dark Landscape* of 1962 (Plate 123), 'impenetrable damp green gloom'[185] redolent of the tangle and mystery of the forest which should be contrasted with *Path in Wood II* of 1958 (Plate 122) and the lyrical, even joyous, treatment of a not dissimilar subject in *Entrance to Lane*, painted in 1939 (Plate 36). As always with Sutherland, changes in style were the product of 'a change of things that came under my eyes', and the tortured images of *Head Against Leaves* of 1963[186] and *The*

Captive (Plate 126), painted at the same time, were, for example, almost direct references to *objets trouvés*.[187] Predisposed as he may have been to notice certain things and to neglect others[188] – as he was when he began, suddenly, to notice thorn bushes at the time of thinking about the Northampton *Crucifixion* – it was unexpected natural forms that released his imagination.

Looseness of brushwork, sometimes luscious and used for decorative effect, was now accompanied by a looseness of form, as in his thorn trees of 1970,[189] and, a logical progression, by an increasing preoccupation with movement; swans and herons reappear in his work, swimmers and divers are used as motifs, and the fountain, a favourite theme, offered the possibility of a flow of streaming water.[190] Sutherland's cisterns and fountains, symmetrical, impressive, and vigorously modelled, tonally, are the 'presences' of this period (Plate 125). Potent though many of his images are, their primary connotation is energy. The suspended *Machine on Black Ground* of 1962 (Plate 130) sends out darting tongues of ochrish colour into space; *Poised Form in a Landscape* of 1969 (Plate 133), inspired by the complex, interlocking forms of a great gnarled oak, appears mechanistic and, though in equilibrium, is equally suggestive of power and motion.

Between 1945 and 1960 Sutherland had made prints of only about fifteen of his subjects. These were all lithographs, a process he had used since 1935. In the last two decades, though there was no diminution in his painting, he turned more decisively to the arduous discipline of printmaking, his work of the 1960s culminating in his *Bestiary* (1968), a series of twenty-six colour lithographs – 'this idea sprang from the studies which I made of animals for the Coventry tapestry'[191] – and that of the 1970s first in the *Bees* (1977), a set of fourteen colour aquatints, and then in a second *Bestiary* (1979) comprising seventeen colour aquatints based on the poems of that name by Apollinaire.[192]

The prints in the *Bestiary*,[193] images which emphasize the natural characteristics of their subjects, range from the elegance of the beetles (Plate 149) and the puckishness of the owl to the dankness of the toad, the nightmarish mystery of the bat and the nobility of the lion and the ram's head, representations which are closely connected with Sutherland's work in portraiture at this time: the magnificent leonine head, for example, may be compared with the drypoint of Dr Adenauer.[194] The sheets of 'correspondences' which also form part of the *Bestiary* demonstrate Sutherland's instinctive urge to translate rock forms into images suggestive of the human head and to construct totemic figures out of mechanical and organic shapes, shapes between which he had always seen 'a curious similarity'.

The aquatints of *Bees*,[195] highly inventive in design, illustrate the stages in the insect's life, and, as befits their subject, are not only in a colour scheme largely made up of browns and yellows (Plate 151) (a scheme familiar from *Formes d'Epines* (Plate 144) of 1970), but richer and more resonant than the *Bestiary*: the magnificent scene in which the queen bee holds court glows with golden light against the deepest, most velvety, background of all.[196] In these, and the equally varied and inventive compositions in the Apollinaire series (Plate 150), Sutherland took full advantage of the advanced process of aquatint developed by his friends Eleonora and Valter Rossi, which, as they explain, was calculated to produce effects of great transparency and luminosity.[197]

In 1967 Sutherland revisited Wales, for the first time in over twenty years, in connection with a film for Italian television directed by his friend Pierpaolo Rug-

gerini.[198] Ruggerini he had met at the Turin retrospective of 1965. This exhibition marked a watershed in Sutherland's later life, for it introduced him to wealthy Italian collectors who were soon to become enthusiastic admirers. 'My Italians,' Sutherland called them, and it was they who responded to his new Welsh style. For, once again, bewitched by its 'curiously charged atmosphere' and 'on good days . . . the extraordinary clear & transparent light',[199] Sutherland fell in love with the Pembrokeshire landscape, and his portfolio of lithographs published in 1972 – *Forests, Rivers, Rocks*[200] – is a clear statement of the preoccupations which absorbed most of his creative energies thenceforward. He returned to Milford Haven every year, for increasingly prolonged stays, bitterly regretting the long period of absence 'brought about by the fact that I thought I had exhausted what the countryside had to offer both as a "vocabulary" & as inspiration. I was sadly mistaken . . .'[201] 'A "vein" can reappear years later, re-seen and re-animated.'[202] The nature and degree of this re-animation is a subject which will be of particular concern to later students of Sutherland's art.

Some of Sutherland's latest Welsh pictures revert to themes of the 1930s: winding roads (Plate 156), the sun setting between hills.[203] Anthropomorphic forms emerge from the roots of trees. But most of the themes are new, and many are derived from the observation of rock formations he had discovered on the shores of the estuary of Milford Haven. One such study, of a rock face curiously serrated in pattern, he developed into his *Cathedral* of 1975,[204] a picture seemingly remote from its ancestry, executed largely in strong reds against a grey background; another, an amalgam of rocks in Sandy Haven and memories of rock huts at St David's, into the *Rock Shelter* of 1973–4,[205] glowing from within with the pinks and reds familiar from his sunsets of the 1930s, and

Fig. 17. *Tree Form in Estuary.* Watercolour and gouache; 19.8 × 24.8 cm (7$\frac{13}{16}$ × 9$\frac{3}{4}$ in.). About 1967–8. Private collection, Milan. One of the earliest elaborate sketches Sutherland made after his return to Wales in 1967. A photograph of the oak tree is illustrated on Plate 134

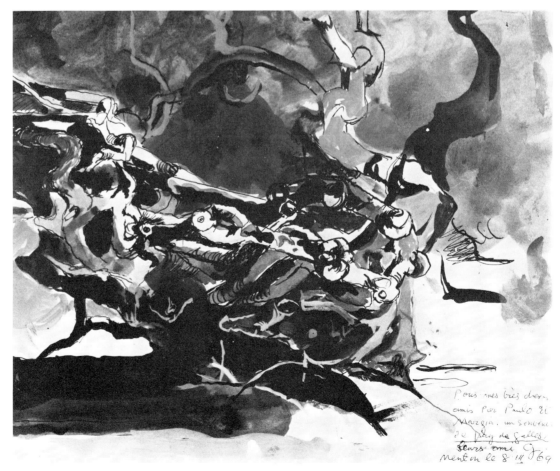

reminding us thus of his reference to the rocks in Blake's Newton drawing. Sutherland's thoughts at this time were of a munificent gift to the nation, and specifically to the region: 'having gained so much from this country, I should like to give something back.'[206] Both canvases are on a large scale, and they are among a group painted specially to form part of the collection of his Welsh work, of all periods, housed, through the generosity of the Philippses, friends and patrons of Sutherland, in a purpose-built gallery in the stable block of Picton Castle, which was opened in 1976.[207] These images are not fully to be understood as presences; translucent in colour, mellifluous in handling, their backgrounds equally diaphanous and barely stained with pigment, these and other recent works should not be interpreted in terms of the intentions of his earlier style. They are imaginings of a different order, inspired by the 'remarkable clarity of the everchanging light'.[208]

The most characteristic of Sutherland's later paintings based on rock forms are the series of *Conglomerates* (Plate 137). These were inspired by a rock unusually rich in protuberances, recesses and variegated colour which he found lying on the ground and returned countless times to draw, and they developed from such works as the *Landscape with Oval Rock* of 1968,[209] where the facets of the rock's surface are picked out in a kind of patchwork. In these paintings countless minuscule shapes are compressed into the framework of gigantic ovals or circles, an exceptionally intricate expression of Sutherland's perennial love of order in variety, 'the maximum action in repose'.[210] These densely interlocked structures permeated other designs. A U-shaped form is used in one picture as a conglomerate,[211] in another to contain a complex of ideas derived from the half-buried wreck of a boat in the sand (Plate 132). *Forest with Chains*, painted in 1970 (Plate 136), contains a poised form of similar complexity, balanced by the simple vertical of a great tree trunk soaring outside the limits of the canvas and set against an abstracted background suggestive of dense woodland, in which the subtly modulated greens create a marvellous sense of light and depth. In *Trees on a River Bank* (Plate 135), painted in the following year, the tree trunks are no longer statuesque – stabilizing forms – but contorted into shapes predicating movement or dissolution, and the handling is correspondingly freer than in the *Conglomerates*.

Freedom of handling, broad areas of thinly brushed colour, looseness of form and an enhanced feeling for rhythmic movement are perhaps the salient features of the last decade in Sutherland's career. Poised forms become swan-like forms,[212] flames shoot out of rocks (Plate 141), the rocks in *Estuary* of 1969 (Plate 138) seem to be enveloped in a continuous undulation along the shore; and undulating forms, thrusting forms similar to his divers (Plate 148), and rhythmically shaped root forms are the subjects of a number of paintings,[213] many more of which than previously have been reproduced as lithographs.[214] Though the scale on which many of these images appear is new, the rhythms are to some extent restatements of an earlier aesthetic. To take two examples, the cascading root forms of his *Picton*, painted in 1972, are reminiscent of the cactus pictures of the late 1940s,[215] while the rotating motion of *Formes d'Epines* of 1970 (Plate 144) harks back to *Midsummer Landscape* of thirty years before (Plate 38).

Beyond everything, however, was the influence of what came before his eyes. His pictures were derived, as they always had been, from specific motifs and specific conditions of light. A majestic gnarled oak (Plate 134), a hunk of chains he found on the beach, sunlight gleaming through the branches of a tree as though it were a jewel (Plate 142), the estuary as the tide receded and the sun went in (Plate 158), an avenue of trees

with overhanging branches. Such trees may once have inspired the poetical *Entrance to Lane* (Plate 36), but in the last few years of his life this avenue haunted Sutherland, and induced a mood of brooding and melancholy, reflected, without pity, in his final works.

In such paintings as his *Primavera* of 1974–5 (Plate 155) or *Bird and Sand II* of 1977 (Plate 158) Sutherland achieved a remarkable clarity and balance, his forms disposed within a shallow space. 'I have always felt the need for an element of equilibrium. In my earlier groping way I found this difficult: even impossible. As I have become older, I have tried to control the unbalance – to control and place the areas which were to me the most fascinating – in a more logical way and to allow the movements of the centres of vitality to proliferate and repeat themselves as in a fugue . . . but *contained* and controlled.'[216] Thus the *Conglomerates* (Plate 137). But *The Thicket* of 1978 (Plate 160), in which Sutherland introduced a terrifying portrait of himself in a dark habit, sketching, is a picture wholly uncontained, a tangle of fantastic shapes conveying the age-old fears of the forest, contained within concentric circles[217] which, in the context of the menace of the whole invention, bring to mind the visions of Dante. 'As one gets older, sudden unaccountable openings present themselves.'[218] This was as true in the last years of Sutherland's career as when he made the remark over fifteen years before. The urge to experiment with group portraits,[219] to introduce figures into his land-scapes, resulted in his *Landscape with Indians* (Plate 162), in which four or five figures are grouped, as a gang of bandits, restless, in the foreground, against the same contorted trees. Such figure groupings he was planning to repeat on a larger scale. His last major canvas (Plate 163), executed in the spring of 1979, carried the dissonance of these late works to the ultimate degree of which it was capable. Beyond the hostile, overblown forms which composed this design lay the mystery of the invisible order.

Right up until his last, brief illness, Sutherland retained the powers and vitality, the freshness and vigour of mind, of a person half his age. Fascinated by opposition and struggle in forms – 'not only Cain and Abel, but one insect destroying another', 'the struggle of a tree to remain standing and grow, against all odds'[220] – he was, temperamentally, a man of opposites, at once passionate and anguished, patient and meticulous, a romantic visionary but yet a sharp and witty commentator upon life, essentially modest and kind. As we have seen, he was highly professional. 'I am, I have to admit, a tireless worker – with regular hours.'[221] Apt to talk of his work as a trade, he was infinitely conscientious about the routine business and interviews associated with it. But he was by nature withdrawn, an observer, and solitude was a condition of his creativity. 'I have a horror – once I am lost in work, of being disturbed. If I could barracade [*sic*] myself within a ring of rocks I would be pleased! To write of the enormous personal complications of the original & genuine "encounter" would be impossible.'[222] Sutherland acknowledged that 'he who is over discriminating becomes narrow in achievement. Yet a singleness of purpose over certain periods of time is necessary.'[223] And the different spheres of his work have each illuminated the other. As Edward Sackville-West wrote long since: 'his art progresses slowly and *en bloc*.'[224] Sutherland's division of the year between the Riviera, Wales and Kent was as regular as his working day. Though he loved France, and it was there that he had his real home, England he could never totally abandon: 'this is not a question of liking England or not liking England; it's a question of where one was born. It's a question also of where one's formative years were spent.'[225] A devout Catholic, he believed in a natural order, the underlying unity of existence, though only too vividly aware that that order is not

necessarily kind;[226] and his faith and the long-enduring happiness of his marriage were the twin sources of his equanimity as he wryly contemplated the absurdities of human nature and human conflict. It is not surprising to learn that Bach was his favourite composer: indeed he cared for little else. 'I am conscious that to such great tight knit architecture I owe more than I can ever realise.'[227]

Sutherland was gifted with an exceptional clarity of thought and expression. He had an unusual capacity to analyse and evaluate his own work, though acutely conscious that words and paint are two distinct things, and inclined to end up by saying: 'I really wish that I had been silent.'[228] He was tenacious in his views, and would never compromise in what he believed to be right.[229] Yet he was a prey to moods. Pictures with totally different implications might be in progress at the same time. *The Fountain* (Plate 125) and *Seated Animal* (Plate 159) were completed within a few weeks of each other. He could be unpredictable, delighted in sensations: he loved the exhilaration of driving fast cars, and was once an addict of the gaming table.[230] Violence he abhorred, but risk had a perennial appeal for him, and the skill, daring and resource engendered by risk he could admire even in criminals. He liked extremes: 'The closeness of opposites in life has always fascinated me. That is to say the tension between opposites. The precarious balanced moment – the hairsbreadth between – beauty & ugliness – happiness & unhappyness [sic].'[231] Transience, which he regarded as an essential element in the beauty of nature, was something he sought to capture. Intellectually, emotionally and spiritually curious, he was for ever probing deeper into the mysteries of human consciousness and the world in which we live, and a restless inner intensity smouldered not far beneath the perfect manners, the fastidious dress and the civilized values and way of life; conversely, as Kenneth Clark has written, Sutherland was always able 'to retreat into the depths behind his eyes where he found those curious equivalents of *objets trouvés* . . . that are the true inhabitants of his imagination.'[232]

Close friend of many artists, Sutherland followed no movement and founded no school, though, notably in the immediate post-war years, painters such as Robert Colquhoun, John Craxton, Robert Macbryde and Keith Vaughan[233] were influenced by his work. His early Welsh landscapes and wartime studies form part of the revival of English romanticism, but his art in general defies classification. In the first place, his vision was too deeply personal, his work 'replete with private symbolism'.[234] In the second, he never ceased from trying to solve fresh pictorial and technical problems. It is the measure of his originality that he was an innovator not only in landscape and his still-life inventions, but in portraiture and religious painting; as a printmaker – and it was as an etcher that he began, and as a printmaker that he did much of his best work in later years – he was versatile, fertile in invention, and highly accomplished. The range of his achievement is exceptional in contemporary art. He had no cause to fear, what he sometimes admitted to feeling, especially after a long stretch of painting on a single theme, that he might eventually dry up.[235] As with any artist, there may have been occasions when his work slackened, his forms lacked urgency; though in his mind he was always aware how a picture ought to look, his hand may have let him down and obliged him to paint more than one version.[236] But few would seek to deny that, in every sphere of his manifold activity, he produced a series of masterpieces which place him firmly in the front rank of British artists of all time. Like that of most innovators, his style continued to evolve. That what he did lay outside the sympathies of the fashionable movements of the last twenty years in Britain is empty criticism.

1 His father studied law, was called to the bar and, after his marriage, worked first in the legal department of the Land Registry and then at the Board of Education, where he served as a Principal (information from the artist).

2 Information from the artist. Cooper, p.65, is misinformed on this point. It should be emphasized, however, that Cooper's precisely documented 'Biographical Summary', based on information received from the artist, remains the indispensable starting-point for a survey of Sutherland's life and career up to 1961. It is followed by Tassi (pp.216–17) without criticism, almost word for word. A full biographical study by Roger Berthoud is in preparation.

3 Barber, p.43. Humphrey Sutherland was born in 1908, Vivien in 1913.

4 Ibid.

5 Sackville-West, p.5; Cooper, p.65.

6 Letter to Hans Juda, printed in Melville (unpaginated). 'If he [a painter] fails to nourish [his] conceptual ideas by familiarising himself with the ways of nature he will dry up and fail to produce' (*The Listener*, 13 November 1941, p.658). It is worth noting that, as early as 1935, when abstract art was in the avantgarde ascendant, Kenneth Clark was writing: 'Without a pinch of earth the artist soon contracts spiritual beri-beri and dies of exhaustion' ('The Future of Painting', *The Listener*, 2 October 1935, quoted by William Feaver in his introduction to the catalogue of the exhibition *Thirties*, Arts Council, October 1979 – January 1980, p.33).

7 Sackville-West, pp.5–6. Sackville-West was wrong in saying that Sutherland 'went to boarding school' in Sutton, and that he learnt Greek there, and in giving the date 1918 for his apprenticeship in Derby.

8 Barber, p.48.

9 It was Sir Henry Fowler, Chief Engineer at the Midland Railway Works, who wrote to Sutherland's father to explain that engineering was not Graham's *métier*, as he was not good at mathematics, and to suggest his going to art school. His father was at first opposed, but was persuaded by Graham's mother. The Slade was full, and Goldsmiths' College was chosen on the advice of a Chief Inspector of Schools who was a friend of Mr Sutherland (information from the artist).

10 Cooper, p.65.

11 Information from the artist. Sutherland followed the complete course, with the exception of architecture and sculpture.

12 Information from the artist.

13 'It was Griggs as an enthusiast and technician from whom, perhaps, we gained most. A master printer of the copper plate, with infinite knowledge and patience, he had a palm as delicate as gossamer' (Graham Sutherland, 'The Visionaries', introduction to the catalogue of the exhibition *The English Vision*, William Weston Gallery, October 1973). Griggs's aesthetic advice Sutherland felt much less able to follow, and this prevented a really close relationship from developing (information from the artist).

14 Barber, p.48.

15 Cooper, p.8, n.6. Mrs Sutherland took up her work again, alone, in 1929 (her fashion studio having been dissolved in 1927) in order to provide an income at this moment of crisis (information from the artist).

16 Their moves are documented ibid., pp.65–6.

17 The Whistlerian tradition, with its emphasis on fine line and open areas of highlight, was the foundation of the teaching at Goldsmiths' as it was at the Royal College of Art under Sir Frank Short.

18 Tassi, pl.1a.

19 Ibid., pl.4.

20 Ibid., pl.14.

21 For example, by Herbert Furst in his review of the exhibition of Sutherland's etchings at the Twenty-One Gallery in 1928 (*Apollo*, November 1928, p.310).

22 Tassi, pl.2; the subject was motivated by the current craze for greyhound racing and inspired by a Frémiet in the collection of his friend Paul Drury's father (information from Paul Drury).

23 Ibid., pls.15, 16.

24 'The Visionaries', op. cit.

25 Letter to Douglas Cooper, December 1959 (quoted in Cooper, p.7). Recently he recalled: 'It seemed to me wonderful that a strong *emotion*, such as was Palmer's, could change and transform the appearance of things. . . . The idea of the way in which emotion can change appearances has never left me' ('The Visionaries', op. cit.).

26 Cooper, p.11, n.2. Cooper gives the date as 'about 1922', but it seems to have been somewhat later (information from the artist). Sutherland recalled that 'I was by this time far too immersed in my admiration for the "Shoreham" Palmer really to respond to Cézanne. My friends were otherwise' ('The Visionaries', op. cit.).

27 Cooper, p.7.

28 Tassi, pl.20.

29 Malcolm C. Salaman, 'A Gossip about Prints', *Apollo*, February 1927, p.85.

30 Furst in *Apollo*, op. cit., p.310.

31 Tassi, pl.26.

32 Ibid., pl.30.

33 Ibid., pl.32.

34 Sutherland had become an Associate in the firm of designers, Bassett Gray (from 1935 renamed Industrial Design Partnership), which his friend Milner Gray had started, as early as 1924. But, although he did some illustrative work for the firm, he did not engage in industrial or craft design until the 1930s. It was Gray who introduced Sutherland to Frank Pick, the chief executive of London Transport (information from Milner Gray).

35 Cooper, p.65.

36 Ibid., p.10. Sutherland did, however, exhibit one work, a *Beach Scene*, with the London Group at the New Burlington Galleries in October 1932 (228).

37 Letter to the author.

38 Cooper, p.11; on p.66 Cooper describes the visit as having been in the summer. Sutherland has confirmed that this first visit to Wales took place in the spring, during the Easter holiday from teaching (information from the artist).

39 Introduction by Graham Sutherland to *Sutherland in Wales* (catalogue of the collection at the Graham Sutherland Gallery, Picton Castle), London, 1976, p.6.

40 Sackville-West, pp.8–9.

41 This long 'letter', which originally appeared under the title 'Welsh Sketch Book' in *Horizon*, April 1942, pp.225–35, has been reprinted in *Sutherland in Wales*, op. cit., pp.11–15. The quotations which follow are all from this statement unless otherwise indicated.

42 Graham Sutherland, 'Thoughts on Painting', *The Listener*, 6 September 1951, p.378.

43 Ibid., p.376.

44 'Art and Life', *The Listener*, 13 November 1941, p.658.

45 'Thoughts on Painting', op. cit., p.376.

46 Introduction by the artist, dated 1 December 1973, to *Graham Sutherland Sketchbook*, London, 1974 (unpaginated); reprinted in *Sutherland in Wales*, op. cit., p.8.

47 Ibid.

48 Graham Sutherland, 'A Trend in English Draughtsmanship', *Signature*, July 1936, p.8. The statements following were made in 1951 and 1964 respectively.

49 'Thoughts on Painting', op. cit., p.376.

50 Barber, p.46.

51 'Thoughts on Painting', op. cit., p.377.

52 Barber, p.52.

53 Kenneth Clark noted in the preface to the catalogue of his first exhibition: 'Nearly all the pictures . . . have been painted from small, careful drawings done on the spot, squared for enlargement and followed most accurately' (*Recent Works by Graham Sutherland*, Rosenberg and Helft, September–October 1938).

54 Dennis Farr, *English Art 1870–1940*, Oxford, 1978, pp.293–5.

55 Cooper, p.12. Sutherland first met Paul Nash in 1929; he was introduced to him by Oliver Simon, the editor of *Signature* (information from the artist).

56 Clark describes in his autobiography how he met Sutherland. In 1935 he had opened the exhibition of Shell-Mex posters at the New Burlington Galleries and, struck by *The Great Globe, Swanage*, asked the publicity director, Jack Beddington, if he would introduce him to the artist. 'He turned out to be a self-possessed, highly intelligent man of the world, with bright eyes which suggested, but in no way revealed, exceptional depths.' A few days later Sutherland brought some of his pictures: 'I bought them all immediately, with great excitement' (Kenneth Clark, *Another Part of the Wood*, London, 1974, p.254).

57 Raymond Mortimer, 'An Arrival', *New Statesman and Nation*, 1 October 1938, p.490.

58 Sackville-West, p.6.

59 Melville (unpaginated).

60 Hayes, p.25.

61 Graham Sutherland, 'An English Stone Landmark', *The Painter's Object*, ed. Myfanwy Evans, London, 1937, p.92.

62 Illustrated in colour in William Vaughan, *William Blake*, London, 1977, pl.12.

63 'An English Stone Landmark', op. cit., p.92.

64 Letter to Hans Juda, 10 August 1950, printed in Melville (unpaginated).

65 Introduction to the catalogue of the Arts Council exhibition *Paintings and Drawings by Graham Sutherland*, Tate Gallery, May–August 1953 (unpaginated).

66 A sheet of studies for this picture is reproduced in Cooper, pl.12a.

67 Melville (unpaginated).

68 Statement dated 4 December 1951, printed in Felix H. Man, ed., *Eight European Artists*, London, n.d. (=1954) (unpaginated).

69 'Thoughts on Painting', op. cit., p.378.

70 'Invited by Penrose. Thought it rather a compliment. Talked to him about light in painting and was witheringly dismissed' (from a letter to Douglas Cooper, quoted in Cooper, p.11, n.4).

71 *Thunder Sounding* and *Mobile Mask* (Melville, fig. 1).

72 Cooper, p.11. He did not meet any of the contributors except Penrose (information from the artist).

73 Barber, p.49.

74 They were shown at the New Burlington Galleries.

75 Cooper, p.17.

76 Sutherland has explained that 'in my family, when we were small, the thought of travelling abroad was equivalent to a major disturbance' (catalogue of the exhibition *Disegni di Guerra*, Palazzo Reale, Milan, June–July 1979, p.144). Nor was he able to afford it ('Images Wrought from Destruction', *The Sunday Telegraph Magazine*, 10 September 1971, p.28).

77 Information from the artist.

78 Man, op. cit. (unpaginated).

79 Melville (unpaginated).

80 Cooper, p.25. The official request is dated 6 June 1940: 'The Committee have suggested that you should be asked to undertake some work on their behalf . . .' (Ministry of Information GP/55/57, p.2; files now preserved in the Imperial War Museum). Such a job had been promised to Sutherland much earlier, but it only matured when the war started in earnest (information from the artist).

81 'I was suddenly faced with certain subjects of which, as far as painting was concerned, I had had no previous knowledge, and I was, in fact, frightened, simply because I didn't know how I was going to react' (Barber, p.47).

82 Cooper, p.18.

83 'A world of such beauty and such mystery that I shall never forget it' (*The Sunday Telegraph Magazine*, op. cit., p.28).

84 His very first job was 'to make drawings of camouflaged aeroplanes. I couldn't make much of them, I am afraid' (ibid., p.27).

85 'Art and Life', op. cit., p.657.

86 Hayes, p.36.

87 *Interview with Graham Sutherland*, Nuremberg–Menton, October 1969 (published in the catalogue of the exhibition *Graham Sutherland Druckgraphik und Zeichnungen mit dem vollständigen Bestiarium*, Kunsthalle, Nuremberg, November 1969 – January 1970 (unpaginated)).

88 Cooper, pl.37.

89 *The Sunday Telegraph Magazine*, op. cit., p.27.

90 Ibid.

91 Statement made on the ITV *South Bank Show*, 1 April 1979.

92 To draw the flying-bomb sites (Ministry of Information GP/55/57, loc. cit., pp.202, 212, 215); *Disegni di Guerra*, op. cit., p.144.

93 Cooper, pl.48d.

94 The unveiling was originally planned for September 1943, but had to be postponed because the sculpture was not ready. Clark erroneously gives the date as February 1943 (Kenneth Clark, 'Dean Walter Hussey: A Tribute to his Patronage of the Arts', *Chichester 900*, Chichester, 1975, p.70) and Cooper as September 1944 (Cooper, p.29).

95 Walter Hussey had asked Henry Moore about a work for the opposite transept, and Moore suggested a painting. With several artists in mind, Hussey sought Moore's advice. Moore's recommendation of Sutherland, which led Hussey to invite him to the unveiling ceremony, does nothing to detract from the vicar's bold decision. The Agony in the Garden was proposed as a subject because of the landscape element (information from Dean Hussey). See also Benedict Nicolson, 'Graham Sutherland's "Crucifixion"', *Magazine of Art*, Washington D.C., November 1947, p.280, and Clark, *Chichester 900*, op. cit., p.71.

96 Révai, p.80.

97 'Thoughts on Painting', op. cit., p.378. The discussions all took place, and the matter was settled, on the day of the unveiling of Moore's *Madonna*. Sutherland wanted to do a Crucifixion 'of a significant size' (information from Dean Hussey).

98 The subjects he attempted then were *The Expulsion from the Garden of Eden* and *Cain and Abel* (Tassi, pls.11, 17).

99 'Thoughts on Painting', op. cit., p.378.

100 Ibid.

101 Letter to Curt Valentin, 24 January 1946 (printed in the catalogue of the one-man

show at the Buchholz Gallery, New York, February–March 1946).

102 'Thoughts on Painting', op. cit., p.377.

103 Letter to Douglas Cooper (quoted in Cooper, p.32, n.4).

104 Letter to Curt Valentin, op. cit.

105 Letter to Douglas Cooper (quoted in Cooper, p.33, notes 5, 6).

106 Cooper, pp.31–2. Some time before, he had confided to Keith Vaughan: 'As for a Crucifixion he did not know whether there was anyone who could handle it. "It is an embarrassing situation," he said, "to say the least of it, to contemplate a man nailed to a piece of wood in the presence of his friends"' (entry for 18 April 1944 in Keith Vaughan, *Journals & Drawings 1939–65*, London, 1966, p.83). Grünewald, he declared over twenty years later, 'I esteem above almost all painters' (*Interview with Graham Sutherland*, 1969, op. cit.).

107 Tassi, pl.17.

108 Cooper, pl.77.

109 The design which Sutherland submitted to the Church Council, but which he skilfully convinced them was inadequate, included various decorative elements and a skull beneath the figure of Christ (information from Dean Hussey).

110 'Thoughts on Painting', op. cit., p.378.

111 Ibid.

112 Nicholson, op. cit., p.280; Walter Hussey recalls this period of self-imposed isolation before Mrs Sutherland came up to Northampton (information from Dean Hussey).

113 Walter Hussey, 'A Churchman Discusses Art in the Church', *The Studio*, September 1949, p.95; Dean Hussey (*Graham Sutherland*, BBC Television film directed by John Read, 1954).

114 Wilhelm Boeck and Jaime Sabartés, *Pablo Picasso*, London, 1955, pl.392. This was the type of Picasso which inspired Francis Bacon's *Three Studies for Figures at the Base of the Crucifixion* of the same year, 1944 (see David Sylvester, *Interviews with Francis Bacon*, London, 1975, p.8).

115 Cooper, p.40, n.9.

116 Ibid., pl.65.

117 Ibid., p.66.

118 *South Bank Show*, loc. cit.

119 Barber, p.50.

120 BBC Television film, 1954, loc. cit.

121 Cooper, p.40.

122 Barber, p.49. 'One would have to be blind not to profit by the new rôle of colour invented by Matisse and his new conception of space, rough colours and line' (*Interview with Graham Sutherland*, 1969, op. cit.).

123 'Thoughts on Painting', op. cit., p.378. Sutherland felt later that it could be that this coincided with the release from the war – 'colour could be liberated' (*Graham Sutherland*, BBC Television film produced by Margaret McCall, 1968).

124 Letter to Douglas Cooper (quoted in Cooper, p.40, n.9).

125 'Thoughts on Painting', op. cit., p.378.

126 *Painter at Work: Graham Sutherland in France*, ABC Television film directed by Peter Newington, n.d. James Thrall Soby aptly commented, at about this time, that Sutherland 'is at his best when he peers rather than scans' (*Contemporary Painters*, New York, n.d. (=1948), p.138).

127 BBC Television film, 1954, loc. cit.

128 Cooper, pp.43–4.

129 Ibid., pl.62b.

130 Ibid., pl.63b.

131 Ibid., pls.61c and 61d.

132 Ibid., pls.88a–91.

133 'Thoughts on Painting', op. cit., p.378.

134 Ibid. Sutherland has been known to alter the colour of a background completely even after a picture has been finished.

135 Cooper, pls.110c, 96a–d, 107b–d and 95a–f.

136 Ibid., pl.144.

137 Ibid., pl.106c.

138 Ibid., pl.103b.

139 Tassi, p.26.

140 Sutherland was also at this time working on sculpture relating to the Standing Forms, but most of it was destroyed (Paul Nicholls, *Interview with Graham Sutherland*, Menton, 19 January 1976, published in the catalogue of the exhibition *Graham Sutherland*, Galleria d'Arte Narciso, Turin, February–March 1976, p.21). See also Cooper, p.47, n.2. One, however, cast in bronze and produced as an edition by Marlborough Fine Art, 1952, is illustrated in Cooper, fig.8.

141 Both at Curt Valentin's Buchholz Gallery.

142 Arts Council 1953, op. cit.

143 Melville (unpaginated). Sir Herbert Read went so far as to say, only a few years later, that 'An artist like Sutherland is not, is *essentially* not, a humanist. (His portraits assimilate the human being to thorny, spicular forms of life . . .) Sutherland is a landscapist, like so many of his English predecessors' (Arts Council 1953, op. cit.).

144 Cooper, pls.61b and 63a.

145 Melville (unpaginated).

146 Hayes, p.25.

147 Ibid., p.17. But see also note 149 below.

148 'Thoughts on Painting', op. cit., p.377.

149 Cooper, pls.103a, 102d, 102c, 122b and 122a.

The tall reeds the height of a man in the valley of the River Var, through which Sutherland used to walk, suggested to him the idea of half-obscured figures, hidden presences (BBC Television film, 1954, loc. cit.).

150 Tassi, p.27.

151 'Thoughts on Painting', op. cit., p.378.

152 For example, Cooper, pl.101a.

153 Ibid., pls.109, 108b.

154 Révai, pp.60–1.

155 For example, by Sackville-West (revised edn., 1955, p.13) and Clark, op. cit., p.255, who described them as 'not always . . . an adequate substitute' for his work in landscape.

156 'In childhood Sutherland had occasionally made self-portraits, but all were destroyed. He experimented with portraits in his student days in a style which he calls 'highly finished but not academic'; these too have been destroyed (Cooper, p.49, n.6). One example was a drypoint of William Reed, the violinist (information from Paul Drury).

157 Kenneth Clark records in his autobiography that one day in 1940 Sutherland told him: 'You know, when the war is over, I should like to paint portraits. . . . Of course I would make my own selection. The human head is only an *objet trouvé* – and a most interesting one' (Kenneth Clark, *The Other Half*, London, 1977, pp.42–3).

158 Ibid., p.50.

159 Barber, p.51.

160 'Thoughts on Painting', op. cit., p.378.

161 Hayes, p.17. The quotations which follow are all from the conversation with the author printed in Hayes, pp.17–28, unless otherwise indicated.

162 Cooper has noted that 'Sutherland . . . regards the "paraphrase" portraits of Picasso as being the highest form of the art' (Cooper, p.54, n.2).

163 'Thoughts on Painting', op. cit., p.378.

164 Ibid.

165 Barber, p.52.

166 See Cooper, pp.55–6. Latterly he painted more portraits than he did earlier. Some were of close friends, such as Mrs Emery Reves (1978–9) and Milner Gray (1979). His portrait of Alfred Hecht was unfinished at his death. But he was also ready to undertake a wider range of commissions.

167 Ibid., p.50.

168 See note 157 above.

169 Barber, p.53.

170 Révai, p.26.

171 See also Cooper, pls.126a–b, 128, 133, 136, 137 and 156.

172 Barber, p.53.

173 Basil Spence, *Phoenix at Coventry*, London, 1962, p.15.

174 Révai, p.90.

175 Ibid., p.91.

176 The mandorla was in Spence's own drawing (ibid., p.38). It was Sutherland's decision to surround the figure of Christ 'with the traditional layout of the four symbols of the Evangelists. In spite of suggestions that I do so, I did not attempt to interpret the letter of the Book of Revelation because I thought it was far too complicated and would lead me into labyrinths which were far too diffuse. I felt that what mysticism I had the power to express could be contained by very simple means through the traditional layout which became current in Romanesque art' (ibid., p.27). 'As far as my knowledge goes no artist in any period, with the possible exception of William Blake, has taken the Book of Revelation at all literally' (ibid., p.39).

177 'The tapestry will be the dominating feature of the Cathedral for all the centuries to come. The congregation will have no choice but to see it all the time by night as well as by day.' This was the opening statement of the Provost's definition of the requirements (ibid., p.90).

178 Ibid., p.42. The quotations which follow are all from the statements which Sutherland made in his conversation with Révai unless otherwise indicated.

179 Letter to Douglas Cooper (quoted in Cooper, p.36, n.1).

180 Révai, pl.9.

181 Sutherland wanted to see the tapestry hung so that he 'could view the various relations of tonality at a distance and, if necessary, cause alterations to be made while the tapestry was still . . . within reach of the weavers' (Révai, p.76). An exhibition in France had been mooted, first at the Louvre, then, on the instance of Malraux, at the Sainte-Chapelle, but permission was refused by the Reconstruction Committee as the organ builders needed a month at least for tonal tuning after the tapestry was hung, and the cathedral was required for rehearsals early in April (Spence, op. cit., p.64). The discord to which this gave rise is described by Spence (pp.64–5), and subsequently alluded to by Sutherland (Révai, pp.73–4). The artist was understandably exasperated: 'One is not an inanimate object producing a machine made cloth merely to act as a baffle plate for the organ!' (Sutherland to the Chairman of the Reconstruction Committee, Menton, 2 February 1962: Coventry Cathedral Archives).

182 Révai, p.82.

183 Cooper believes that these were a form of private symbolism related to the troubles at the Tate about which Sutherland was concerned as a Trustee (see note 229) (Cooper, p.48), but this was doubted by Sutherland (information from the artist).

184 Arcangeli, pl.156.

185 *Sutherland in Wales*, op. cit., p.13.

186 Arcangeli, pl.136.

187 Letter to the author.

188 'Out of the thousand things I see – *one* juxta-position of forms – above all others seems to have a meaning. I don't always understand what I am doing – or what I am likely to do' (letter to G. (=Giorgio Soavi), 11 March 1972, *Graham Sutherland Sketchbook*, op. cit. (unpaginated); reprinted in *Sutherland in Wales*, op. cit., p.17).

189 Ibid., pls.192, 193.

190 Tassi, pl.129; *Sutherland in Wales*, op. cit., pl.8; Tassi, pls. 147, 143; Arcangeli, pls.139, 140, 151, 153, 154.

191 *Interview with Graham Sutherland*, 1969, op. cit.

192 Published subsequent to Tassi. Both the aquatints and the studies were exhibited at Marlborough Fine Art in November 1979 – January 1980.

193 Tassi, pls. 81–109. The publisher was Marlborough Fine Art, and the studies were exhibited there in May–June 1968.

194 Compare Tassi, pls. 84 and 72.

195 Ibid., pls.179–197. Both the aquatints and the studies were exhibited in London by the co-publishers, Marlborough Fine Art, in June–July 1977.

196 Ibid., pl.183.

197 Tassi, between pls.178 and 179.

198 Arcangeli, p.21.

199 Introduction to *Sutherland in Wales*, op. cit., p.6.

200 Tassi, pls.120–7.

201 Introduction to *Sutherland in Wales*, op. cit., p.6.

202 Barber, p.47.

203 Arcangeli, pl.185.

204 *Sutherland in Wales*, op. cit., pl.10.

205 Ibid., pl.5.

206 Ibid., p.6.

207 Ibid., p.7. The collection has been vested in the Picton Castle Trust, and further plans for its display are under active consideration.

208 *Sutherland in Wales*, BBC Wales Television film written and produced by John Ormond, 1977.

209 Arcangeli, pl.167.

210 Hayes, p.20.

211 Arcangeli, pl.169.

212 Ibid., pls.184, 196.

213 Ibid., pls.220, 209, 205, 207.

214 Always with variations, and often with changes in colour. Sometimes the lithograph precedes the painting. For examples, compare ibid., pls.169, 210, 215, 216, 220 and *Sutherland in Wales*, op. cit., pls.9 and 10 with Tassi, pls. 112, 127, 123, 121–122, 134, 168–169, 160–161.

215 Compare Arcangeli, pl.215 with Cooper, pl.97a.

216 Paul Nicholls, *Interview with Graham Sutherland*, op. cit., p.21.

217 These were actually inspired as a result of looking at subjects through a camera viewfinder.

218 Barber, p.48.

219 Hayes, p.25.

220 Ibid., p.24.

221 Letter to G., op. cit., p.17.

222 *Graham Sutherland Sketchbook*, op. cit., (unpaginated); reprinted in *Sutherland in Wales*, op. cit., p.8.

223 *Sutherland in Wales*, op. cit., p.11.

224 Sackville-West, p.8.

225 Barber, p.50.

226 Cooper, p.63.

227 Graham Sutherland, 'The Nature of Poetry & Painting', speech delivered in Hamburg, 1974; partially reprinted in *The Sutherland Gift to the Nation*, Marlborough Fine Art, March–April 1979 (unpaginated).

228 BBC Television film, 1954, loc. cit.

229 For example, his concern about what he believed to be malpractices in the administration of the Tate Gallery during the latter part of his term as a Trustee, which ultimately led him to resign his Trusteeship in 1954 (see Cooper, p.48).

230 Ibid., p.62.

231 Man, op. cit. (unpaginated).

232 Clark, op. cit., p.255.

233 All these artists, with the exception of Vaughan, exhibited with Sutherland, e.g. at the Lefèvre Gallery in February 1946. Vaughan records in his diary for 18 April 1944 discussions with Sutherland which meant much to him about such matters as perfection in painting, exemplified by the different merits of Bellini's and Mantegna's *Agony in the Garden* (Vaughan, op. cit., pp.82–3).

234 Cooper, p.62.

235 BBC Wales Television film, 1977, loc. cit.

236 *Painter at Work*, ABC Television film, loc. cit. Sutherland has explained, in particular, how this applies to his portraiture: 'If I lose the first statement I would probably start again' (Hayes, op. cit., p.22).

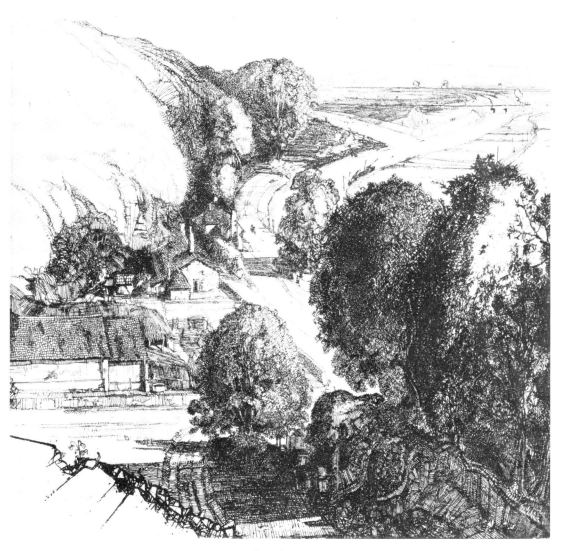

1. *The Black Rabbit*. Etching; 19.2 × 21.3cm (7½ × 8⅜ in.). 1923

At the age of twenty Sutherland was already not only a virtuoso etcher but a skilled composer, capable of subordinating a wealth of descriptive detail to the exigencies of mass and rhythm. This etching, whose title refers to a public house, is of a view near Arundel, country he had walked over since he was a boy, and is indicative of his critical attitude towards 'the stereotyped Seymour Haden etc. engraving tradition of the school [Goldsmiths' College], which caused in me a bias towards heavily worked plates'. This open, linear tradition, handed down from Legros and Whistler, pervaded etching technique at the time and is best exemplified in the work of Sir Frank Short, an influential figure who taught etching at the Royal College of Art from 1891 to 1924 and succeeded Haden as President of the Royal Society of Painter-Etchers in 1910.

2. *Lammas*. Etching; 11.2 × 16.2 cm ($4\frac{3}{8}$ × $6\frac{3}{8}$ in.). 1926

3. SAMUEL PALMER: *Early Morning*. Pen and sepia ink; 18.9 × 23.3 cm ($7\frac{7}{16}$ × $9\frac{3}{16}$ in.). Signed and dated 1825. Ashmolean Museum, Oxford

Sutherland's first sight of an etching by Samuel Palmer proved a turning-point in his development: 'I was amazed at its completeness, both emotional and technical. It was unheard of at the school to cover the plate almost completely with work, and quite new to us that the complex variety of the multiplicity of lines could form a tone of such luminosity.' Drawn as a young man to a 'strongly romantic' approach to nature, Sutherland was almost predestined to come under the spell of Palmer in the mid-1920s. This was the period of the great Palmer exhibition at the Victoria and Albert Museum (1926), and Sutherland's friend and mentor F. L. Griggs, the finest etcher and technician of his day, was a devotee. In 1928 Sutherland went to live at Farningham, close to the Shoreham Valley in which Palmer had worked during his 'visionary years'. *Lammas* is a Palmeresque twilight romantic idyll typical of these years, densely worked and highly stylized. See also p. 12 for a contemporary description.

4. *Cottage in Dorset, 'Wood End'*. Etching; 14.2 × 18 cm ($5\frac{5}{8} \times 7\frac{1}{8}$ in.). 1929

Sutherland's personal style, as it developed in the late 1920s, was charged with energy and a certain sense of mystery, the product of his dramatic chiaroscuro. The stylized trees incised in light relate to the wood-engraving tradition of the 1920s, represented by Paul Nash, whom Sutherland first met in 1929 and later came to know well. See also p. 12.

5. *Study of Cottages*. Pen and ink, watercolour and gouache; size unknown. About 1928. Ownership unknown

This study, one of many such gouache drawings of this period sadly no longer extant, displays Sutherland's delight in surface textures and brings to mind Palmer's well-known *Barn with a Mossy Roof*. See also p. 12.

6. *The Garden*. Etching; 21.7 × 15.6 cm (8½ × 6⅛ in.). 1931

Sutherland's magnification of modest, even minuscule natural forms, which lies at the
heart of his romantic vision, is first exemplified in this powerful image, a symbol of the
principle of organic growth derived from a rose bush in his garden at Farningham. The
strangeness of this image, truly imagination worked up to 'the state of vision' (Blake), is
accentuated by the exaggerations and sharp foreshortenings in the background. Sutherland's
rose bush may be compared with the apple tree in Palmer's *In a Shoreham Garden* although, by
this date, he felt that he had said all he 'wanted to say within the Palmer tradition'. It was *The
Garden* which caused the Royal Society of Painter-Etchers and Engravers, of which Sutherland
had been an Associate since 1925, to refuse to show his work. See also p. 12.

7. *The Lane at Farningham*. Poster colours; size unknown. About 1931–2. Ownership unknown

Sutherland's stylized representation – exaggerated forms, steep perspectives and broad areas of colour – was admirably suited to poster design, a medium to which he turned after the collapse of the print market following the American slump. This study of the lane outside his home in Farningham was shown to Frank Pick and led to his being commissioned to design posters for London Transport.

1935
Solva Hills

valley above
Porthclais

Sutherland
1935

54

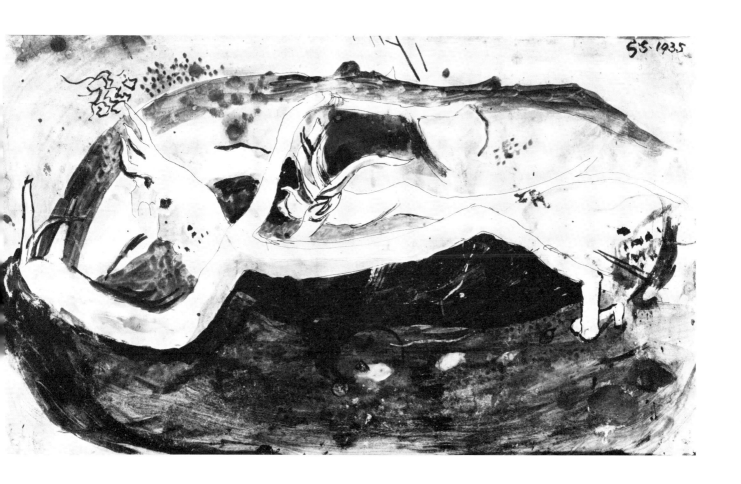

8. *The Gribben, Solva and Valley above Porthclais*. Pen and wash; 12.5 × 21 cm (4⅞ × 8¼ in.). Dated 1935. National Museum of Wales (Graham Sutherland Gallery, Picton Castle)

9. *The Swan, Solva*. Pen and black ink and grey wash; 14 × 23.5 cm (5½ × 9¼ in.). Signed and dated (at a later date) 1935. National Museum of Wales (Graham Sutherland Gallery, Picton Castle)

10. *Tree Form, Dorset*. Pen and sepia ink and wash, touched with white; 19 × 33.5 cm (7½ × 13¼ in.). Signed with initials and dated (at a later date) 1935. Mrs Graham Sutherland

Studies done in Pembrokeshire and Dorset. *Valley above Porthclais* (on the outskirts of St David's: the site is marked on Sutherland's map of the region, see Fig. 6) well illustrates Sutherland's remark about the Pembrokeshire landscape that 'the astonishing fertility of [the] valleys and the complexity of the roads running through them is a delight to the eye.' The descriptive line in these early sketches is like a 'tough thread of black cotton' (Edward Sackville-West).

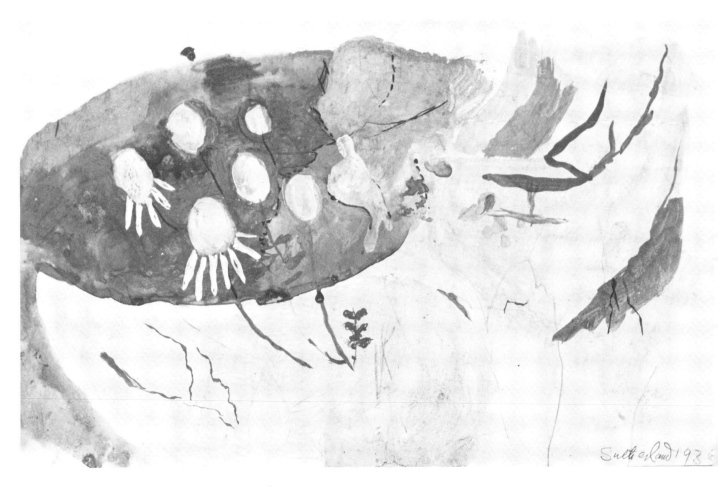

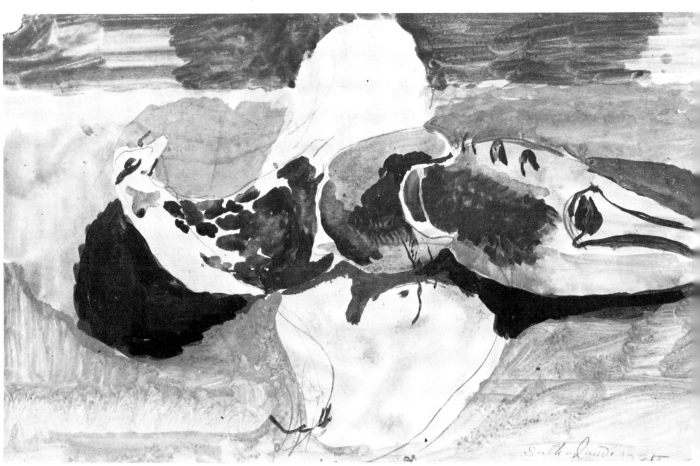

56

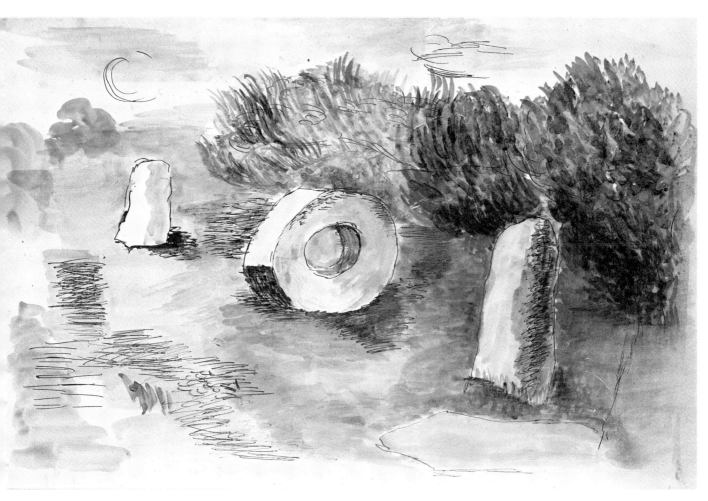

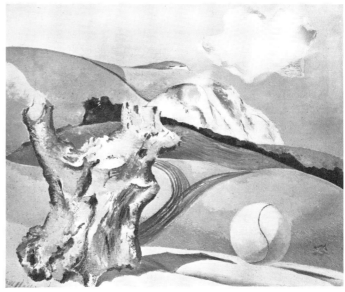

1. *Camomile Flowers, Porthclais*. Gouache; 20.5 × 33 cm
(8⅛ × 13 in.). Signed and dated (at a later date) 1936. National
Museum of Wales (Graham Sutherland Gallery, Picton Castle)

2. *Lobster Claw*. Gouache; 20.5 × 33 cm (8⅛ × 13 in.). Signed
and dated (at a later date) 1935. National Museum of Wales
(Graham Sutherland Gallery, Picton Castle)

3. *Mên-an-Tol, Cornwall*. Pen and ink and watercolour;
51.7 × 76.2 cm (20⅜ × 30 in.). 1933 (?). Ownership unknown

Sutherland was greatly encouraged in his tentative beginnings
as a landscape painter by the example of Paul Nash, whose own
imagery was often derived from the most ordinary natural
forms. Their approach to landscape was, however, entirely
different. Nothing could be further from Sutherland's intentions
— an ever deeper probing into the mysteries of organic growth
and relationships, with the ultimate aim of making 'the real
more real' – than Nash's surrealist preconceptions and their
resulting clarity of form, a point critics still fail to understand.
Sutherland has declared firmly: 'I am not a surrealist.' *Mên-an-
Tol* (Stone of the Hole) is an accurate transcription of a
prehistoric monument on open downland near Penzance. The
treatment of the foliage in *Mên-an-Tol* is similar to that in his
poster *The Great Globe, Swanage* of 1932 (Fig. 3).

14. PAUL NASH. *Event on the Downs*. Canvas; 50.8 × 61 cm
(20 × 24 in.). 1934. Department of the Environment

15. *Landscape with Road*. Canvas; size and location unknown

16. *Pembrokeshire Landscape*. Canvas; 16 × 20.5 cm (6⅜ × 8 in.). Signed and dated (at a later date) 1935. National Museum of Wales (Graham Sutherland Gallery, Picton Castle)

17. *Welsh Landscape with Roads*. Canvas, 61 × 91.4 cm (24 × 36 in.). 1936. Tate Gallery, London

Two broadly handled oil sketches and a finished painting, all dating from the mid-1930s. In each case the viewpoint is high, in order to achieve a decorative harmony, and winding roads, one of Sutherland's preoccupations at this time, predominate in the compositions. *Welsh Landscape with Roads*, for which Sutherland made a preliminary oil sketch, is derived from the upper part of the drawing *Valley above Porthclais* (Plate 8). In this impressive early picture, with its thickly encrusted paint surface, the colours are not differentiated as the forms recede, and depth is created by line, while the wayward and strongly rhythmic design is effectively unified by the muddied tonality which prevails throughout. The site of this subject is marked on Sutherland's map of the region (Fig. 6).

18. *Welsh Outcrop*. Pen and ink and watercolour; 32.7×54.6 cm ($12\frac{7}{8} \times 21\frac{1}{2}$ in.). 1935. Private collection, London

A study of the low hills on St David's Head, which appear like mountains against the slowly rising ground. The scene is outlined in a thin, broken, faltering line and completed in watercolour washes, pale, flat and decorative rather than descriptive, with yellow predominating, and would seem to be a developed idea for a finished picture drenched in sunlight.

19. *Pembrokeshire Landscape*. Pen and ink and gouache; 35.6 × 54.6 cm (14 × 21½ in.). 1936. National Museum of Wales, Cardiff

A panoramic landscape, similar in its sunlit tonality to *Welsh Outcrop*, but totally different in conception: atmospheric in treatment and dominated by a broad road bisecting the composition and by strong areas of shadow. The site of this subject is marked on Sutherland's map of the region (Fig. 6).

20. *Clegyr-Boia II*. Etching and aquatint; 20 × 14.9 cm (7⅞ × 5⅞ in.). 1938

In his etching with aquatint of a Welsh landscape (Plate 20) Sutherland has simplified the component forms into a bold but fundamentally decorative and almost abstract design. The site of this subject is marked on Sutherland's map of the region (Fig. 6). Two quite different interpretations of a Welsh mountain scene (Plates 21 and 22) demonstrate his dual interests at this period, the construction of bold, abstracted shapes (which link with his poster design) and the pursuit of romantic feeling, the dissolution of forms under powerful effects of light, very often, as here, those of the setting sun. See also p. 21.

21. *Welsh Mountains*. Canvas; 55.9 × 91.4 cm (22 × 36 in). 1937. Art Gallery of New South Wales, Sydney

22. *Sun Setting Between Hills*. Watercolour; 25.1 × 35.6 cm ($9\frac{7}{8}$ × 14 in.). 1937. Lord Clark of Saltwood

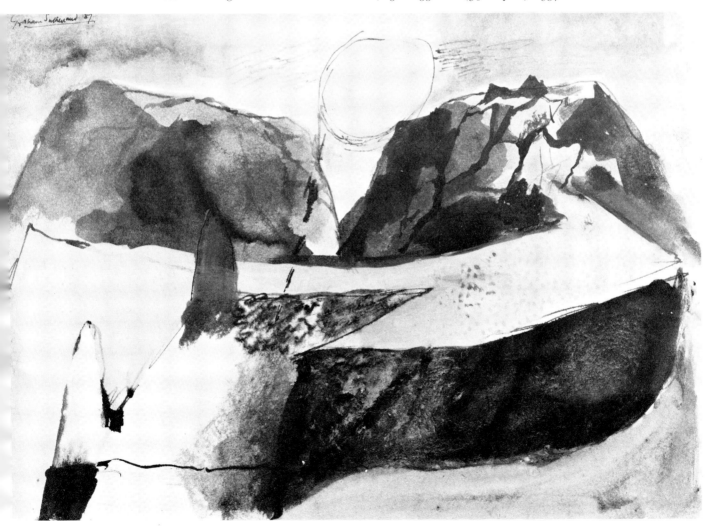

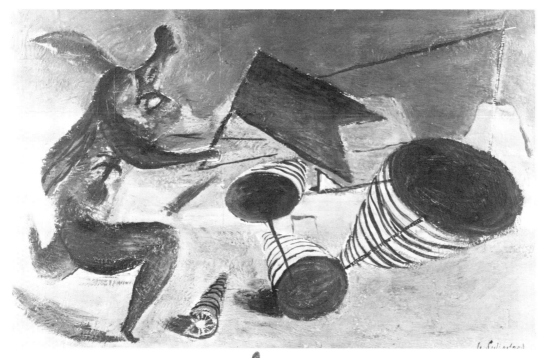

23. *Thunder Sounding*. Panel; 36.2 × 58.4 cm (14¼ × 23 in.). 1936. Ownership unknown

Thunder Sounding was one of Sutherland's two contributions to the International Surrealist Exhibition in London in 1936. He had been invited to show by Sir Roland Penrose, but he was not, and never became, a surrealist painter. Characteristically, for Sutherland's mind operated easily on different levels, he had already employed this selfsame design the previous year as a Christmas card for Robert Wellington. Similarly, the design for the other 'surrealist' work he sent in, *Mobile Mask*, was used as a cover for the Curwen Press in June of that year.

24. *The Sick Duck*. Colour lithograph; 49 × 77 cm (19¼ × 30¼ in.). 1937

An overt example of the wit – here slightly whimsical, usually more sophisticated – which has always been a characteristic element in Sutherland's artistic thinking.

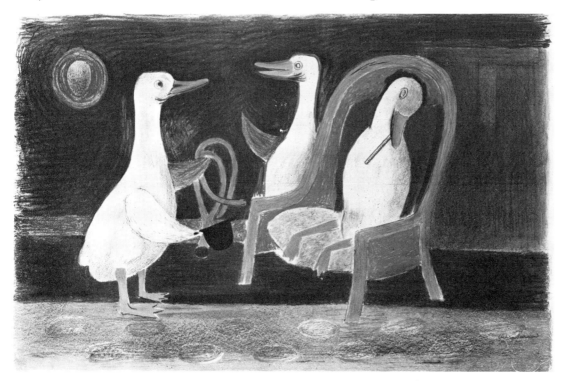

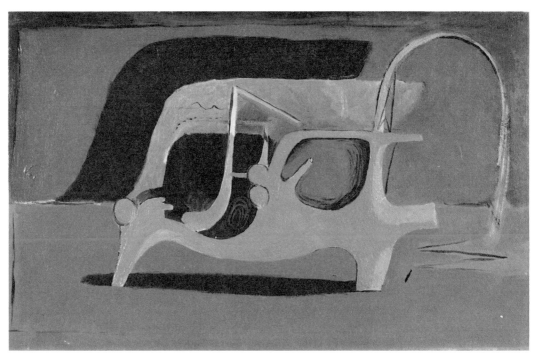

25. *Red Tree*. Canvas; 55.9 ×91.4 cm (22 ×36 in.). 1936. Private collection, London

26. *Red Tree*. Canvas; 55.9 ×97.8 cm (22 ×38½ in.). 1936. British Petroleum Company, London

The two versions of *Red Tree*, both painted in the same year, demonstrate Sutherland's ability to transmute a potent organic image into a flat, abstract composition in which both subject and shadow have become purely decorative features. The latter painting (Plate 26) now seems very much of its period, those years in which abstraction and 'the modern movement' dominated the avant-garde in Britain.

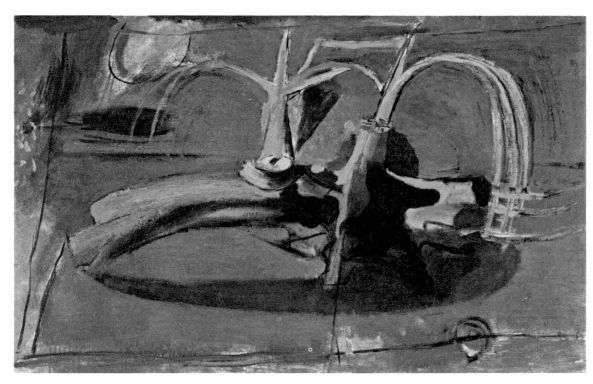

27. Studies for *Red Monolith*. Pen and ink and watercolour; 20.3 × 15.2 cm (8 × 6 in.). 1937. Ownership unknown

The sheet of studies (Plate 27) shows, on the right, Sutherland's initial sketch for *Red Monolith* and, centre and left, the development of his idea. The drawing on the left was amplified in a gouache before work was begun on the finished painting, in which the forms are broadened and the contours strengthened. The resulting image, with its background of colour harmonies related purely to the design rather than to anything in nature, is one of Sutherland's most powerful 'presences' of those intensely creative years in his career, the late 1930s. Note also, in the sheet of studies, the anthropomorphic sketches of a vase-like tree form. The site of this subject is marked on Sutherland's map of the area (Fig. 7).

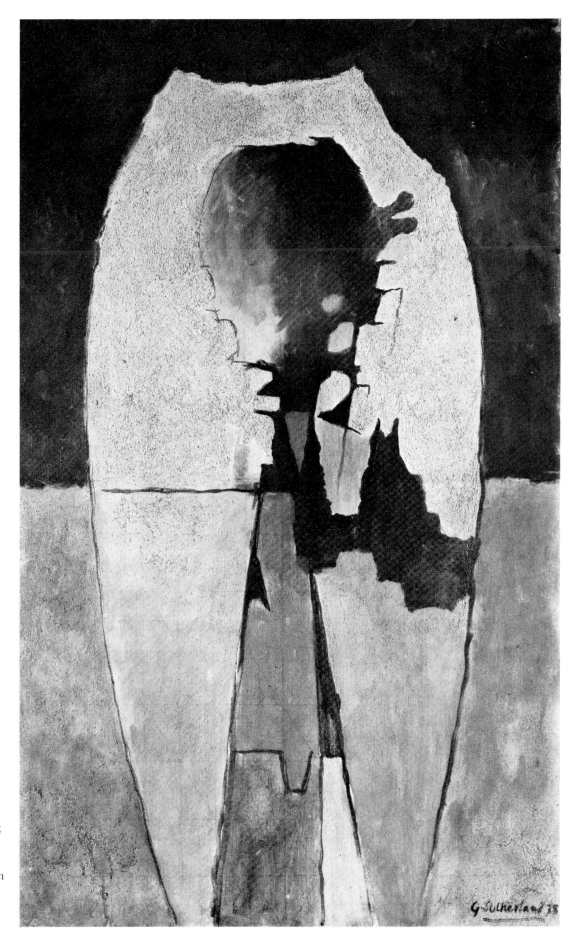

58. *Red Monolith*. Canvas;
101.6 × 63.5 cm (40 × 25
in.). Signed and dated
1938. Hirshhorn Museum
and Sculpture Garden,
Smithsonian Institution,
Washington

67

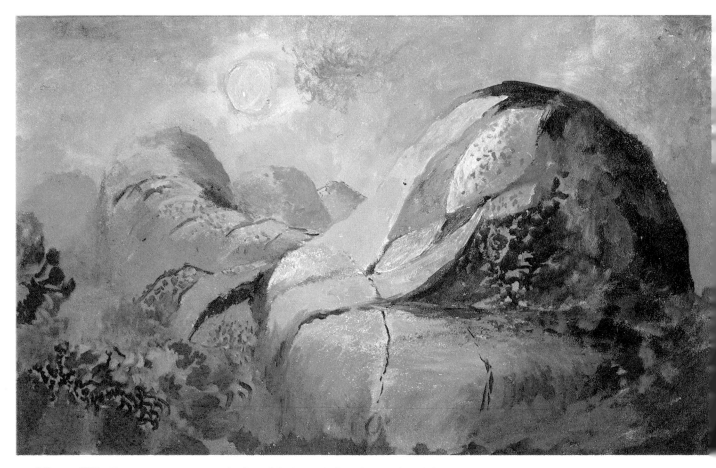

29. *Western Hills*. Canvas; 57 × 91.5 cm (22½ × 36 in.). 1938. Scottish National Gallery of Modern Art, Edinburgh

30. *Road and Hills in Setting Sun*. Canvas; 61 × 50.8 cm (24 × 20 in.). 1938. Ownership unknown

Two contrasted landscapes which demonstrate the range of Sutherland's imaginative powers at this period. One is atmospheric, broken and rich in colour, with something of 'the texture and form that we associate with the uncontrolled blots on French marbled papers'; the other is broad, abstracted and thinly handled, but precipitating with equal strength reds and yellows from the setting sun. The rather awkward running figure is a feature of a number of the landscapes of this period: 'To see a solitary human figure descending . . . a road at the solemn moment of sunset is to realize the enveloping quality of the earth which can create . . . a womb-like enclosure – which gives the human form an extraordinary focus and significance'.

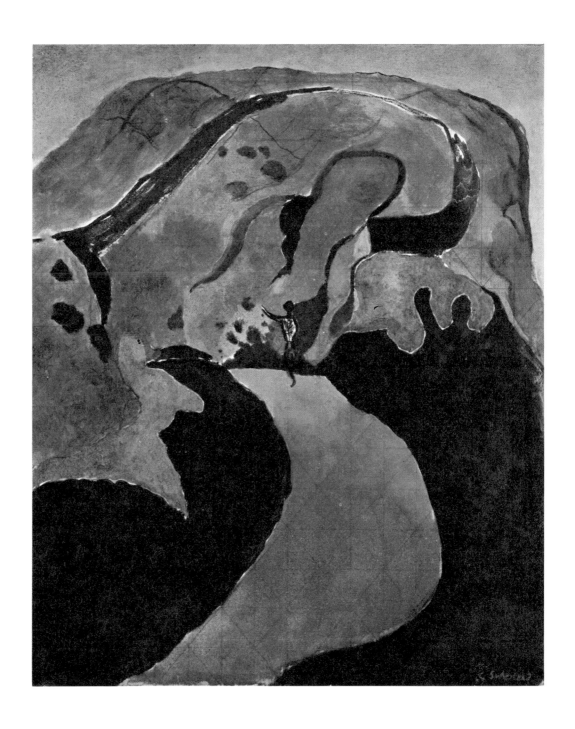

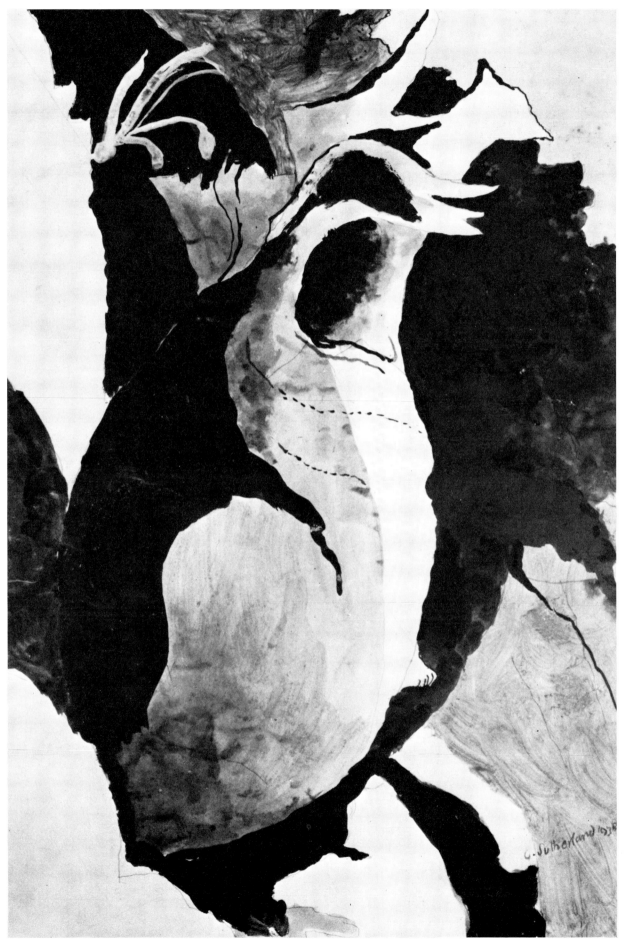

31. *Hollow Tree Trunk*. Watercolour; 56.8 × 39.1 cm (22⅜ × 15⅜ in.). Signed and dated 1938. Laing Art Gallery, Newcastle-upon-Tyne

32. *Study of Two Figures*. Pen and ink and wash; size unknown. Signed and dated (at a later date) 1939. Ownership unknown

The watercolour of a hollow tree trunk is more overtly anthropomorphic than the tree-form sketches of the previous year (see Plate 27), and the birdlike shape anticipates Sutherland's *Hybrid* compositions of the early 1970s. 'There is a thread of family likeness in the images which I find, which speak to my own particular nervous system.' This continuity in Sutherland's imagery reflects his tenacity and integrity of purpose. The site of this subject is marked on Sutherland's map of the area (Fig. 7). Sketches of the human figure are rare in Sutherland's *œuvre* at this period, though he was engaged, in 1939, on a series of illustrations to Shakespeare's *Henry VI Part 1*.

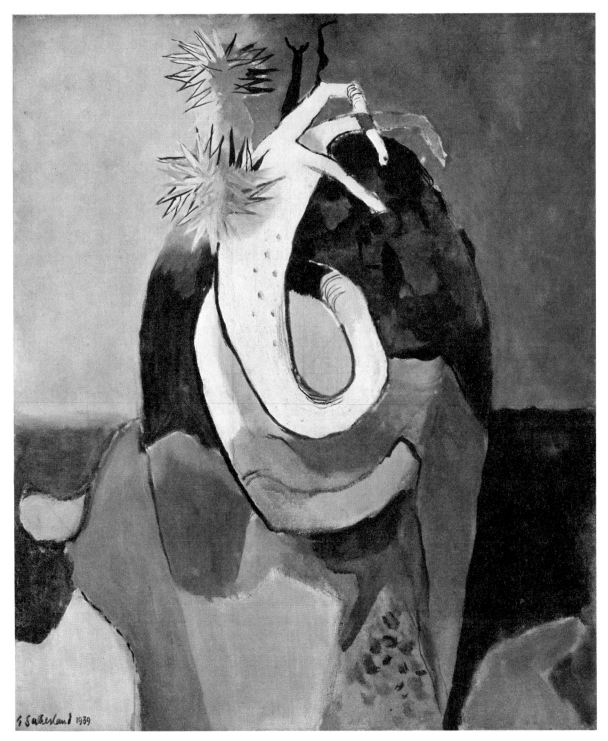

33. *Gorse on Sea Wall*. Canvas; 62.2 × 48.3 cm (24½ × 19 in.). Signed and dated 1939. Ulster Museum, Belfast

34. *Vase-like Tree Form*. Pen and ink and wash; size unknown. Signed and dated (at a later date) 1937. Ownership unknown

In both these works Sutherland has used the vase-like shape of *Red Monolith* for the framework of his design. A doctor friend informed him that in *Gorse on Sea Wall*, perhaps his best-known early work, an imaginative masterpiece with subdued but subtle colour harmonies which Robert Melville described as 'a grave and noble portrait', he had unconsciously reproduced the form of the inner ear. See also p. 22.

35. Study for *Entrance to Lane*. Canvas; size unknown. Signed and dated 1939. Ownership unknown

36. *Entrance to Lane*. Canvas; 61 × 50.8 cm (24 × 20 in.). Signed and dated 1939. Tate Gallery, London

Entrance to Lane is not only one of the most familiar of Sutherland's early landscapes but one central to our understanding of his artistic development. Vigorous in line and colour, in the thickly encrusted pigment in the blacks, and in its rhythmical design, it combines an innate lyricism with a gentle sense of mystery, a mildly tantalizing doubt as to what lies beyond, which in certain later works becomes foreboding. The first sketches are dominated by high hedges and by an overhanging bough. The watercolour study (Plate 35) introduces the rhythmical element and makes much of the garland of leaves. In the finished work the lane itself, accentuated by the brilliant white which creates a further plane, is the focus of attention. The site of this subject is marked on Sutherland's map of the area (Fig. 7). Sutherland returned to this theme in 1945.

37. Studies for *Midsummer Landscape*. Pencil, pen and ink and watercolour; 20.3 × 15.2 cm (8 × 6 in.). Signed and dated Summer 1940. City Museums and Art Gallery, Birmingham

38. *Midsummer Landscape*. Gouache; 67.9 × 47 cm (26¾ × 18½ in.). 1940. City Museums and Art Gallery, Birmingham

In *Midsummer Landscape* Sutherland added 'legs' (as can be seen from the sketch centre right) to one of the root forms he had discovered and charged it with a superhuman rotating energy, echoed in the sky. Nothing in Sutherland's early work is closer to the kind of imagery employed, for a totally different purpose, by Paul Nash (compare Plate 14).

76

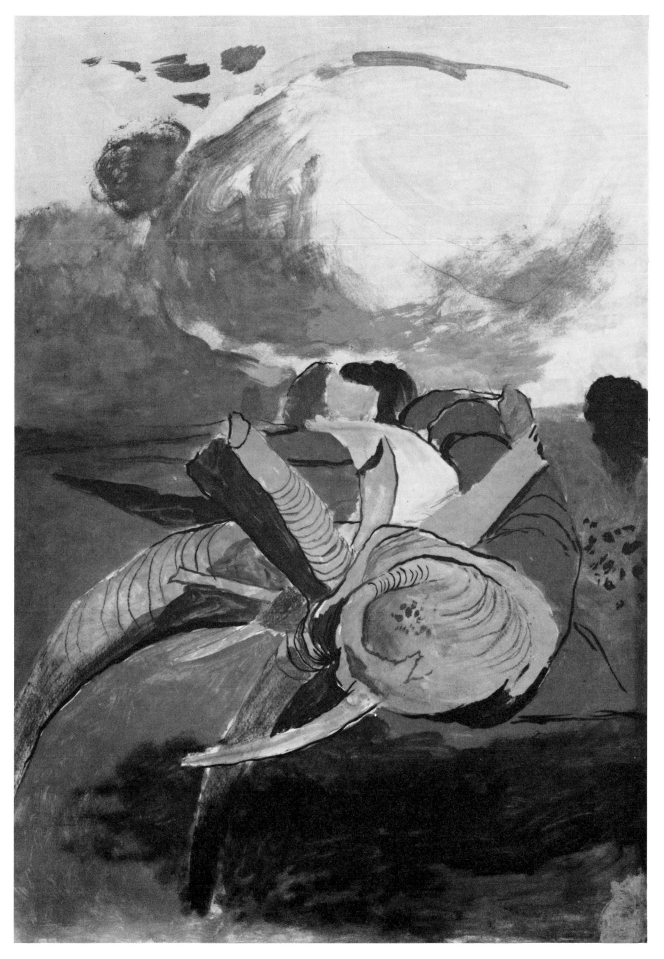

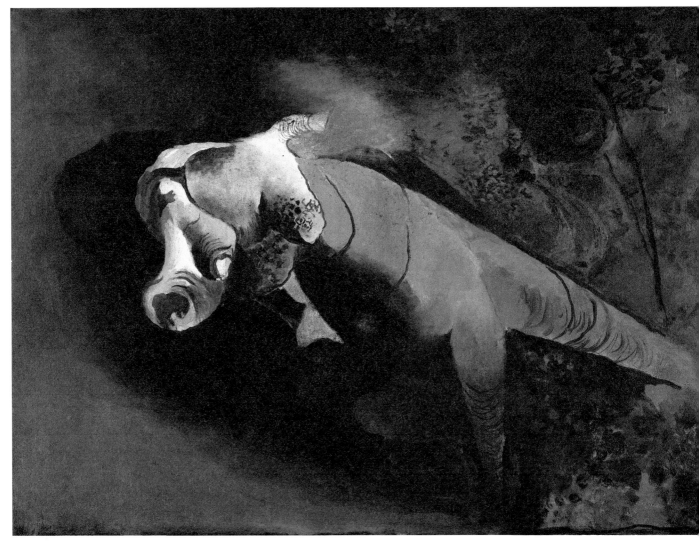

39. *Green Tree Form: Interior of Woods*. Canvas; 78.7 × 107.9 cm (31 × 42½ in.). 1940. Tate Gallery, London

40. *Mountain Road with Boulder*. Canvas; 62.2 × 111.8 cm (24½ × 44 in.). Signed and dated 1940. Formerly Kerrison Preston, Merstham, Surrey

41. Design for Backcloth for the Ballet *The Wanderer*: Act II. Gouache; 20.3 × 22.9 cm (8 × 9 in.). 1940. The Hon. Colette Clark, London

Green Tree Form, based on a fallen tree-trunk with its roots exposed, lying across a grassy bank, is a menacing anthropomorphic image, thrusting forth from an amorphous green background, which Sutherland worked up, in the peace of Gloucestershire, during the so-called 'phoney war', from sketches he had made in 1939. At that time he had interpreted his subject in an upright format, in terms of some monstrous 'animal' with almost recognizable features, lurching forwards on two stilt-like legs. The equally powerful romantic image, and the ballet backcloth (Plate 41) derived from the identical original sketches, are discussed on p. 19.

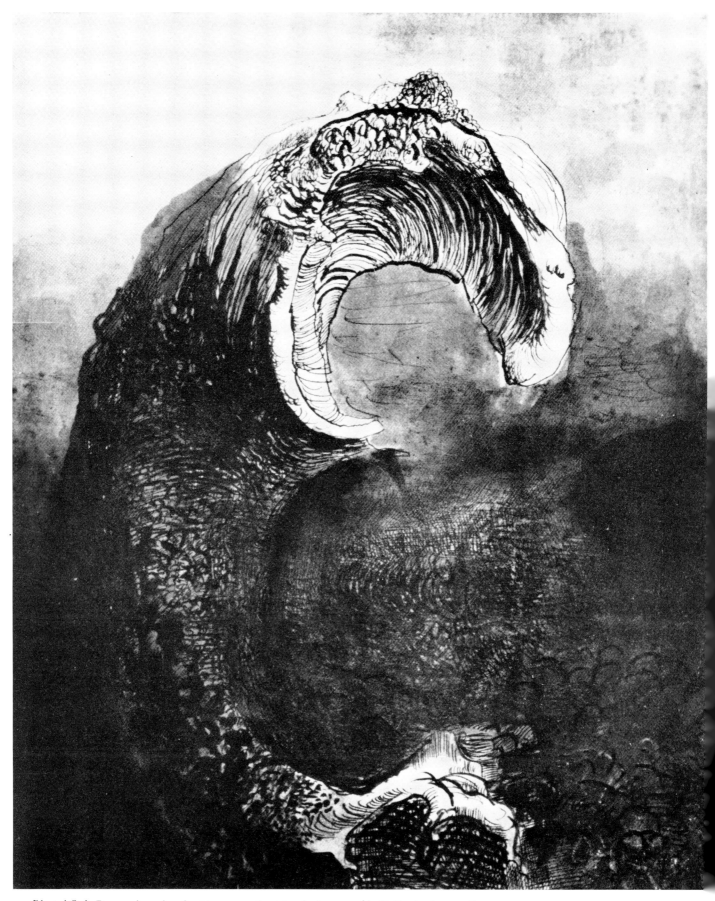

42. *Blasted Oak*. Pen and wash; 38.1 × 30.5 cm (15 × 12 in.). 1941. Sir Colin Anderson, Jersey

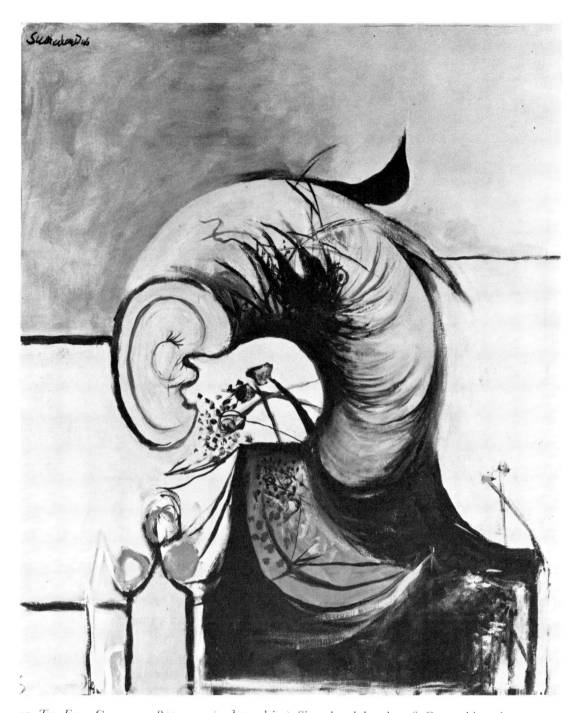

43. *Tree Form*. Canvas; 57.8 × 54 cm (22¾ × 21¼ in.). Signed and dated 1946. Ownership unknown

Blasted Oak is one of Sutherland's most vigorous pen drawings. The beak and claw which he created out of elements of this inert shape are both predatory and savage. Sutherland has described his approach to such subject-matter with characteristic clarity: 'It is not a question so much of a "tree like a figure" or a "root like a figure" – it is a question of bringing out the anonymous personality of these things; at the same time they must bear the mould of their ancestry.' The painting which he made when he returned to the same subject five years later, shortly after the war, affords an instructive contrast: though it has the breadth of line and colour of Sutherland's rapid stylistic development at this period, it is by comparison a stage monster, softened, more rounded, less sinister; in a word, decorative rather than expressionist.

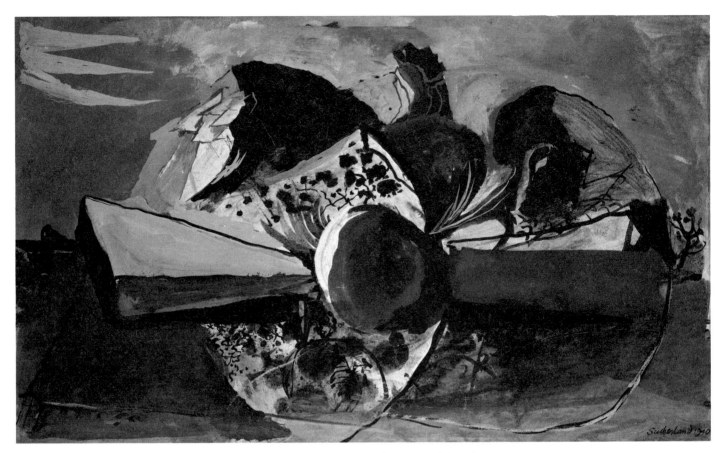

44. *Rocky Landscape with Cairn*. Gouache; 50.8 × 83.8 cm (20 × 33 in.). Signed and dated 1940.
Private collection, London

Sutherland always possessed a sure sense of tone values. In his sunsets he combined a range of reds,
oranges and yellows with contrasting blacks and browns; here he has limited himself successfully to a
palette of blacks, browns and greys. Almost as dynamic as *Midsummer Landscape* (Plate 38), the cairn
seems to be rotating like some giant wheel.

45. *A Mountain Road*. Pen and ink, watercolour and gouache; 27.9 × 21.6 cm (11 × 8½ in.). Signed and
dated Easter 1940. Private collection

A sketch of a mountain road at sunset, glowing with colour, and taken from the high viewpoint
Sutherland so often favoured. It was made during his last visit to Pembrokeshire before the war
started in earnest and he was invited, by Sir Kenneth Clark, to become an official War Artist. The site
of this subject is marked on Sutherland's map of the region (Fig. 6).

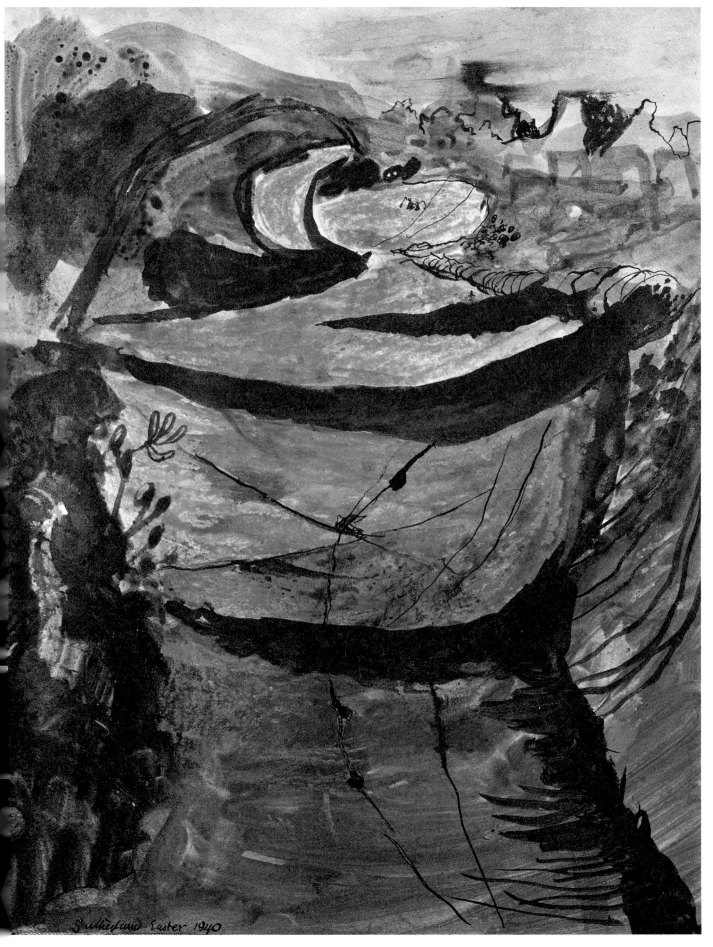

Sutherland Easter 1940

46. *Bombed Farm House near Swansea*. Pencil, pen and ink, pastel and watercolour; 17×14 cm ($6\frac{3}{4} \times 5\frac{1}{2}$ in.). 1940. National Museum of Wales (Graham Sutherland Gallery, Picton Castle)

The recording of bomb-damaged Swansea in the summer of 1940 was one of Sutherland's earliest assignments as a War Artist. This fine study, with its remarkable strength in the use of pen line, something to a large extent new in Sutherland's work, was made on the Gower peninsula shortly after the first raid on the city.

47. *Devastation: City, Fallen Lift Shaft*. Pen and ink and gouache; 16×12 cm ($6\frac{1}{4} \times 4\frac{3}{4}$ in.). 1941. Mrs Graham Sutherland

To Sutherland's anthropormorphic imagination a collapsed lift shaft in a city office block immediately suggested an animal shape. 'In the way it had fallen it was like a wounded animal. It wasn't that these forms *looked* like animals, but their movements were animal movements. One shaft in particular, with a very strong lateral fall, suggested a wounded tiger in a painting by Delacroix.' The similarity of this remarkable image of crushed machinery to his *Green Tree Form* (Plate 39) is not coincidental, for it is even more marked in other renderings of the subject, where the curve is exaggerated and highlit against a dark background.

48. *Tin Mine: A Declivity*. Pen and ink, watercolour and gouache; 49.5 × 95.2 cm (19½ × 37½ in.). 1942. City Art Gallery, Leeds

49. *Devastation: City, Twisted Girders*. Pen and ink, charcoal and gouache; 65.7 × 112.1 cm (25⅞ × 44⅛ in.). Signed and dated 1941. Ferens Art Gallery, Kingston-upon-Hull

His studies of twisted girders Sutherland turned into a majestic rhythmical composition fully as dramatic as his drawings of collapsed lift shafts. The entwined forms in the foreground, like some grotesque rococo plasterwork, are reminiscent of *Midsummer Landscape* (Plate 38). A declivity in a tin mine – the slopes and tunnels of which, some of them 'precipitous perspectives of extraordinary and mysterious beauty', Sutherland found endlessly fascinating, suggesting to him all kinds of novel compositional possibilities – he saw in terms of a womb-like structure, the walls rich in mottled colour, supposedly from the reflected light of the miners' acetylene lamps but in practice largely romanticized. Here Sutherland was able to cultivate his developed sense of the mysterious, and in these wartime studies he comes closest to the shapes and colour harmonies of early-nineteenth-century English romanticism, especially those of Blake in, for instance, his Dante illustrations.

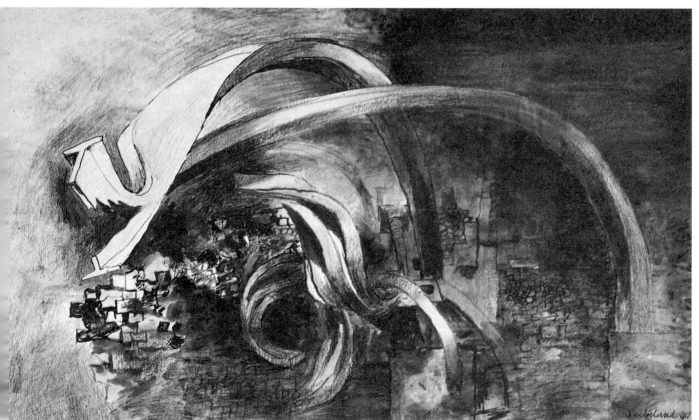

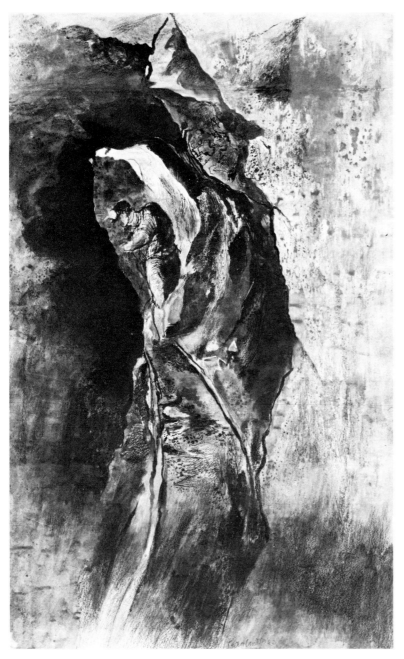

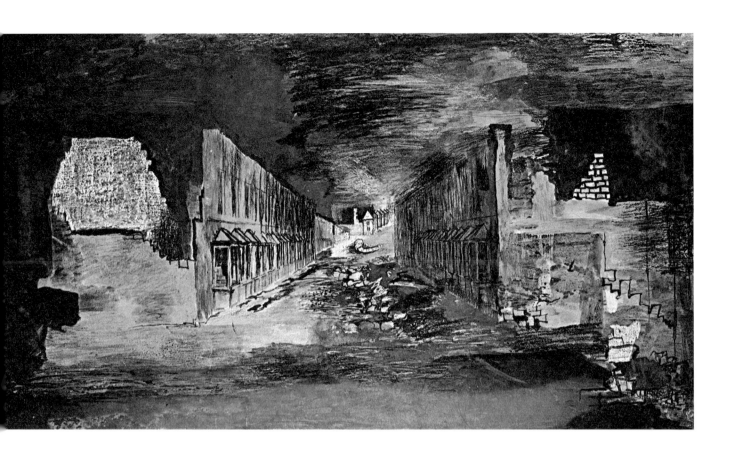

50. *Tin Mine: Miner Approaching*. Pen and ink, pastel and gouache; 116 × 73 cm (45⅝ × 28¾ in.). 1942. British Council

51. *Waterloo Bridge*. Etching; 26.3 × 9.8 cm (10⅜ × 3⅞ in.). 1923

52. *Devastation: East End Street*. Pen and ink and gouache; 64.5 × 114 cm (25⅜ × 44⅞ in.). Signed and dated 1941. Tate Gallery, London

Against his sketch for this tin-mine subject Sutherland noted: 'Miner approaching turns on hearing voice issuing from slope below. Walls dripping with moisture. Do painting sufficiently large to give an impression of the actual scale of the mine tunnel.' Sutherland always loved the drama it is possible to convey by means of perspective, narrow openings and a high viewpoint. His etching of Waterloo Bridge is a brilliant youthful example. In his view of devastation in Silvertown in the East End, the houses, now hardly more than façades, painted a brilliant yellow against the night sky, it is the long perspective of the deserted street which creates the effect of endless desolation.

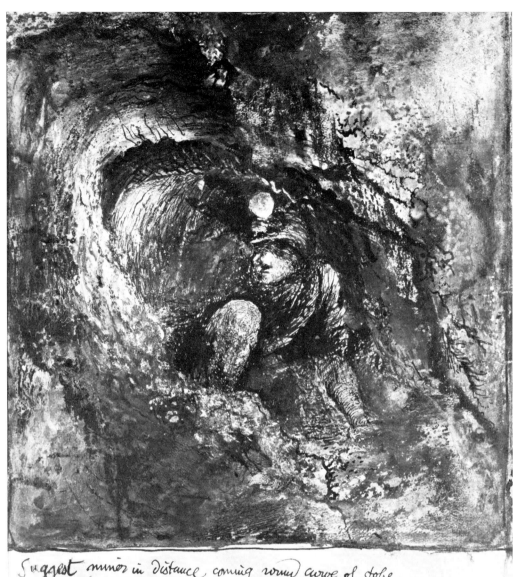

Suggest miners in distance, coming round curve of stope
(very strong feeling of shut-in-ness & weight of stone)
Miner emerges from entrance of stope Very mysterious. Approach
associated with noise of boots & falling stones & with approaching light of lamp
Remember light flesh colour derived from light reflected from close walls.

53. *Tin Mine: Miner Emerging from a Slope*. Pen and ink, pastel and gouache; 18.4 × 14 cm
($7\frac{1}{4}$ × $5\frac{1}{2}$ in.). 1942. Mrs Graham Sutherland

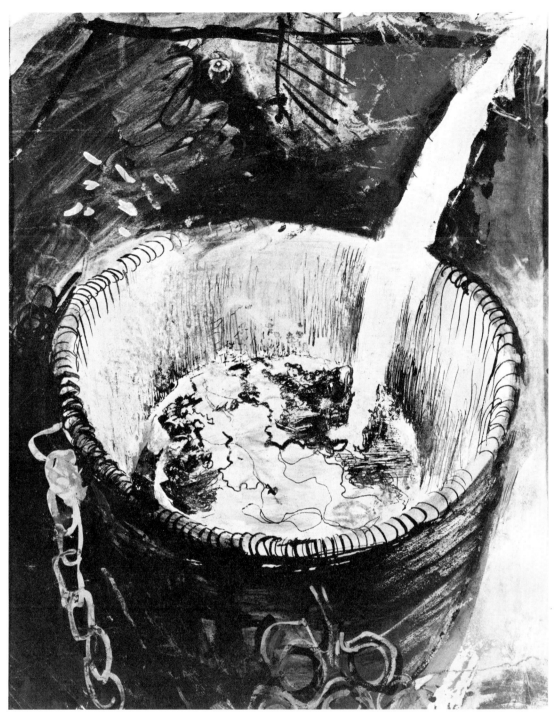

54. *Pouring Molten Iron into a Container*. Pen and ink, pastel and gouache; 27 × 21.5 cm ($10\frac{5}{8}$ × $8\frac{1}{2}$ in.). 1942. Mrs Graham Sutherland

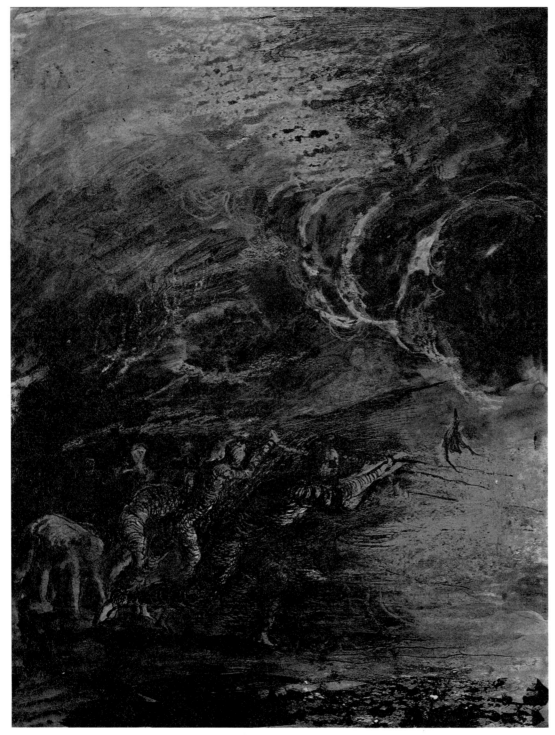

55. *Men Probing a Furnace, Cardiff*. Pen and ink, pencil and gouache; 37 × 28 cm (14⅝ × 11 in.). 1942. National Museum of Wales (Graham Sutherland Gallery, Picton Castle)

56. *Tapping a Steel Furnace, Swansea*. Pen and ink, pastel and watercolour; 27.9 × 20.3 cm (11 × 8 in.). 1942 (incorrectly dated 1943). Private collection

Sutherland executed a number of drawings of men probing a furnace, in some of which his figure grouping is masterly. Here the scene is one of vigorous action. In all these sketches the rich colours glowing out of the darkness admirably convey the intensity of the heat and glare. The deep perspective and the movements of the foreground figures in *Tapping a Steel Furnace* are reminiscent of similar effects in Tintoretto.

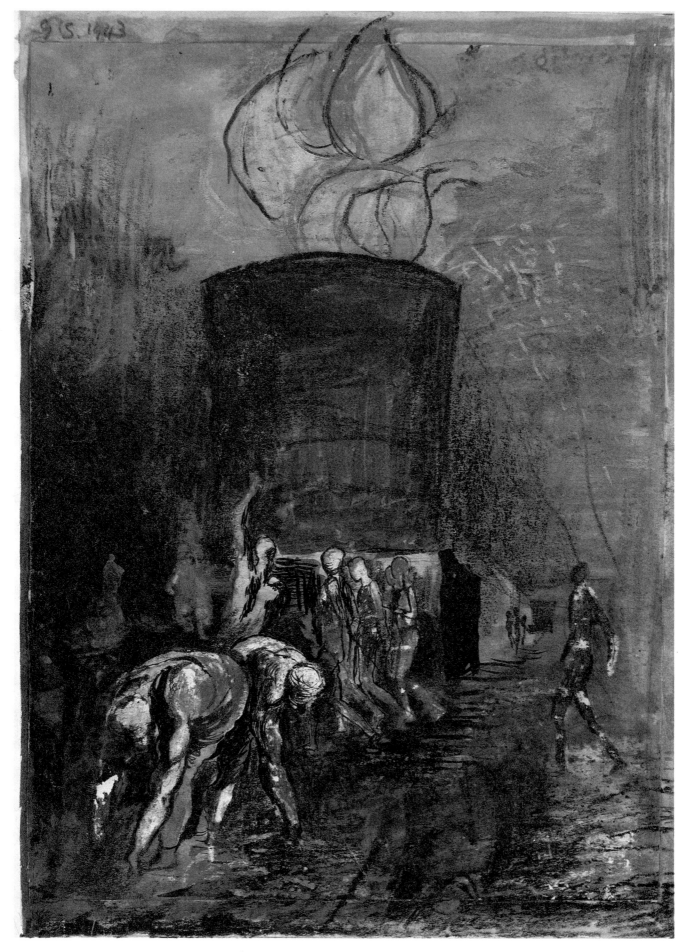

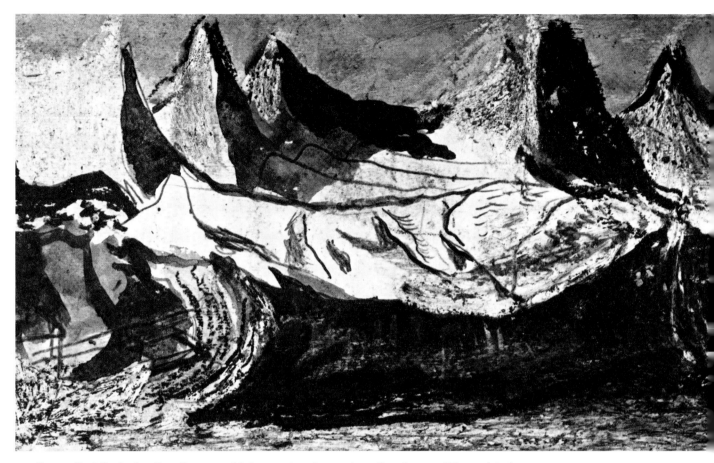

57. *Outcast Coal Production*. Pencil, pen and ink, pastel and gouache; 16 × 28.2 cm (6¼ × 11⅛ in.). 1943. Mrs Graham Sutherland

Sutherland's study of outcast coal production in 1943 resulted in a number of bold, swirling compositions dramatized by the huge pyramids of earth excavated by the draglines. The wasteland depicted here was intimidating and quite alien to his feeling for nature.

58. *Trappes:* Study for *Wrecked Locomotive*. Chalk and wash; 41.6 × 34.6 cm (16⅜ × 13⅝ in.). Signed and dated 14 December 1944. City Art Gallery, Leeds

At the end of November 1944 Sutherland was sent to France, where he was confronted with a 'panorama of destruction' such as he had never encountered before, even in the East End. The buffers of the foremost locomotive in this sketch of the wreckage in a marshalling yard at Trappes are thickly brushed and have a certain expressionist quality. The resulting oil painting is one of Sutherland's boldest wartime compositions.

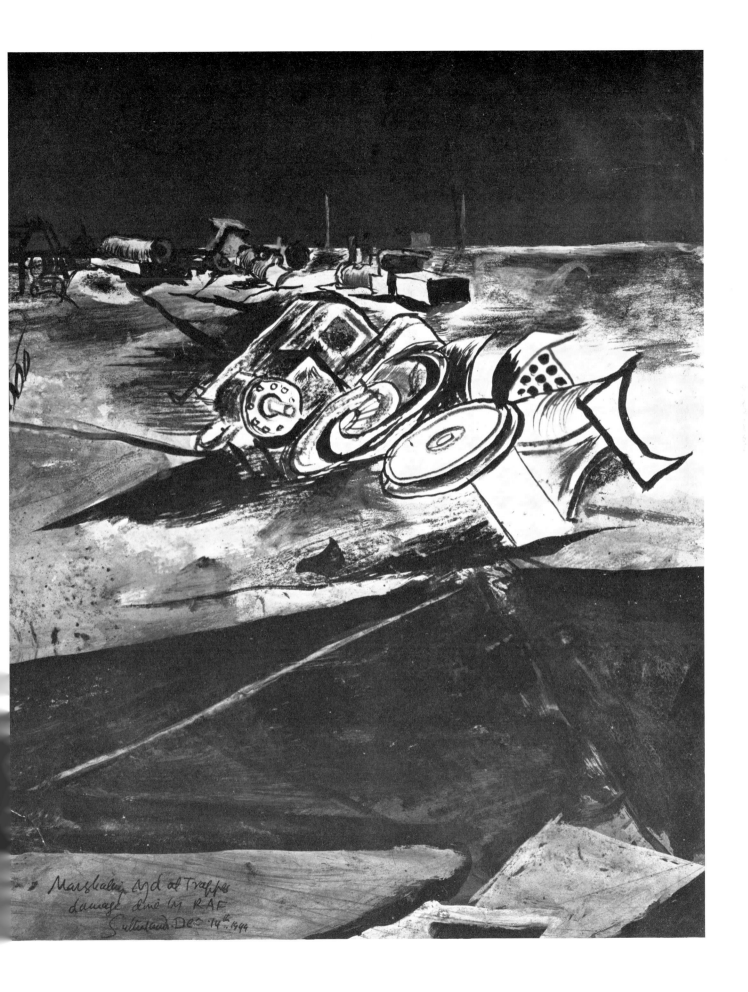

Marshaling Yard at Trappes
damage done by RAF
Sutherland Dec 14th 1944

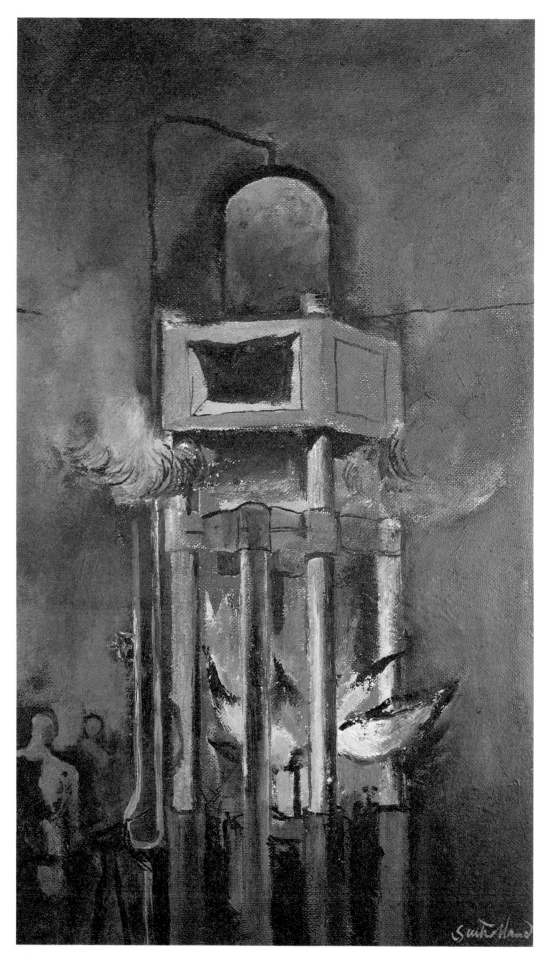

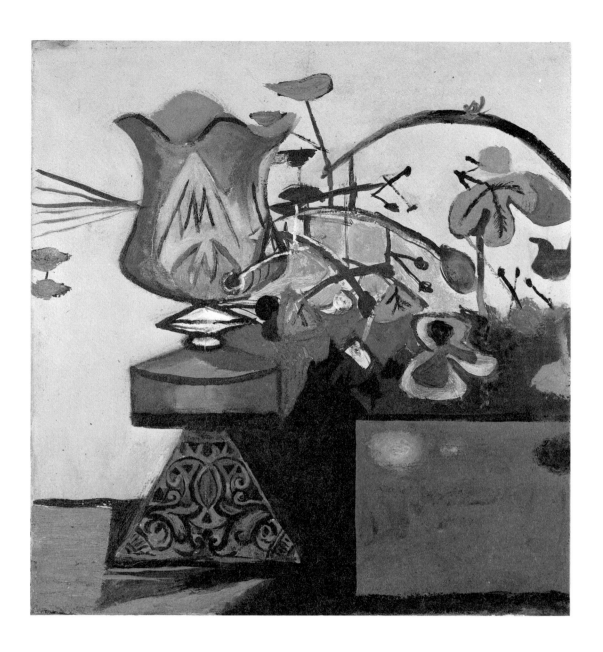

59. *Hydraulic Press for Making Shells, Woolwich*. Pen and ink, pastel and watercolour; 74.6 ×44.8 cm (29⅝ × 17⅝ in.). 1944. City of Manchester Art Galleries

60. *The Lamp*. Canvas; 63.5 ×61 cm (25 ×24 in.). Signed and dated 1944 (on the reverse). Ownership unknown

Sutherland's grandly architectural dramatization of a hydraulic press for making shells at Woolwich Arsenal should be contrasted with his equally striking compositions entitled *The Lamp* of the same year, when the war seemed almost won. They were inspired by an actual lamp in the small room occupied by the Sutherlands in a cottage they were staying in at Sandy Haven in Pembrokeshire. Though thickly contoured and boldly coloured, these are images of peace and repose. In this version the lamp, which gives out a gentle, even glow, is surrounded by the cheerful greenery of indoor plants.

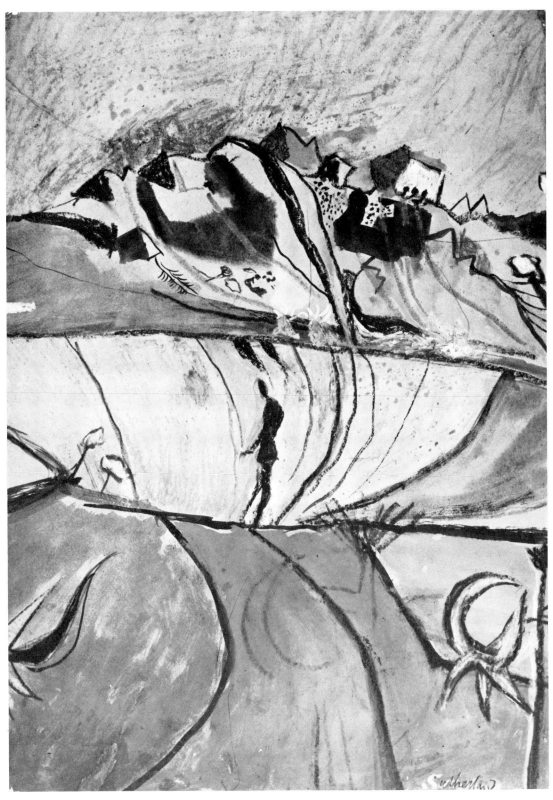

61. *Triple-Tiered Landscape*. Pen and ink, chalk and watercolour; 55.9 × 40.6 cm (22 × 16 in.). 1944.
Formerly Raymond Mortimer, London

When Sutherland took up landscape painting again in 1944 his work displayed a new breadth, and a
closer affinity with modern French art. See p. 26.

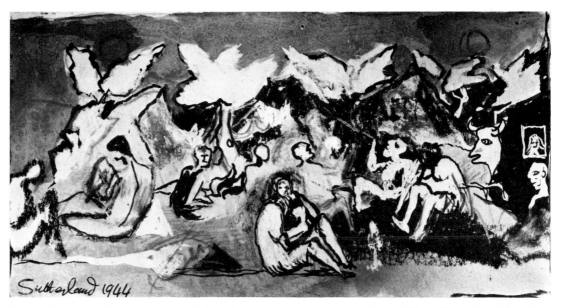

62. *Landscape with Figures.* Pen and ink and gouache; 10.5 × 20.6 cm (4⅛ × 8⅛ in.). Signed and dated 1944. Private collection, London

63. *Stone Head.* Black chalk; 11.3 × 14.9 cm (4$\frac{7}{16}$ × 5⅞ in.). 1946. Mrs Graham Sutherland

Sutherland's tiny sketch of a landscape with figures is clearly indebted to French *Baigneuses* compositions; the central figure is similar in pose to the nude in Manet's *Déjeuner sur L'Herbe*. It may also be noted that Picasso's *Bacchanale* (after Poussin) was painted in the same year. The celebrated *Stone Head* was inspired by Picasso's distorted portraits, which Sutherland much admired, but the organic derivation of the dilated features in this wild, expressionistic image – the essential realism of the representation – is alien to Picasso's more cerebral, broader, and often witty method of approach, and has more in common with the horrific imagery of Francis Bacon (Plate 127).

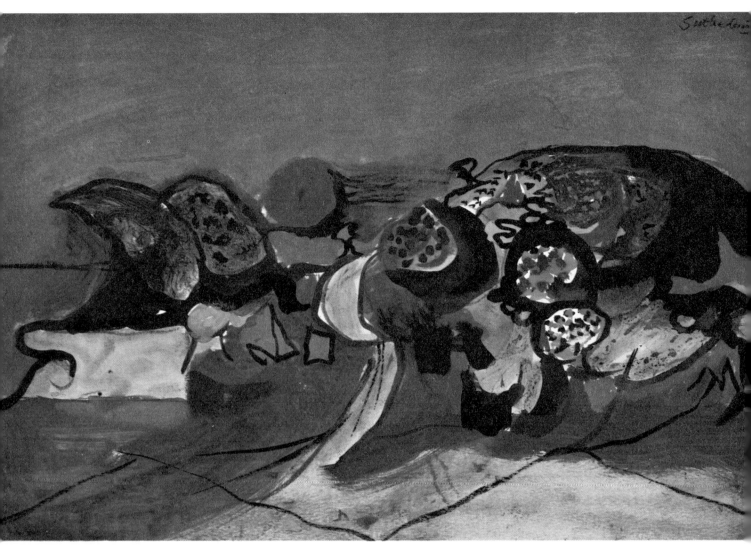

64. *Landscape with Estuary*. Chalk and gouache; 24.8×38.1 cm (9¾×15 in.). Signed and dated 1945. Private collection, England

65. *Horned Forms*. Canvas; 66×51.1 cm (26×20⅛ in.). 1944. Tate Gallery, London

Sutherland had used arbitrary colour in the backgrounds of a number of his landscapes of the 1930s, such as *Red Tree* (Plate 25) and *Gorse on Sea Wall* (Plate 33). In *Landscape with Estuary* the partly decorative, partly expressionist intent of this use of colour is enhanced by the bold, generalized forms of the trees and rocks, perhaps a personal response to the exuberant style of Picasso at this period. In *Horned Forms* the bands of arbitrary colour, orange in the sky, dark red in the foreground, form a simplified decorative setting, an empty landscape in which these sinister inventions can disport themselves. Backgrounds somewhat similar in hue were also used by Francis Bacon at this period. See also p. 26.

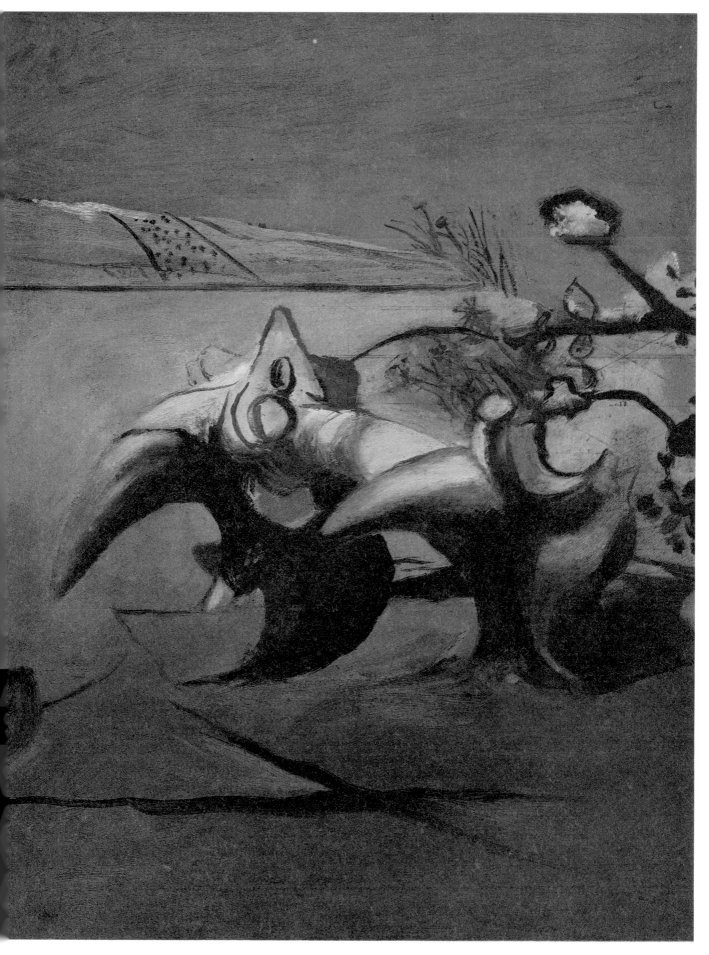

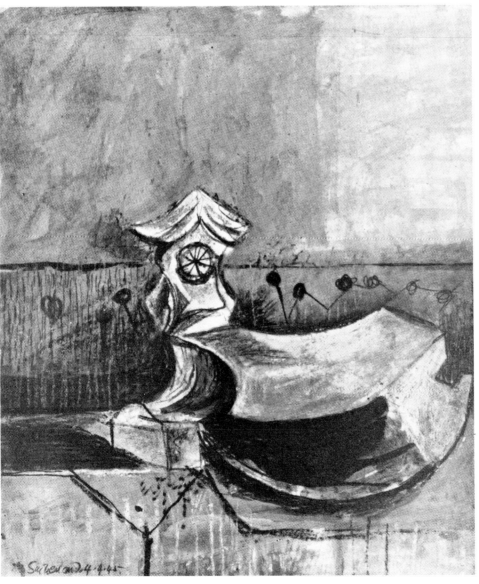

66. Study for *Staring Tree Form*. Chalk and watercolour; 10.2 × 17.8 cm (4 × 7 in.). 1945. Mrs Graham Sutherland

67. *Staring Tree Form*. Chalk and gouache; 47.3 × 40.6 cm (18⅝ × 16 in.). Signed and dated 4 April 1945. Formerly Wilfred Evill, London

68. *Chimère I*. Canvas; 199.4 × 120.6 cı (78½ × 47½ in.). Signed and dated 1946. Private collection, Canada

In the post-war years Sutherland was capable of transforming his studies of natural forms, in this case a bit of a branch with an unusual knot in the wood, into images far more remote from their sources than those of the 1930s, and far more in the mainstream of contemporary European art. Significantly, this version of *Chimère* was first exhibited in Paris in the year it was painted. See also p. 26.

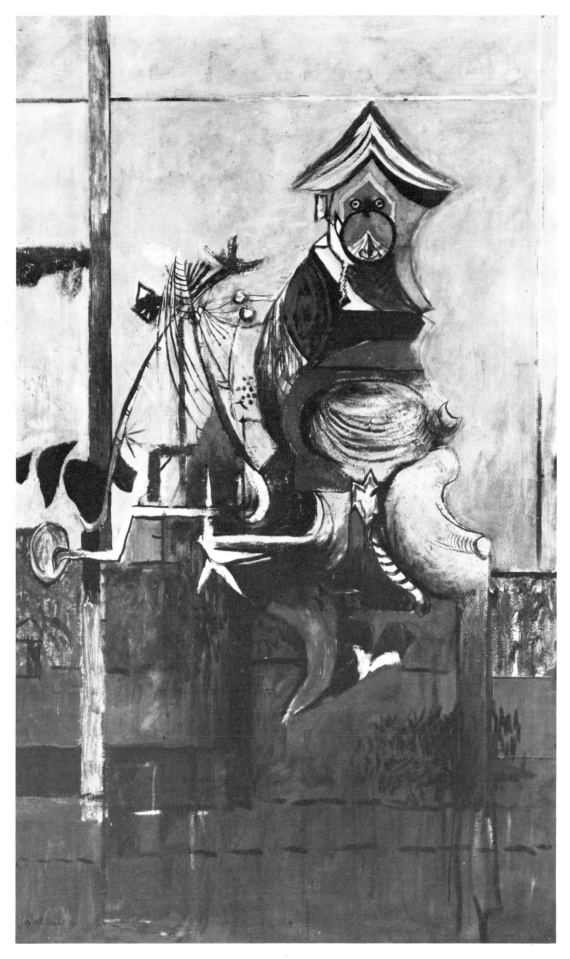

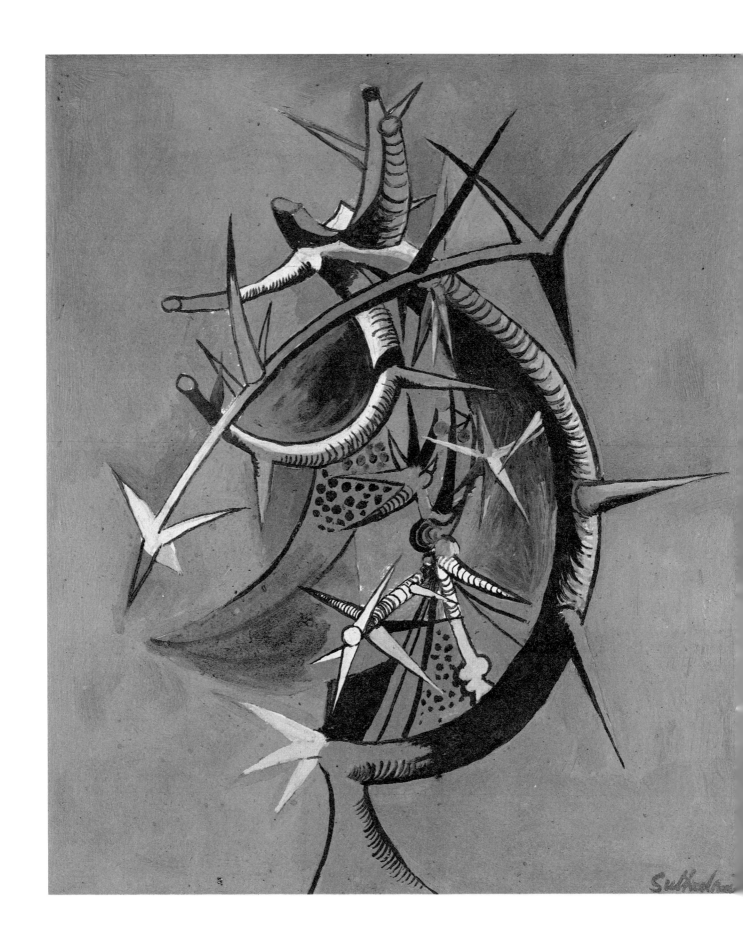

69. *Thorn Head*. Panel; 33.7 × 28.9 cm (13¼ × 11⅜ in.). Signed and dated 1946. Dr Roger M. Atwood, Tulsa, Oklahoma

70. Two Studies for the Northampton *Crucifixion*. Black chalk; 66 × 40.6 cm (26 × 16 in.). Signed and dated 1944. Mrs Graham Sutherland

71. Study for the Northampton *Crucifixion*. Hardboard; 90.8 × 121.9 cm (35¾ × 48 in.). 1946. Tate Gallery, London

Sutherland's series of *Thorn Heads* were inspired by his observation of 'the structure of thorns as they pierced the air', images which began to force themselves on his attention in his walks during the months he was turning over in his mind the form his painting of the Crucifixion might take. These pictures, and the development of his ideas for the *Crucifixion*, including the studies reproduced here, are discussed in detail on p. 24.

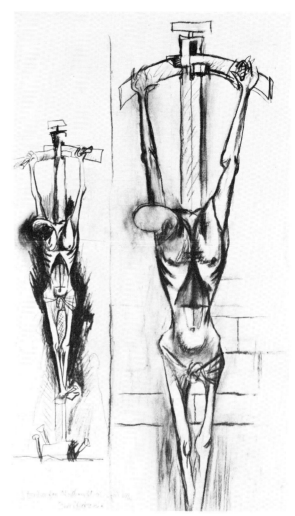

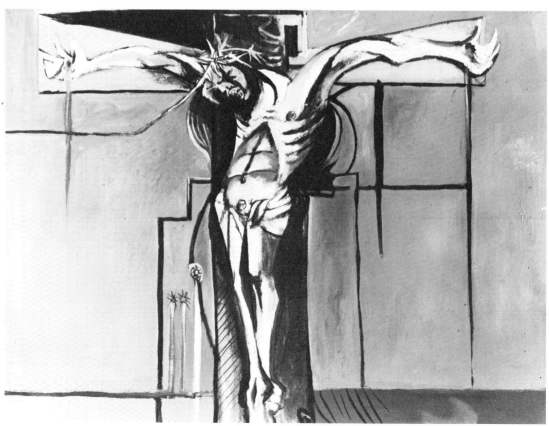

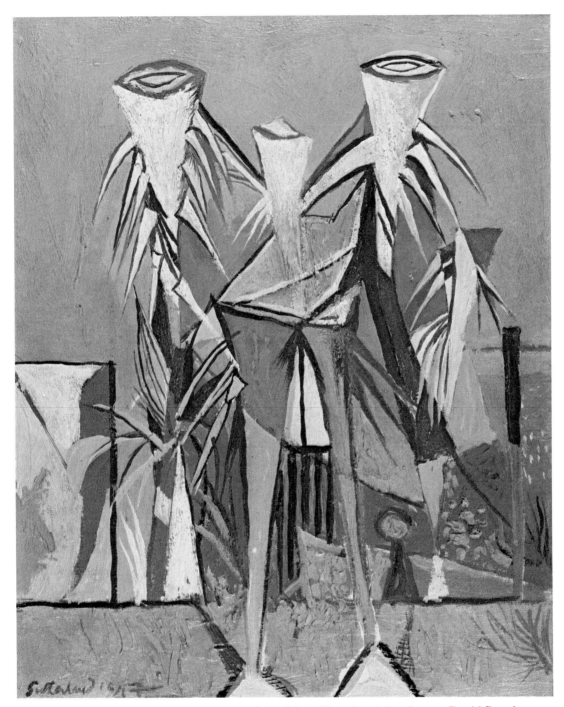

72. *Palm Palisade*. Canvas; 49.5 × 39.4 cm (19½ × 15½ in.). Signed and dated 1947. David Breeden, London

73. *Palm Palisade*. Canvas; 110.5 × 92.7 cm (43½ × 36½ in.). Signed and dated 1948. Wright Ludington, Santa Barbara, California

Palm trees, a familiar feature of the Riviera, Sutherland used constantly as motifs, emphasizing their barbed branches to form frankly decorative compositions with varied backgrounds of comparatively undifferentiated colour; passages in the Breeden painting are as encrusted in handling as a Van Gogh. See also p. 27. One of his *Crucifixion* studies included palms as supporting features on each side of the crucified Christ.

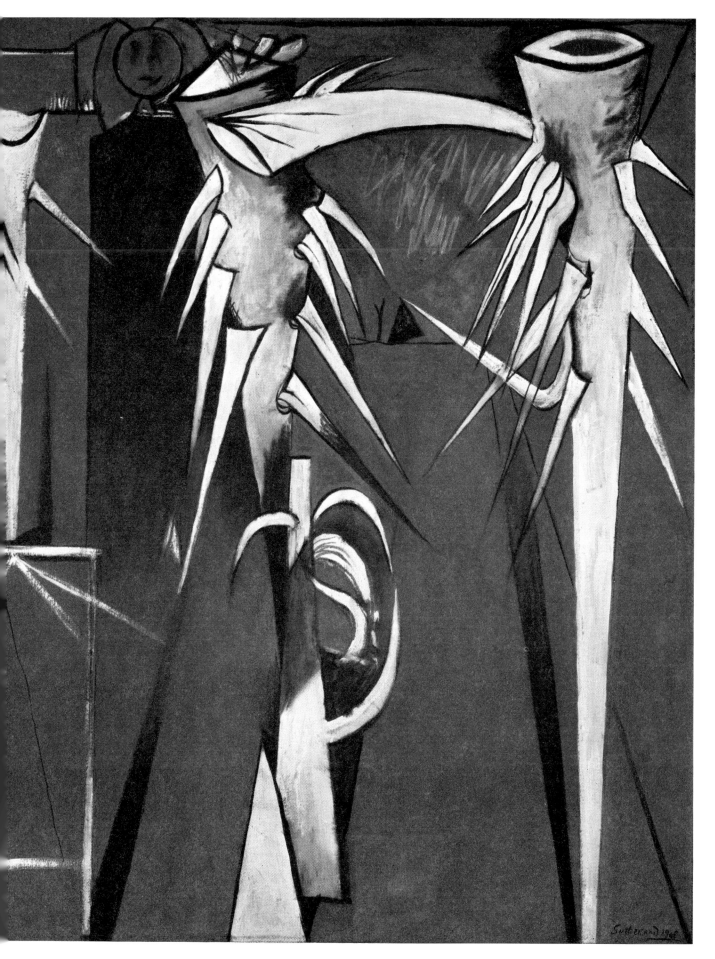

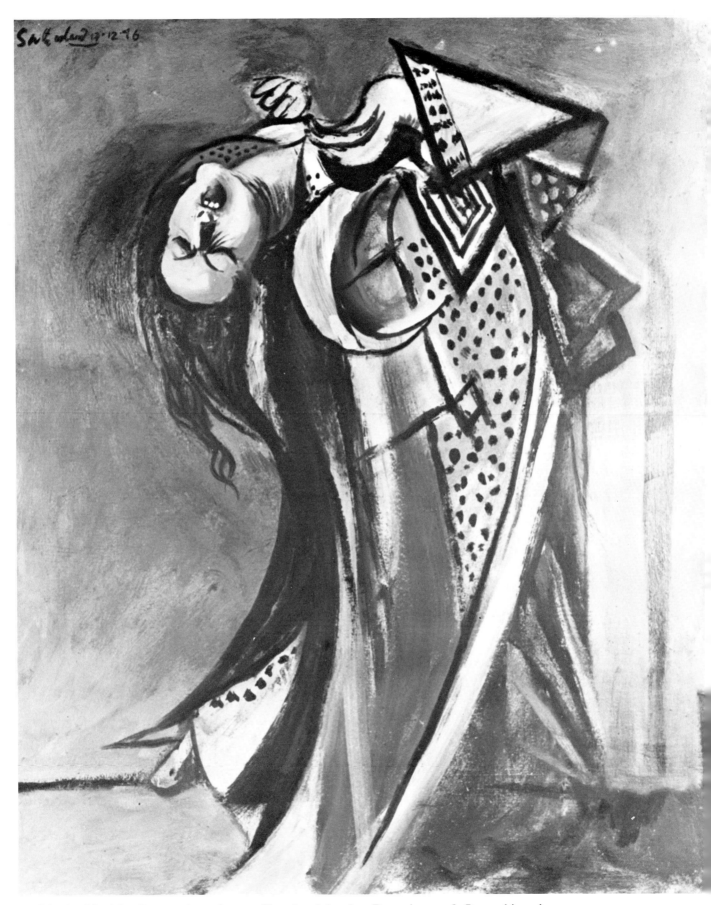

74. *Weeping Magdalen*. Canvas; size unknown. Signed and dated 12 December 1946. Ownership unknown

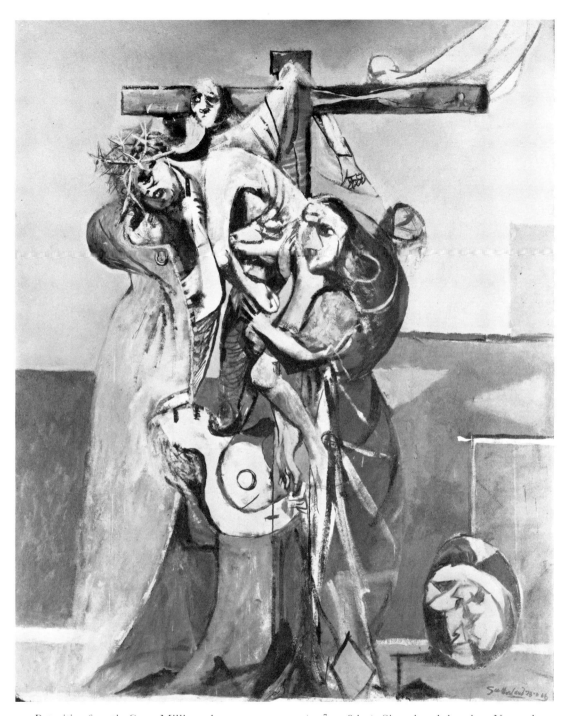

75. *Deposition from the Cross*. Millboard; 152 × 121.9 cm (59⅞ × 48 in.). Signed and dated 23 November 1946. Fitzwilliam Museum, Cambridge

76. PABLO PICASSO: *Guernica* (detail). Canvas. 1937. On extended loan to the Museum of Modern Art, New York

Sutherland had originally intended to include in his *Crucifixion* the traditional mourners at the foot of the Cross: the Virgin, St John and Mary Magdalen. A month after the unveiling he painted this violently expressionistic *Magdalen*, in which the forms sweep upwards in powerful rhythms and the head is even more contorted by anguished despair than in Grünewald's Isenheim altarpiece, a work Sutherland greatly admired. The shriek and the head thrown back are reminiscent of the agonized mother in Picasso's *Guernica*, also the source for the Magdalen in the *Deposition*, overtly in Picasso's style, which he painted at this same time. It is worth noting that Sutherland's friend Francis Bacon had only recently painted his horrific *Three Studies for Figures at the Base of a Crucifixion* (Plate 127), which was avowedly inspired by Picasso.

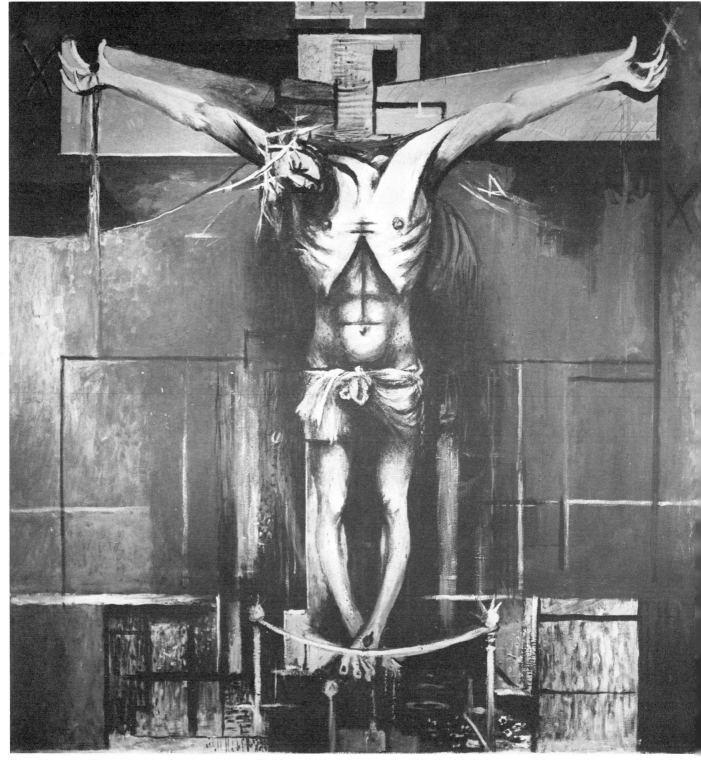

77. *Crucifixion*. Hardboard; 243.8 × 228.6 cm (96 × 90 in.). 1946. St Matthew's Church, Northampton

78. Detail of Plate 77

The circumstances of this commission, and the evolution of the design, are described in detail on pp. 24 ff. Not long ago Lord Clark described Sutherland's *Crucifixion* as 'one of the greatest things he has ever done' (*Chichester 900*, 1975, p.71).

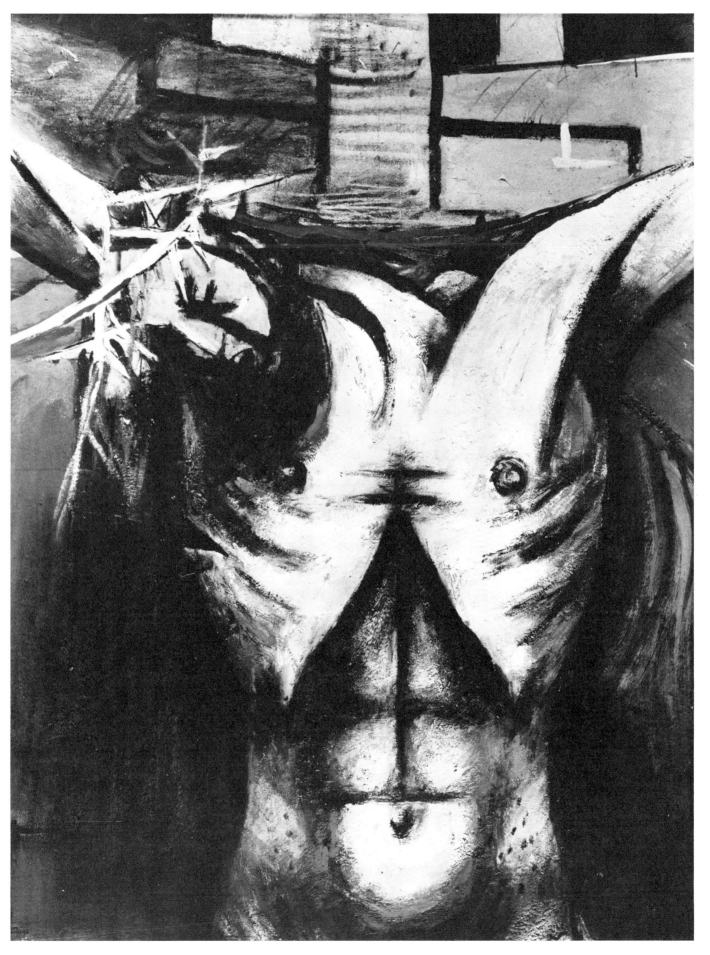

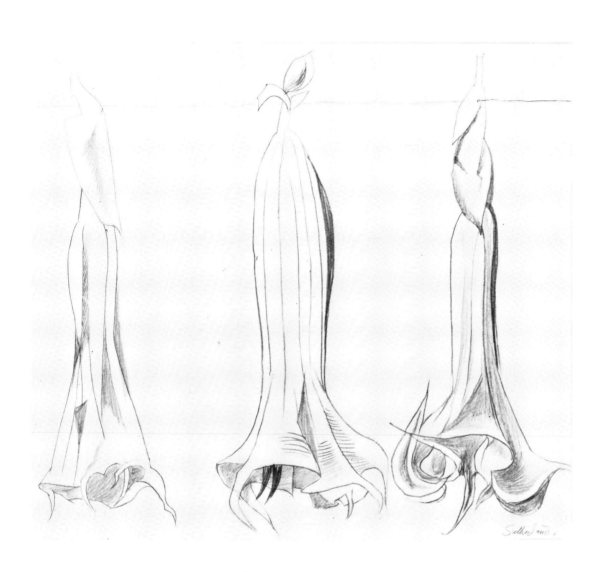

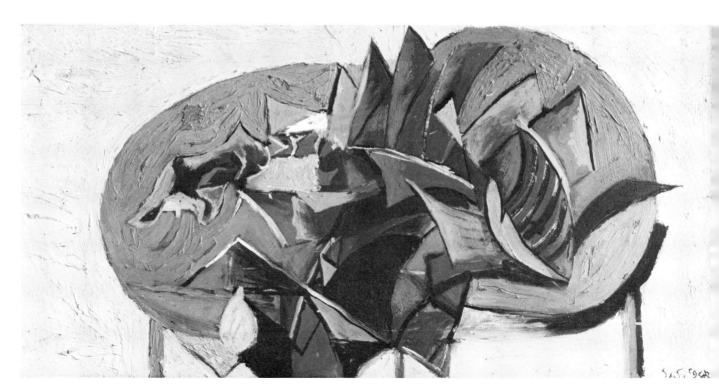

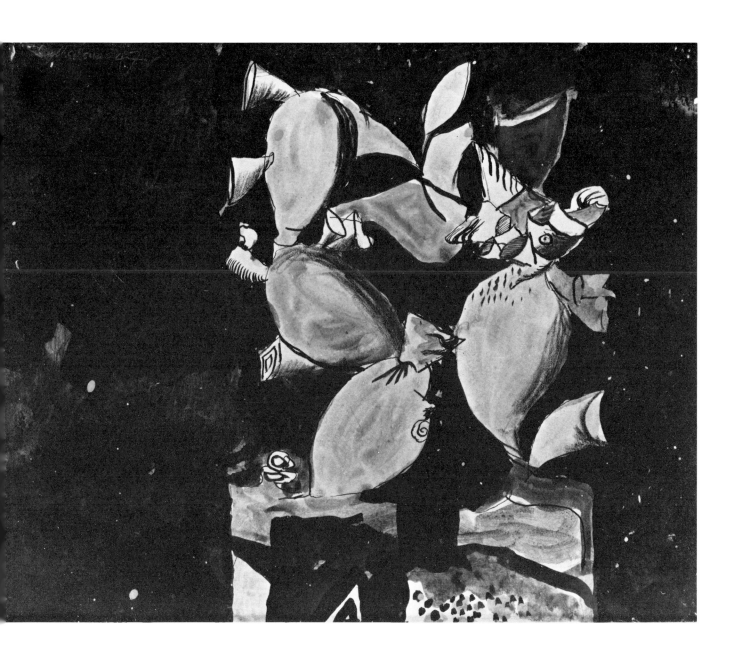

79. *Datura*. Pencil; 35.6 × 40.6 cm (14 × 16 in.). 1949. David Breeden, London

80. *Still Life with Banana Leaf*. Masonite; 27.3 × 53.3 cm (10¾ × 21 in.). Signed and dated 1947. Private collection, London

81. *Cactus*. Pen and ink and watercolour; 22.9 × 28.6 cm (9 × 11¼ in.). Signed and dated 1947. Formerly James Bomford

In the first years he spent in the South of France (1947 onwards) Sutherland revelled in exploring the forms of the exotic trees and plants he now found around him – the datura tree on his terrace, cacti, hanging maize, banana plants, gourds, aubergines, artichokes, pomegranates – analysing their growth and the character they assumed. His *Datura* drawings show the sensitivity of his command of line, while the richly impasted *Still Life with Banana Leaf*, its forms tilted upwards in the style characteristic of still-life painting since Cézanne, is a brilliant expressionistic composition based on these new studies.

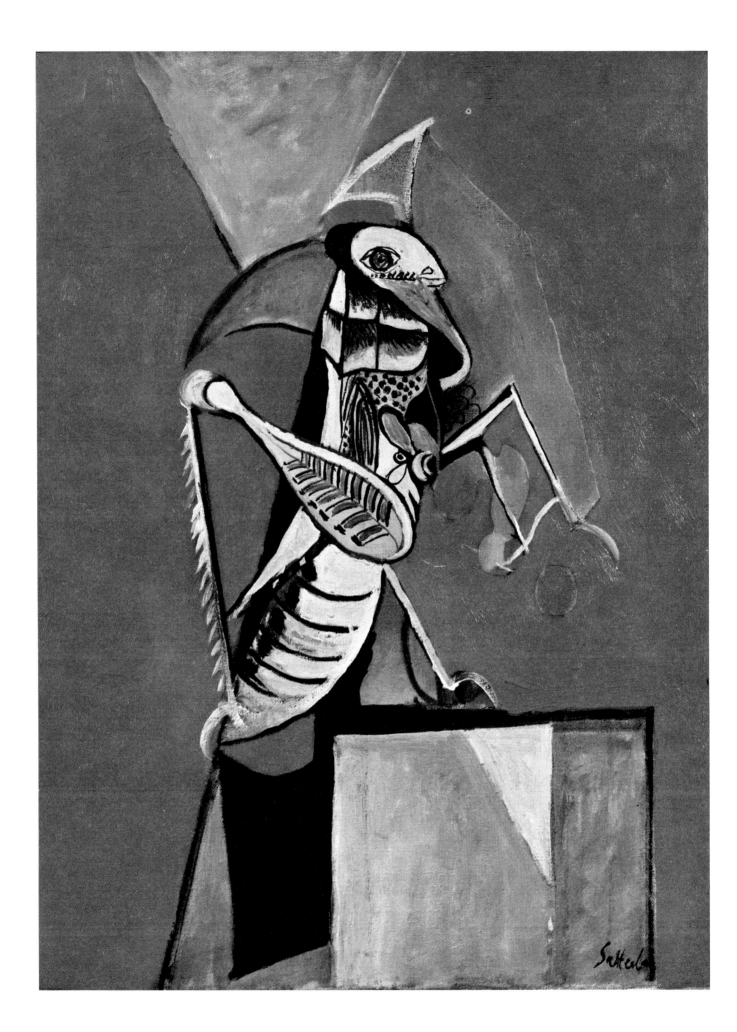

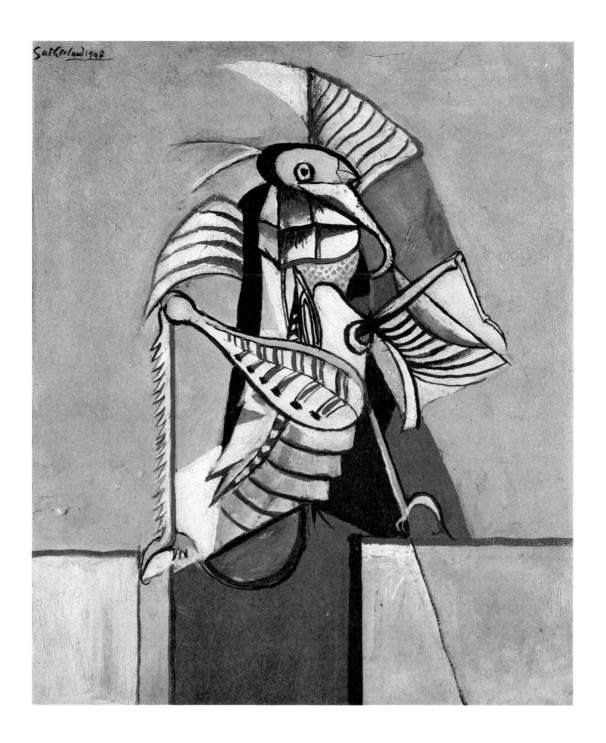

82. *Cigale*. Canvas; 68.6 × 50.8 cm (27 × 20 in.). 1948. Ownership unknown

83. *Cigale*. Canvas; 68.6 × 50.8 cm (27 × 20 in.). Signed and dated 1948. Mr and Mrs Peter Adam, London

Using differently coloured decorative backgrounds, Sutherland magnified the forms of insects such as the mantis and the cicada to make pictures which possess something of the dignity of portraits and are as striking and as haunting as his large *Chimères* (Plate 68). Both these small canvases were shown at the Hanover Gallery in 1948, the exhibition which did most to establish Sutherland's post-war style in London – the style he had developed through his understanding of Picasso and Matisse – and to secure his reputation as an artist of international standing.

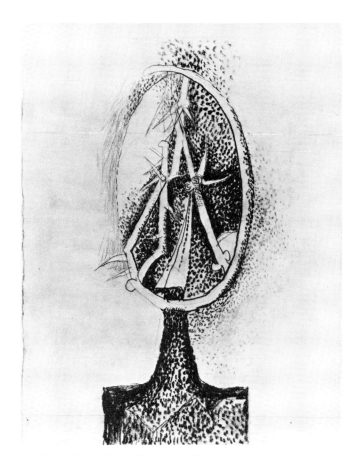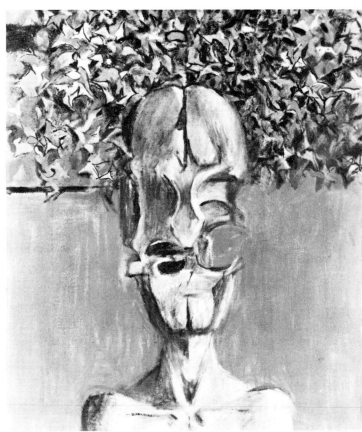

84. Study for a *Thorn Head*. Pencil and black chalk; 36.4 × 28.3 cm (14$\frac{5}{16}$ × 11$\frac{1}{8}$ in.). 1949. Mrs Graham Sutherland

85. *Head Against Bougainvillaea*. Canvas; 61 × 50.8 cm (24 × 20 in.). Dated 1951 (on the reverse). Mrs Graham Sutherland

Sutherland's brilliant sketch of a laughing woman, expressionist in the modern tradition of such painters as Munch with its sweeping brushwork and arbitrary colour (blues predominating in the flesh tones, deep blues and greens in the hair), is unusual in his post-war *œuvre*. At this time he felt unable to develop a study of so fleeting an expression into a satisfactory finished work. More characteristic are his metamorphoses of the human head in terms of thorns, and the skeletal heads derived from *objets trouvés*, in which he seems to be exploring the relationship between human features and machine forms.

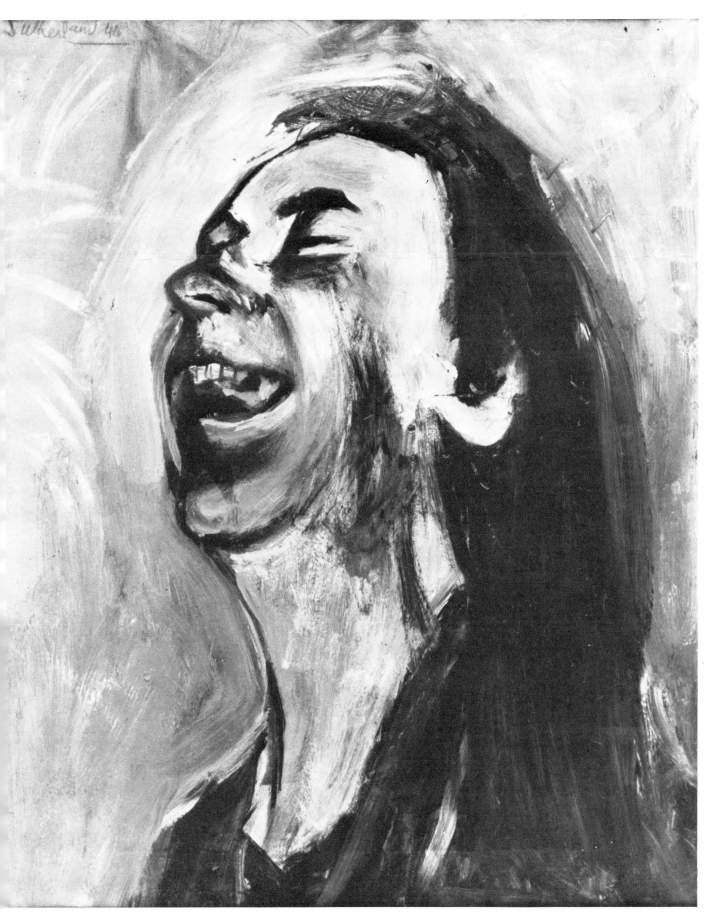

86. Study for *The Laughing Woman*. Canvas; 45.7 × 36.8 cm (18 × 14½ in.). Signed and dated 1946. Private collection, England

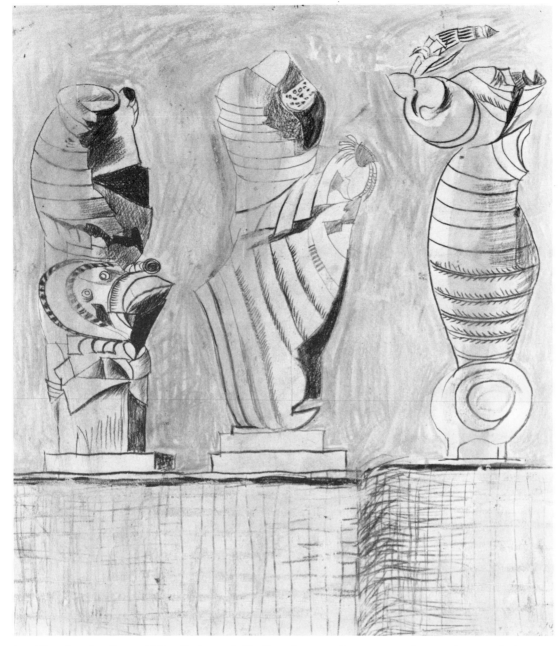

87. *Three Standing Forms, Yellow Background*. Chalk and watercolour; 53.3 × 48.3 cm. (21 × 19 in.). 1949. Assis Chateaubriand, São Paulo

Sutherland made his reputation as a landscape painter, but many of his landscapes have been dominated by images which have human connotations, and figurative art has never been far from his mind. Between 1949 and 1953 he was deeply preoccupied with a series of pictures, the so-called *Standing Forms*, in which he sought to catch 'the essence of the presence of the human figure . . . by a substitution'. It was characteristic that he should need to experiment with the problems posed by figurative art in this oblique fashion; for these works were composed largely of the root and other organic forms with which he had always been absorbed, distorted and magnified in the same way as the insects he had used for such compositions as his *Cigales* (Plates 82, 83). See also p. 29.

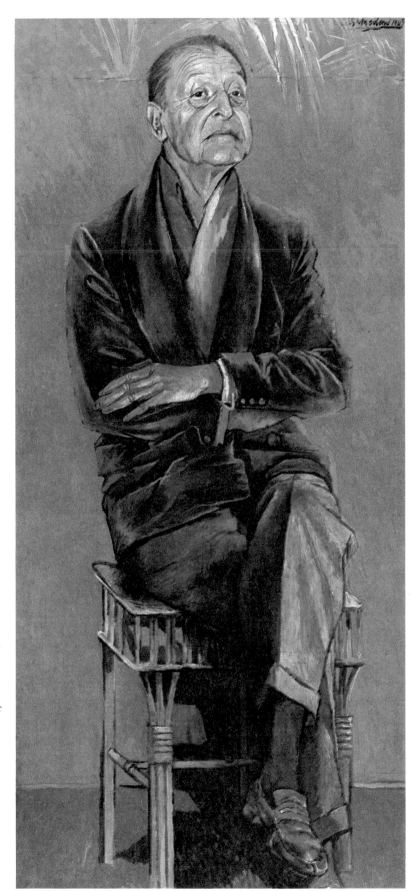

8. *Portrait of Somerset Maugham* (1874–1965). Canvas;
137.2 × 63.5 cm (54 × 25 in.). Signed and dated 1949.
Tate Gallery, London

It was no accident that the painting of the *Somerset
Maugham*, Sutherland's first portrait and a work of
startling originality, should coincide with that of the
earliest of his *Standing Forms* – pictures which he saw as
'monuments and presences' – since the latter were an
essential preparation for his portraiture. Even their
linear structure has its counterpart in the modelling of
the *Maugham*, and the set of the jaw, the erect pose, the
unusual narrowness of the canvas, and the plain
though broken and roughly impasted background, all
contribute to a monolithic quality shared by the
Standing Forms which was Sutherland's aim in his early
portraiture. The sardonic character of Maugham is
caught perfectly, and the yellowish background is
symbolic, for yellow is a royal colour in the Orient,
where Maugham had travelled widely. Difficulties in
the management of the legs, the subject of numerous
trial sketches, are masked by the incisive line of the
trouser crease. See also pp. 31 ff.

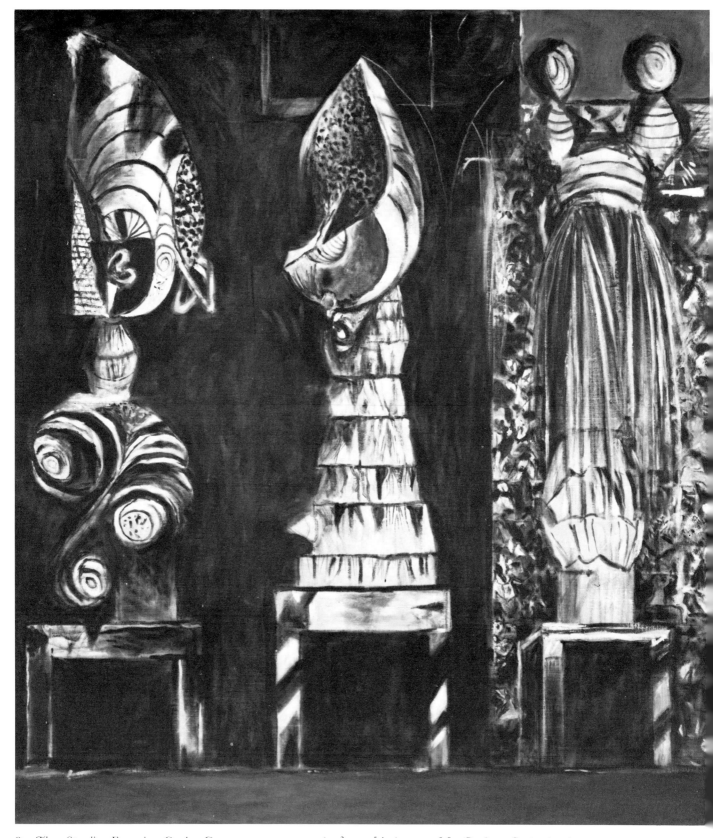

89. *Three Standing Forms in a Garden*. Canvas; 133 × 121 cm (52⅜ × 47⅝ in.). 1951. Mrs Graham Sutherland

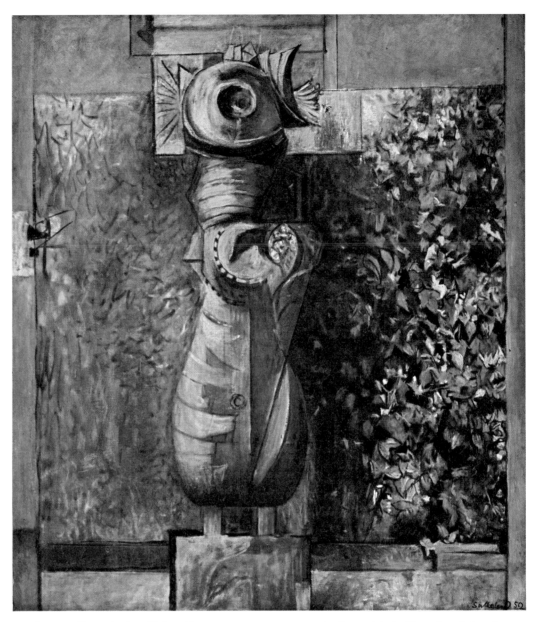

90. *Standing Form Against Hedge*. Canvas; 132.5 × 115.9 cm (52⅛ × 45⅝ in.). Signed and dated 1950. Arts Council of Great Britain

Two of Sutherland's most important large-scale *Standing Forms*, that reproduced in Plate 90 being composed largely of mechanically inspired – rather than organic – shapes. These inventions 'stemmed from seeing figures in gardens – half hidden in shade. At the time, I wanted to try and do forms in such a setting which were not figures but parallel to figures – figures once removed.' Sutherland's 'fetish-like *Forms* are, in themselves, essentially unreal, but because they are painted in pseudo-sculptural terms and have human connotations they achieve a potent degree of pictorial reality' (Douglas Cooper). See also p. 30.

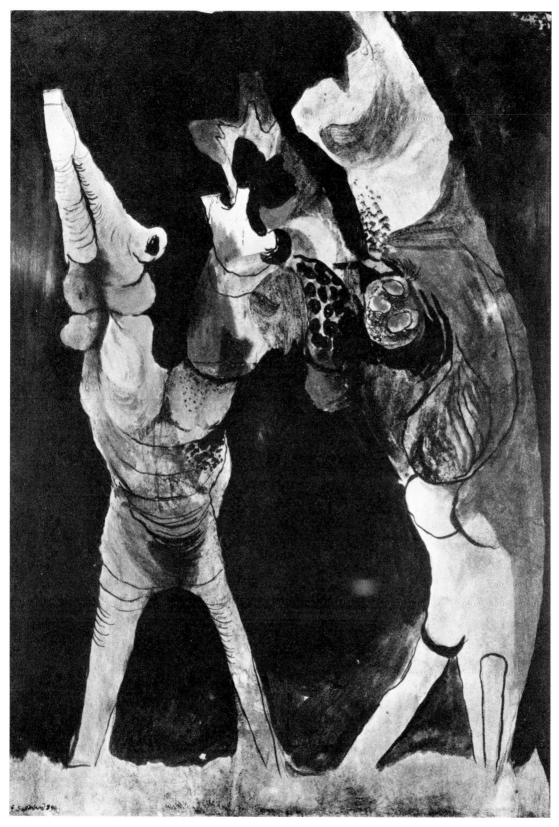

91. *Association of Oaks*. Pen and ink and gouache; 68.6 × 48.3 cm (27 × 19 in.). Signed and dated 1940.
Mrs Edward R. Root, New York

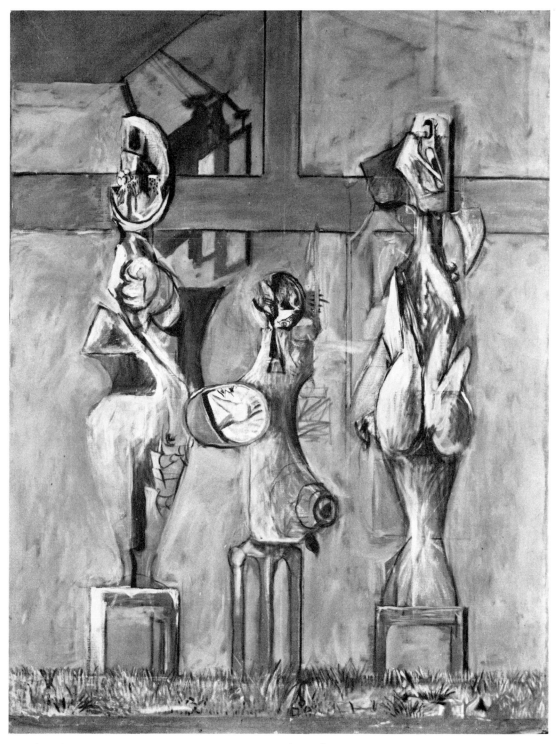

92. *Three Standing Forms*. Canvas; 181 × 141.6 cm (71¼ × 55¾ in.). 1952. Myron O'Higgins, New York

The painting reproduced in Plate 92 possesses nothing of the majesty of *Standing Form against Hedge* (Plate 90) and demonstrates the range of Sutherland's investigations of the figurative at this time; the form on the right is reminiscent of an *écorché*, and the sense of human degradation, somehow emphasized by the sunny open-air setting (the background is bright yellow) is close to the outlook of Francis Bacon, whom Sutherland knew particularly well in the years after the War. Although the *Standing Forms* are inventions, almost constructions, drawing upon the wealth of imagery stored away in his mind and his sketchbooks, it is worth stressing the continuity of Sutherland's anthropomorphic approach to his sources by comparing these canvases with his more immediate reaction, 'off the nerves', to suggestive visual images, in such works as his celebrated *Association of Oaks* of a decade earlier.

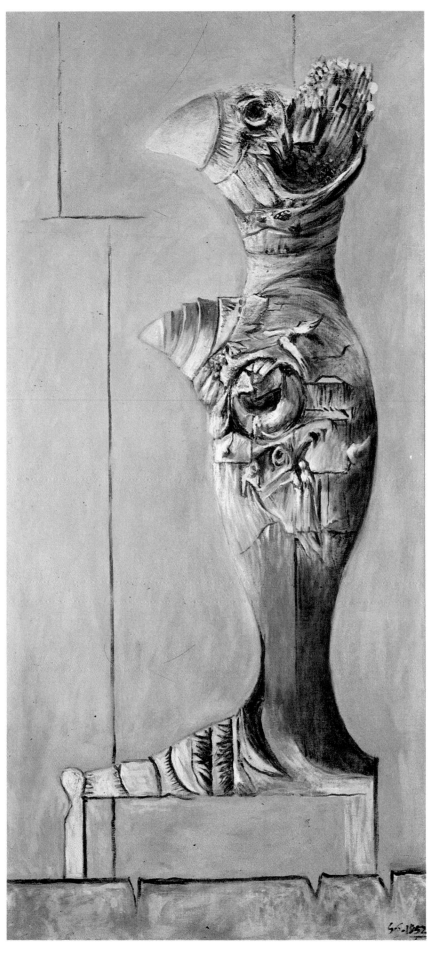

93. *Standing Form*. Canvas; 219.7 × 102.2 cm (86½ × 40¼ in.). Signed and dated 1952. Musée National d'Art Moderne, Centre National d'Art et de Culture Georges Pompidou, Paris

94. *The Origins of the Land*. Canvas; 425.4 × 327.7 cm (167½ × 129 in.). 1951. Tate Gallery, London

The Origins of the Land, by far the largest work Sutherland had so far attempted and in consequence broadly and thinly handled with th white of the canvas freely used, was painted as a mural for the 'Land of Britain' pavilion at the Festival of Britain. On its exhibition, the canvas was wilfully slashed and had to be repaired. Symbolical in intent, the background representing the life-giving force of the sun, the arrangement of the composition is suggestive of geological strata, with the region of fire at the heart of the universe depicted along the bottom of the canvas. 'It is as if you were looking at a cliff face', Sutherland has explained. The pterodactyl and root forms typify the process of fossilization beneath the earth's surface and the array of rocks the eroding process above, while man, in the shape of a 'standing form', is shown looking on. The more intricately constructed an totem-like *Standing Form* (Plate 93), its massive feet reminiscent of Egyptian sculpture, was developed from this figure.

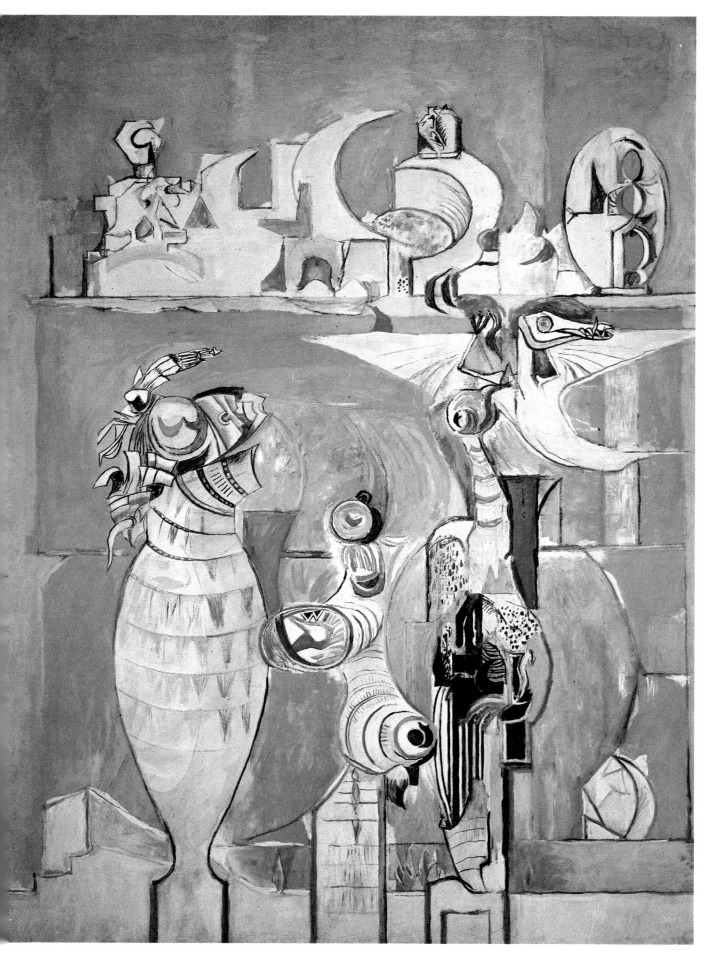

95. *Study of Boulders*. Pen and ink, chalk and wash; 19.7 × 15.9 cm (7¾ × 6¼ in.). 1942.
Mrs Graham Sutherland

96. *Head*. Chalk and gouache; 33 × 24.1 cm (13 × 9½ in). 1951. Formerly Rex Nan Kivell, London

The gorges and fortified villages of the Vallée du Loup are amongst the most spectacular sights of the Alpes Maritimes. The rocks and stones which Sutherland found in a dry river-bed at Tourettes-sur-Loup, and in which he saw a microcosm of the mountainous landscape, not only formed a logical starting-point for the upper part of *The Origins of the Land* (Plate 94) and other compositions of this period, but suggested to him the shape of the human head (compare also Plate 85). Similarly suggestive boulders had constantly caught Sutherland's imagination over the years, as can be seen from Plate 95. The table of his studio in Menton was a litter of such *objets trouvés*.

97. *Hanging Form Over Water*. Canvas; 109.3 × 86.4 cm (43 × 34 in.). 1955. Private collection, London

Always fascinated by 'the tension between opposites' and 'the precarious balanced moment', both in nature and in life, Sutherland painted a series of swinging, hanging and poised forms in the 1950s (see also Plate 129). His suspended monkey, in particular, reminds us of his fascination with the visual effects of Goya's terrible drawings of executed men hanging upside-down. An abstract background containing vertical and horizontal lines 'to stabilize the movements' now became a familiar device. The looseness of handling and the subtleties of textures, modelling and tonal relationships in these works should be compared with the stark, generally more planar structure of his paintings of the immediate post-war years, expressed in terms of thick, black contours and broad areas of bright, undifferentiated colour. The title *La Petite Afrique* is derived from the village where the sketches for this picture were made.

98. *La Petite Afrique III*. Canvas; 142.2 × 121.9 cm (56 × 48 in.). Signed and dated 1955. Private collection, London

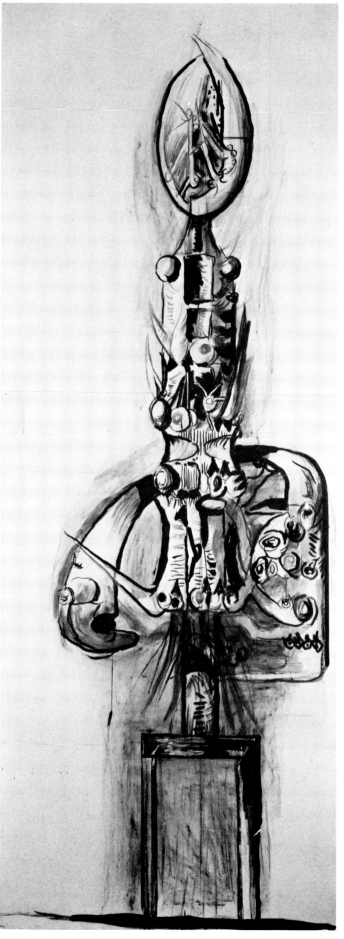

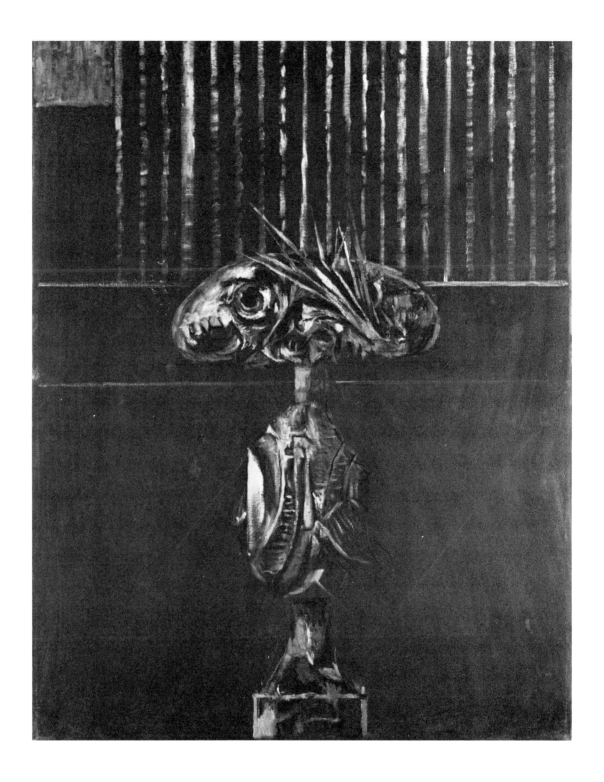

99, 100. *Studies of a Cut Tree*. Pen and ink, black chalk, grey and grey-black washes and gouache; each 197 × 75 cm (77½ × 33½ in.). About 1953. Private collection, London

101. *Head III*. Canvas; 114.4 × 88.3 cm (45 × 34¾ in.). 1953. Tate Gallery, London

Sutherland customarily outlined the structure and tonal relationships of his canvases in charcoal and white chalk, or in black and white paint, before beginning to work in colour. The two large canvases of a 'Cut Tree', totems constructed of complex relationships of tree forms, which were left as magnificent, decorative *grisailles*, were executed for the foot of the staircase at Saltwood Castle. *Head III* – atmospheric, subtly modelled, and painted in the most restrained of palettes, the background a delicately stained lightish brown – is equally noble as an image, timeless in its perfect poise.

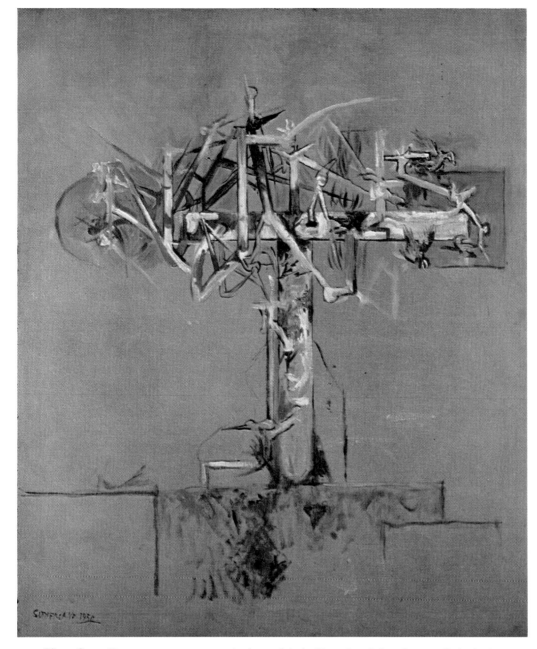

102. *Thorn Cross*. Canvas; 113 × 95.2 cm (44½ × 37½ in.). Signed and dated 1954. Galerie des 20. Jahrhunderts, West Berlin

It had been the spiky shapes of thorn bushes, evocative of the cruelty of the crown of thorns, that first inspired Sutherland when he began thinking about his *Crucifixion* for Northampton. Similar images of cruelty, for which he made fresh studies from nature in the South of France, filled his mind during the early stages of his work on the Coventry tapestry. For the background of such subjects 'blue skies are, in a sense, more powerfully horrifying'.

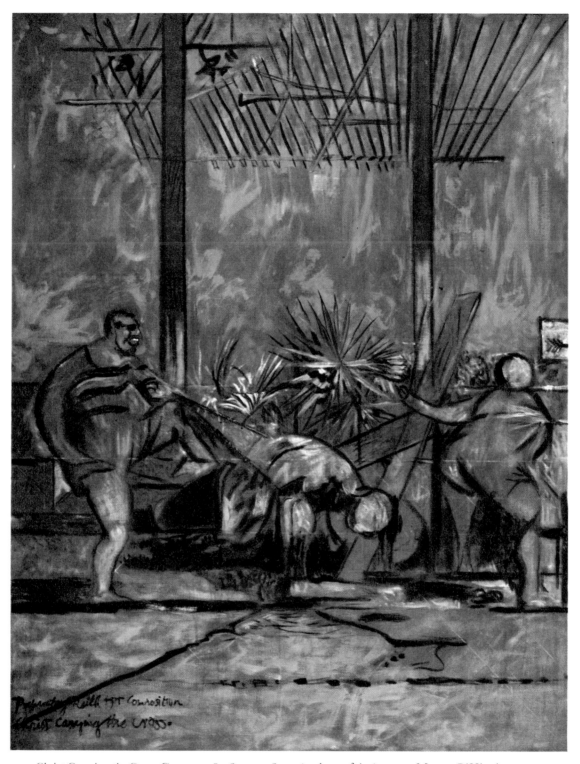

103. *Christ Carrying the Cross*. Canvas; 181.6 × 141.6 cm (71½ × 55¾ in.). 1953. Myron O'Higgins, New York

A large-scale sketch, developing a composition Sutherland had painted, along with other subjects related to the last days of Christ's life on earth, at the time of the Northampton *Crucifixion*. The central figure of Christ, shown stumbling from weakness and exhaustion after the ordeal of His mocking and torture, is nobly rather than pathetically conceived; the bloated figure behind, callously booting Him on, recalls similar types by Francis Bacon. The broken handling of paint, predominantly sombre in tone, is tragic in connotation. As always with Sutherland, the setting is unconventional; it reminded Edward Sackville-West of 'the remains of an abandoned Mediterranean villa', and the stark columns and ruined canopy add to the sense of impending tragedy.

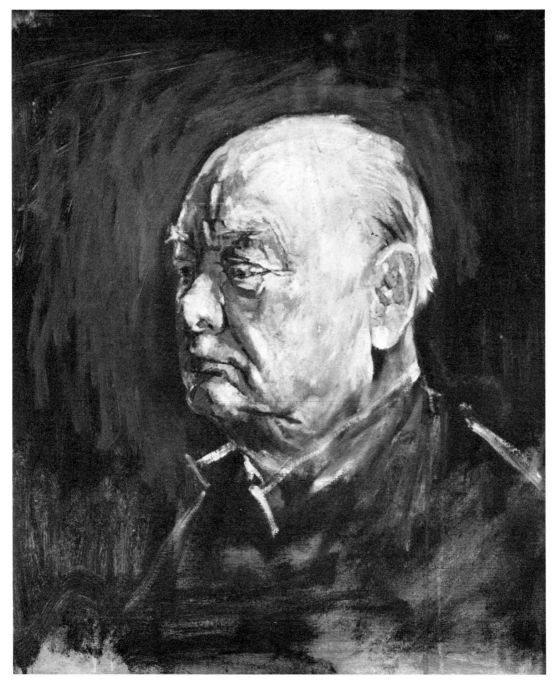

104. *Study of Sir Winston Churchill* (1874–1965). Canvas; 61 × 50.8 cm (24 × 20 in.). Signed and dated 1954. Private collection, London

The controversial portrait of Sir Winston Churchill, which Churchill himself hated because he said it 'makes me look half-witted' and which was destroyed out of anger only a year or two after its completion, was commissioned in 1954 by past and present members of the House of Lords and House of Commons, and presented to the great statesman as a celebration of his eightieth birthday at a ceremony in Westminster Hall on 30 November of that year. Though Churchill would have preferred to have been painted in his robes as Knight of the Garter, the All-Party Committee had specified that he should be represented as the House of Commons had always known him, and the spotted bow-tie, black coat and waistcoat and striped trousers in which Sutherland painted him were indeed the dress familiar to every one of Churchill's parliamentary colleagues. At the first sitting Churchill asked Sutherland: 'How will you paint me, as a cherub or the bull dog?' 'He showed me a bulldog so I painted a bulldog.' Though the picture could never have been other than a portrait of an old man,

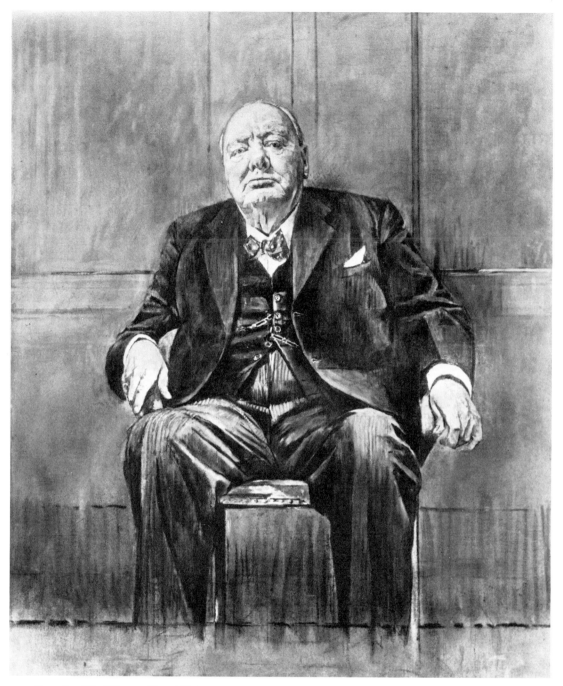

105. *Portrait of Sir Winston Churchill* (1874–1965). Canvas; 147.3 × 121.9 cm (58 × 48 in.). 1954.
Destroyed

and one reluctantly about to relinquish power, Sutherland conveyed to the full the distinction and tenacity of the elder statesman who had saved the world from thraldom to Hitler's 'Thousand-Year Reich' in 1940. The pose is firm, the weight of the form massive, and Churchill's legs seem like mighty columns precisely because they have been truncated. 'The tyranny of the edge of the canvas, where to end the movement, is always a great problem with any kind of painting . . . Where to make the cut between the knee and the foot is not easy.' The brilliant oil sketch (Plate 104), now the finest surviving painting of Churchill, shows the great man in one of his characteristic moods, abstracted and brooding. After lunch one day he had agreed to be photographed by Felix Man, at the same time as he was dictating letters to his secretary; he had gone over to the window and, as the sun was low, his skin seemed transparent, an effect most sensitively portrayed by Sutherland.

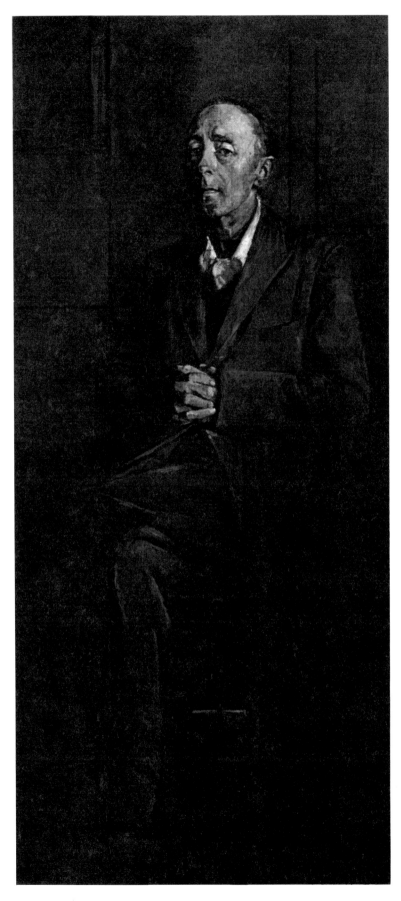

106. *Portrait of Edward Sackville-West, later Lord Sackville*
(1901 –65). Canvas; 169.5 × 77.2 cm (66¾ × 30⅜ in.).
1954 (signed and dated 1955 on the reverse). Private
collection, England

Edward Sackville-West, the distinguished writer and
musicologist, and a close friend of Sutherland, was
hypersensitive and highly strung, and seemed, as Lord
Clark writes, 'to stand permanently on the threshold of
death's door'. This almost evanescent work, arguably
Sutherland's masterpiece in portraiture, was painted
exceptionally thinly (save for the rich greys, ochres and
creams in the hands) in a muted colour scheme based on
the dark red priming evident throughout; in the lower
part of the canvas, Sutherland deliberately tried to
create 'an impalpable atmosphere'. The sitter is perched
on a high stool – contrast this with the commanding
position taken up by Somerset Maugham (Plate 88) –
his hands nervously clasped (the habit of kneading his
fingers was a characteristic nervous compulsion), and his
expression tense, almost anguished; notwithstanding, as
Sutherland says, he 'sat like a rock'. The impression of
imbalance is corrected by the careful placing of the
background rectangles.

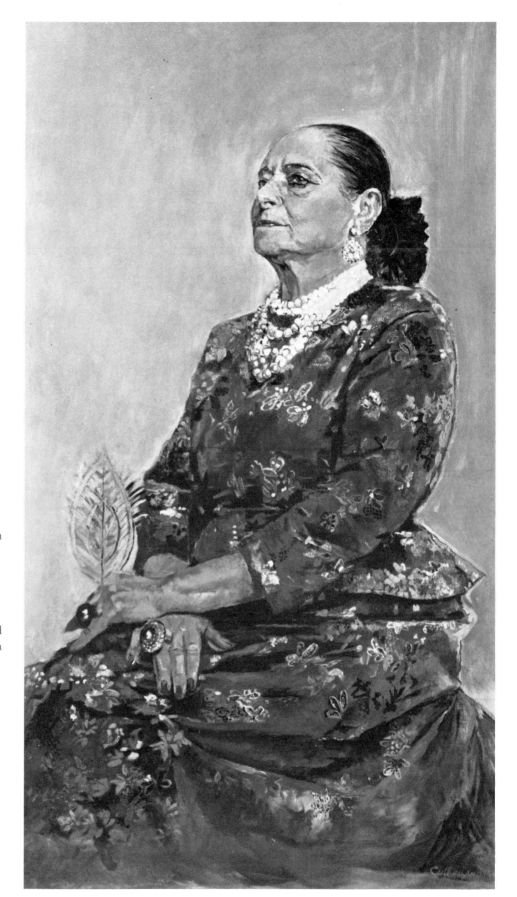

107. *Portrait of Helena Rubinstein*
(1871–1965). Canvas; 156.8 ×92.7 cm
(61¾ ×36½ in.). Signed and dated
1957. Helena Rubinstein Foundation,
New York

No greater contrast to the infinitely
subtle portrait of Sackville-West could
be imagined than this regal image of a
queen of the beauty world used to
wielding absolute power, the broad
forms of her bright red Balenciaga
brocade gown, overlaid with sequins
and semiprecious stones, building up
inexorably towards the smooth,
cosmeticized but imperious head,
sharply etched against a pale, plain
background. To have encompassed
such a range with such outstanding
success sets Sutherland high amongst
European portraitists of any period.

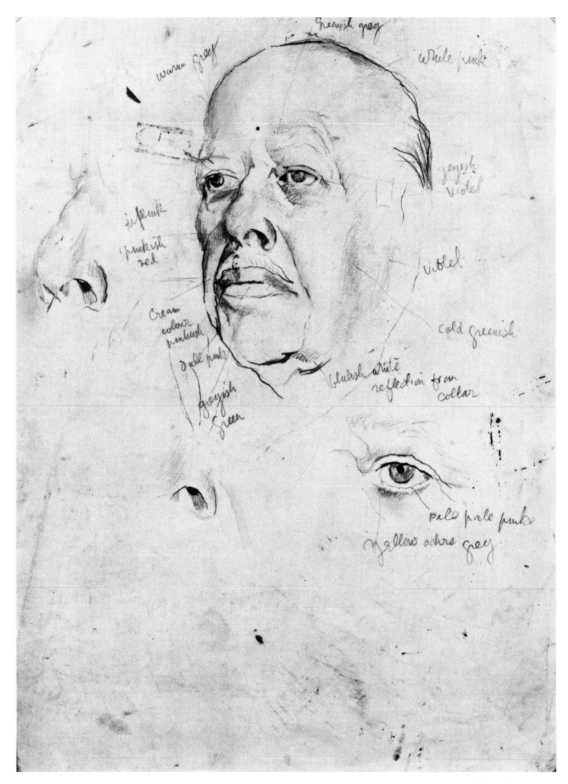

108. Study for the portrait of *Max Egon, Prince von Fürstenberg*. Pencil; 32.7 × 23.8 cm (12⅞ × 9⅜ in.).
1958. Mrs Graham Sutherland

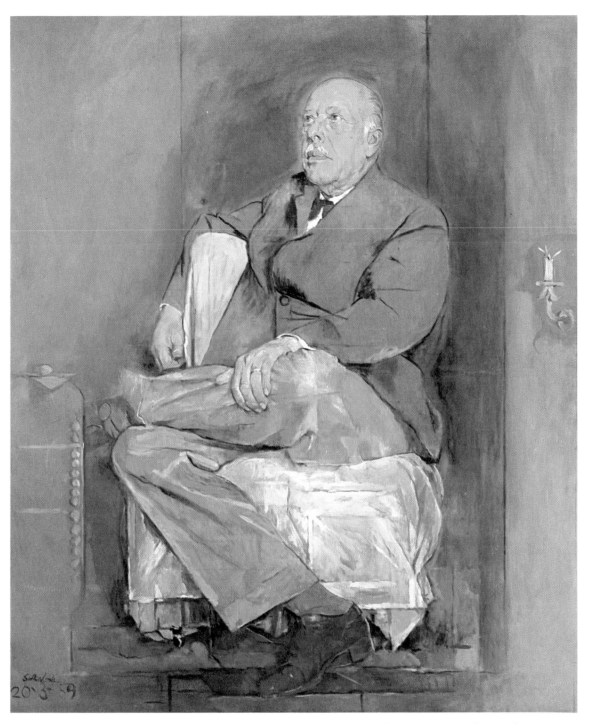

109. *Portrait of Max Egon, Prince von Fürstenberg* (1896–1959). Canvas; 165.1 × 139.7 cm (65 × 55 in.).
Signed and dated 20 March 1959. Joachim, Fürst zu Fürstenberg, Donaueschingen

Sutherland never dictated the pose of a portrait any more than he could dictate the organic growth of
a tree or root form. His approach in both spheres was always to let his subjects reveal themselves. But
he was at his best when, like Prince von Fürstenberg, a sitter spontaneously adopted a pose in which
'the forms, while full of diversity, complexity and variety, yet have a rhythm which holds them all
together'. Here the whole design literally springs from the tip of the sitter's shoe. The head, over the
exact turn of which Sutherland took infinite trouble, is magisterial. The sheet of studies (Plate 108),
with its elaborate colour notes relating to the features and complexion, and even the reflection from
the collar, is characteristic of Sutherland's meticulous observation in front of the sitter. Prince von
Fürstenberg, a distinguished patron of the arts and of modern music, Sutherland found to be a
solitary man who 'liked to be alone in his hunting box'.

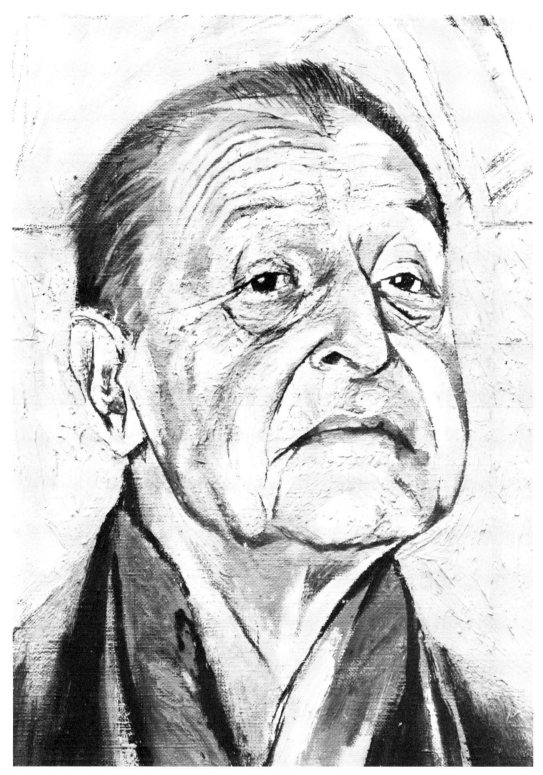

110. *Portrait of Somerset Maugham* (1874–1965). Canvas (detail, cf. Plate 88). 1949. Tate Gallery, London

The portraits of Somerset Maugham and of the Swiss conductor Paul Sacher illustrate Sutherland's changing approach to painting the human head as he gained in experience. Sutherland was always preoccupied with line and, although the portrait of Maugham is thickly painted, it was through the agency of line that he set down the features of his sitter's remarkable countenance; he had begun to see 'in the lines, forms and convolutions of a human face the same sort of expression of the process of

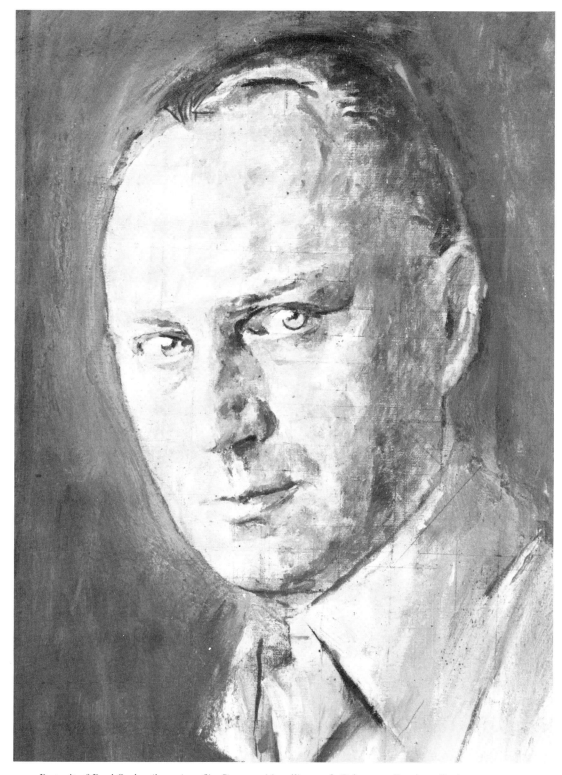

111. *Portrait of Paul Sacher* (born 1906). Canvas (detail). 1956. Private collection, Basle

growth and struggle as he found in the rugged surfaces and irregular contours of a boulder or a range
of hills' (Douglas Cooper). The head of Paul Sacher, done seven years later, is strongly lit but
atmospherically conceived and thinly painted, the touch – brushwork defining the relationships
between different planes in subtle gradations of tone – being the essential instrument of modelling.

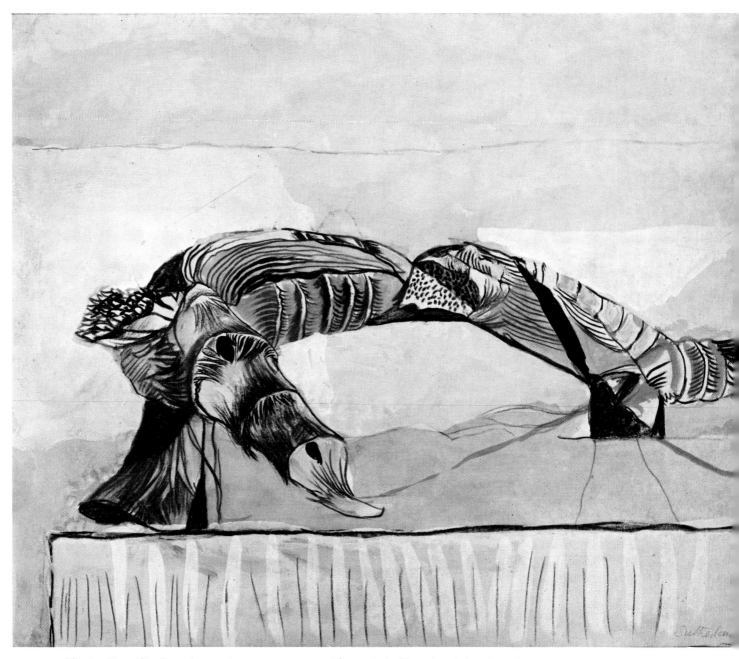

112. *Turning Form*. Chalk and gouache; 22.2 × 27.9 cm (8¾ × 11 in.). Signed and dated 1948.
Mr and Mrs John Macdonell, Sarasota

The painterly handling of the sinister-looking toad, slithering along on its belly in search of prey, its eyes bloodshot, is a remarkable portrait of a living creature, painted at a time when Sutherland was becoming increasingly concerned with studying the essential characteristics of animals: 'only through this demonstration of their nature do animals pay unconscious tribute to the power which created them.' This approach contrasts with Sutherland's work of a decade earlier, when he was either magnifying and distorting such studies for pictorial ends (Plates 82, 83) or constructing forms which gave the appearance of living creatures from his sketches of maize or root forms and characterizing them in linear rather than painterly terms.

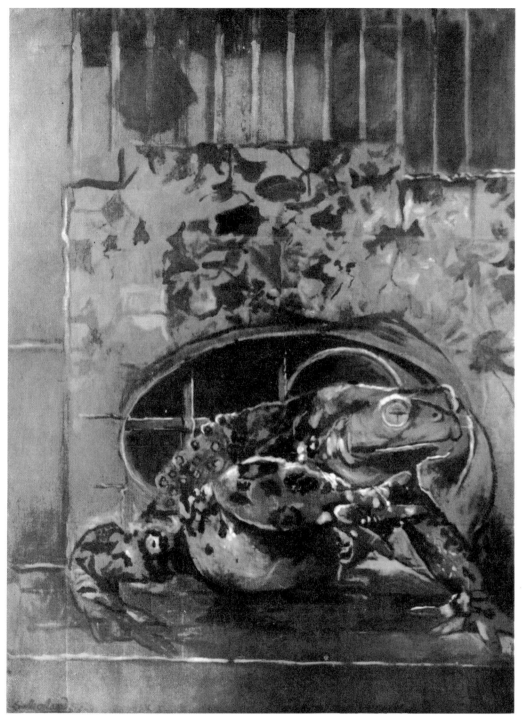

113. *Toad II*. Canvas; 128.9×97.2 cm (50¾×38¼ in.). Signed and dated 1958–9. Ownership unknown

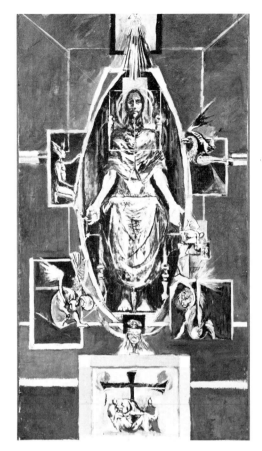 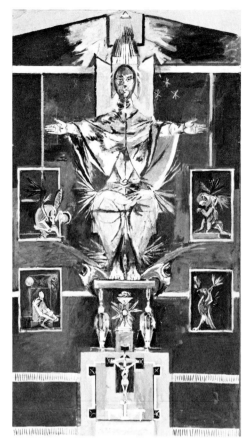

114, 115. First cartoon for the *Christ in Glory* for Coventry Cathedral, 1953; second cartoon (without the triptych beneath), 1955. Oil and gouache on board; each 201.9 × 110.5 cm (79½ × 43½ in.). Herbert Art Gallery, Coventry

116. *Christ in Glory*. Tapestry; 22.76 × 11.58 m (74 ft. 8 in. × 38 ft.). Signed and dated 1962. Coventry Cathedral

Although he tried out innumerable permutations, Sutherland evolved three considered compositional schemes for his great tapestry of *Christ in Glory* for Coventry Cathedral, which was unveiled on 25 May 1962. These were embodied in the cartoons submitted to the Bishop in 1953 and to the Reconstruction Committee in 1955 and 1957 respectively; the final work was a modification of the last cartoon. All involved frontal poses, since, above everything else, Sutherland wanted to emulate both the 'pent-up force' he found in Egyptian sculpture and the stillness of the Pantocrator heads in Byzantine art. In the first design (Plate 114), which was inspected, and approved, at Sutherland's home in Kent, Christ is depicted seated with his arms stretched downwards: though this arrangement gave 'a certain strength and linear relationship with the outside panels', Sutherland became unhappy with the pose, as he thought it sentimental, and experimented with other solutions, including one with the hands folded in the lap. In the second design (Plate 115) Christ's arms are outstretched, and the mandorla consequently excluded; the sleeves have been enlarged to fill the space created by the raised arms, and the whole effect is more dramatic. This was shown, together with the original cartoon, to the Committee, who had to decide whether they preferred the arms raised or lowered. They chose the former. The third design shows Christ in the act of blessing, and the mandorla has been restored to the scheme. In the maquette for the use of the weavers the draperies were given a horizontal emphasis, thereby producing a greater effect of solidity in the figure; a final modification to their lower part, altering the shape over the knees to an oval, made the form a little more rhythmic and introduced a note of ambiguity, which Sutherland liked, as to whether the figure was seated or standing. For the subject beneath, Sutherland first conceived a *Pietà*, but this was regarded by the authorities as unsuitable, partly because it was 'not scriptural', partly because the subject-matter was intended for a Lady Chapel. Considerable changes were made throughout in the design of the panels depicting the four beasts. The commission is discussed in more general terms on pp. 35 ff.

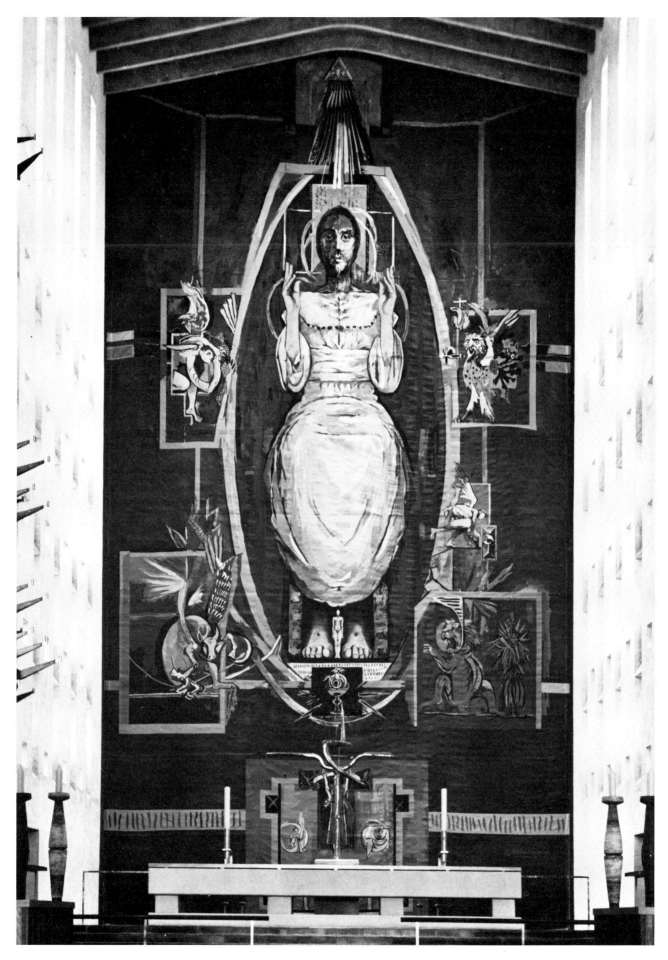

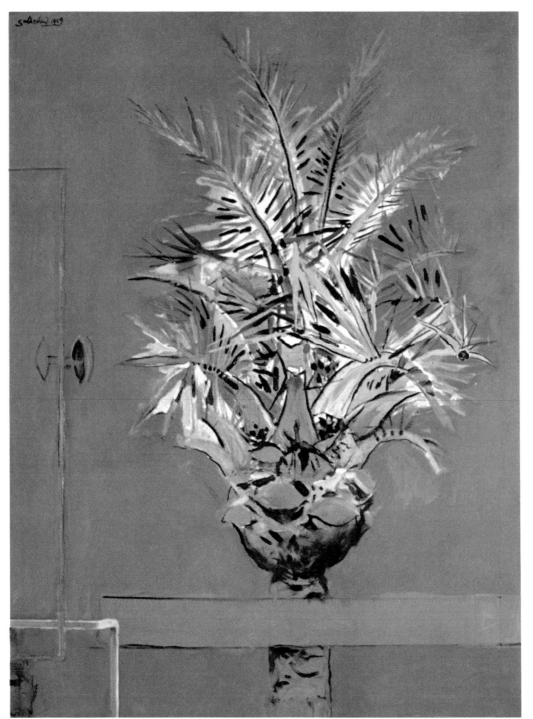

117. *The Palm*. Canvas; 129.6 × 96.8 cm (51 × 38⅛ in.). 1959. Private collection, U.S.A.

The Palm is a decorative work somewhat in the manner of Matisse and, as in paintings by Matisse, the gay colour of the background has not been modified to take account of the intrusion of naturalistic features such as doors or tables. In the 1960s Sutherland's handling became much looser than it had been previously. The forms of the predatory *Mantis* spread out across the canvas and seem to envelop the spectator. Painted thickly in dull reds and greens against a black background, with stabilizing verticals of red and white on each side, the handling is expressive of the age, related in style to, though, as Sutherland says, in no way influenced by, the abstract expressionism of the New York school. In some paintings of this period, such as *Night Landscape*, the use of paint is almost explosive in character.

118. HENRI MATISSE: *Le Grand Intérieur Rouge*. Canvas; 146 × 97.1 cm (57½ × 38¼ in.). Signed and dated 1948. Musée National d'Art Moderne, Centre National d'Art et de Culture Georges Pompidou, Paris

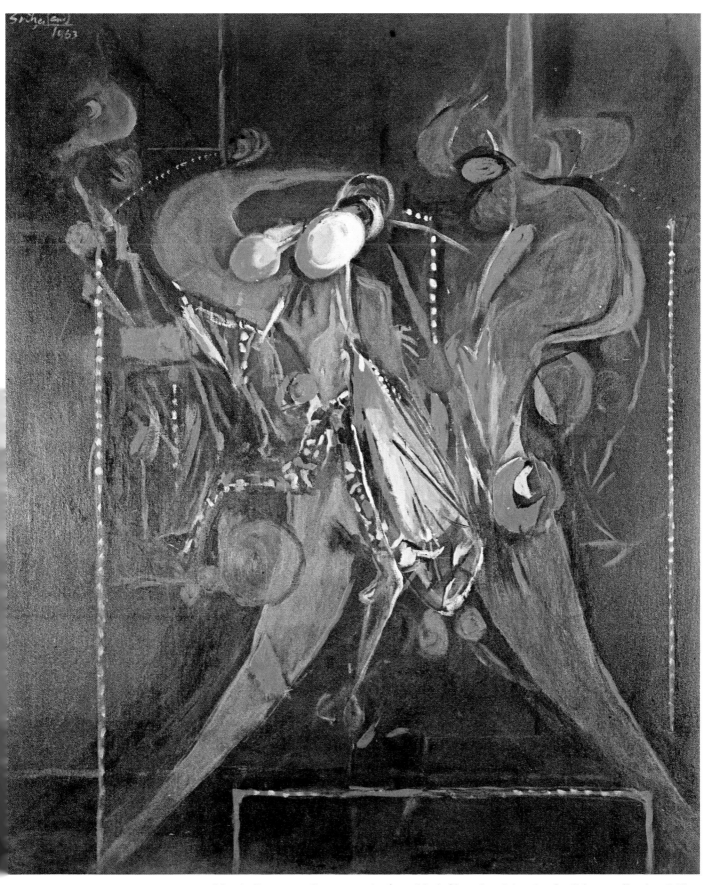

119. *Mantis*. Canvas; 146 × 122 cm (57½ × 48 in.). Signed and dated 1963. Private collection, Milan

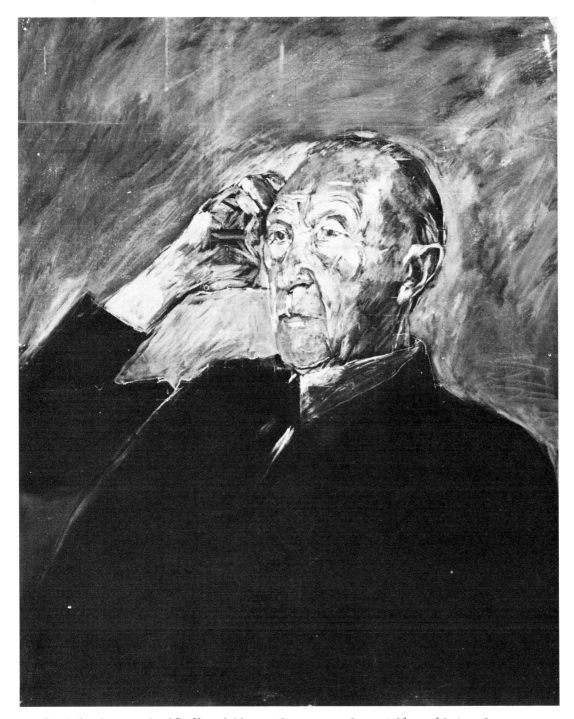

120. Study for the portrait of *Dr Konrad Adenauer*. Canvas; 73 × 60 cm (28¾ × 23⅝ in.). 1963.
Kulturministerium, Baden-Würtemberg (on permanent loan to the Staatsgalerie, Stuttgart)

For his portrait of Dr Adenauer, Sutherland executed a rapid but brilliant oil sketch in front of the
sitter which captures the very essence of the statesman's complex personality: the detachment, the
austerity, the contemplative and visionary and the hard-headed grasp of affairs. In the finished work
the sense of detachment remains, emphasized by the erectness of the pose contained within the tall
verticals of the wicker chair, but the expression is less severe and the left arm limp, and the
contemplative mood is enhanced by the forward tilt of the head, largely achieved by painterly means:
the richness of tones used in the modelling of the domed forehead. Adenauer is reported to have said
that he was glad that Sutherland had painted him 'as a thinking man'.

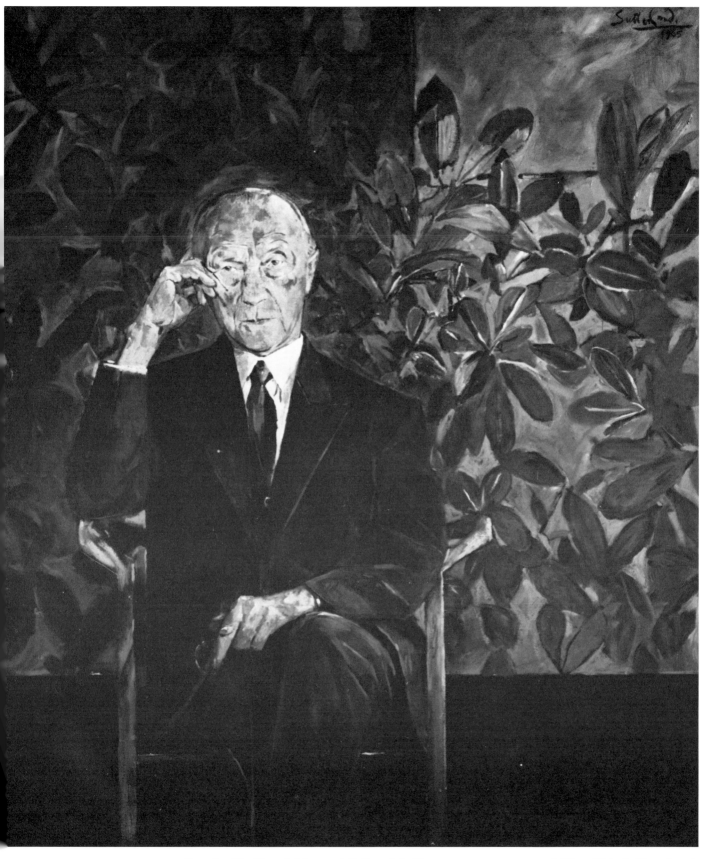

121. *Portrait of Dr Konrad Adenauer* (1876–1967). Canvas; 143.9 × 123.2 cm (56⅝ × 48½ in.). Signed and dated 1965. Mrs Reiners-Adenauer

122. *Path in Wood II*. Canvas; 61 × 50.8 cm (24 × 20 in.). Signed and dated 1958. David Breeden, London

123. *Dark Landscape*. Canvas; 129.9 × 96.8 cm (51⅛ × 38⅛ in.). Signed and dated 25 May 1962. Private collection, Milan

The mass of richly broken, glowing, emerald green in *Path in Wood II* suggests the play of dappled light among the trees, and the spectator is led progressively, by linear means, into sunlit depths, where the white of the canvas is freely used. One of a number of pictures of this period in which Sutherland found himself drawing closer to the 'fragmentary analyses' of Cézanne, this is a lyrical work comparable with *Entrance to Lane* of twenty years earlier (Plate 36). *Dark Landscape* is similar in framework: a pergola leads to some stepping stones beyond which there is a broadly oval opening into the forest. But this forest is not welcoming. It exudes something of that 'impenetrable damp green gloom' which Sutherland had discovered in certain parts of Pembrokeshire, and this effect is enhanced by the tangled wildness of the brushwork. The scene was Sutherland's garden at Menton.

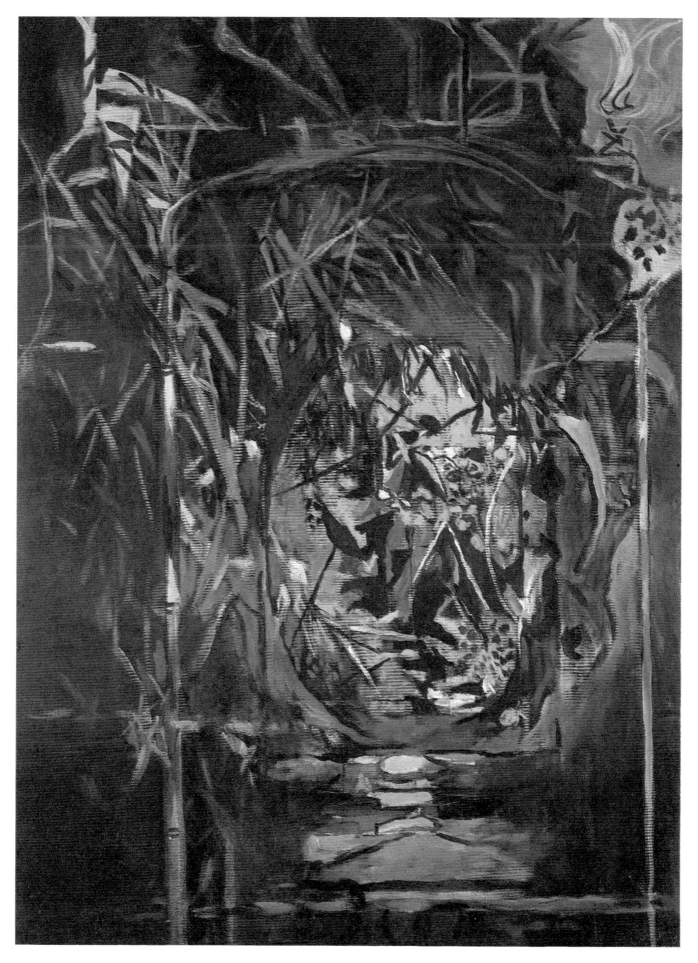

124. *The Scales*. Canvas; 127.1 × 101.6 cm (50 × 40 in.). Signed and dated 20 June 1959. Private collection, California

This version of *The Fountain* is the most glowing of several similar pictures of fountains that Sutherland painted in the mid-1960s. Although the design is conceived in terms of two shallow but interrelated planes, the bright glow from the sun permeates the entire canvas, and the use of varied tones of blue in the fountain itself gives weight to the form. The curtain of dark leaves, a decorative transmutation of the wild effects in *Dark Landscape* (Plate 123), is similar in arrangement to the background in the portrait of Dr Adenauer (Plate 121), which was intended as a reference to the sitter's love of gardens. The boldness of handling as well as of composition typical of this period should be contrasted with his preoccupations of the late 1950s. In *The Scales* the space is equally shallow, and the subject similarly aligned with the picture plane, but the play of tonal relationships is of the subtlest and the design is based on the penetration of sunlight into areas of deep shadow. It is characteristic of Sutherland's approach to painting that both subjects were suggested by actual objects, in one case some rusting old scales which he found and placed in sunlight outside a window of his house, in the other the village fountain of Castellar, above Menton (at the summit of a road of alarming hairpin bends on which he himself lived), typical of many such fountains in the district.

125. *The Fountain*. Canvas; 145 × 121.9 cm (57⅛ × 48 in.). Signed and dated 21 May 1965. David Breeden, London

126. *The Captive*. Canvas; 139.5 × 122 cm (55 × 48 in.). Signed and dated August 1963 – January 1964. Neue Pinakothek, Munich

127. FRANCIS BACON: *Three Studies for Figures at the Base of a Crucifixion* (centre panel). Canvas; 94 × 73.7 cm (37 × 29 in.). 1944. Tate Gallery, London

The Captive provides an especially interesting insight into Sutherland's processes of mind. The idea, originating with the stone lions that he encountered in Venice, was inspired by Goya's drawings of prisoners; but the image itself was suggested by a shape at the side of a lane in Kent which reminded Sutherland of a rhinoceros. Inevitably, however, not least in the handling of paint, it calls to mind the tortured images which obsess Bacon's imagination. But the differences are as important as the similarities are striking. Whereas in Bacon's work there is so often an insistence on the demands made by the functions of the body, the flesh which he revels in painting almost dissolves in front of one's eyes, and the degradation of man is absolute, in the Sutherland there is a tension, an alertness, a defiance which suggests at least the possibility of a conquest of the flesh by the spirit. It is 'the precarious balanced moment' of which Sutherland has often spoken. 'People have said that my most typical images express a dark and pessimistic outlook. That is outside my feeling.'

154

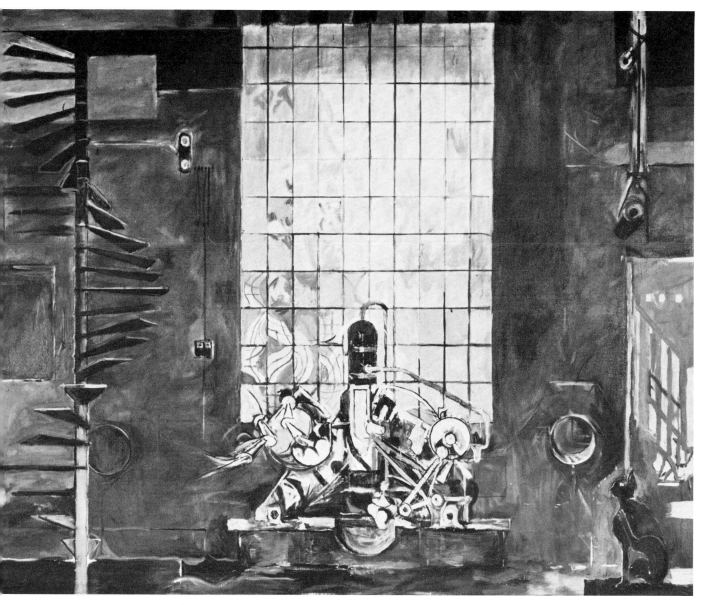

128. *Large Interior*. Canvas; 260.2 × 290.1 cm (102⅜ × 114⅛ in.). 1965. Private collection, Switzerland

Sutherland painted two versions of this subject, both huge canvases because they were suggested by a large space, a disused boathouse in the garden of the Hotel Cipriani, on the Giudecca in Venice, which (until the present swimming pool was built) was placed at his disposal as a studio during his annual summer visits (Sutherland worked in Venice 1954–66). The immense window and the spiral staircase were features of the building and, because machinery had previously been kept there, Sutherland made machine forms, as closely enmeshed as his organically inspired shapes, the 'subjects' of his pictures. The old equipment of the disused laundry at the hotel, which had inspired these forms, was also the source for the 'correspondences' in his *Bestiary*.

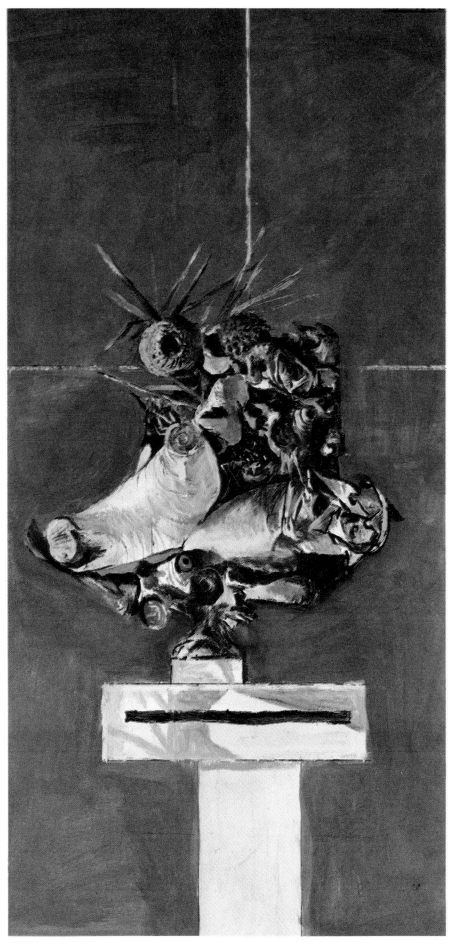

129. *Poised Form*. Paper; 104.2 × 51.4 cm
(41 × 20¼ in.). Signed and dated 1953.
Ownership unknown

130. *Machine on Black Ground*. Canvas;
142.8 × 122.6 cm (56¼ × 48¼ in.). Signed and
dated 1962 on the reverse. Private collection,
New York

Sutherland's tautly suspended machine form
of 1962 is already activated, like the
machinery in his *Large Interiors* (Plate 128).
Darting tongues of bright colour, beginning
to take the shape of the undulating forms of a
decade later, reach out into space, and the
impression of motion is heightened by the
sketchy brushstrokes beneath, which
challenge the equilibrium. By contrast his
Poised Form of 1953, composed of densely
packed root forms, has a restraint, dignity
and balance which link it with the period of
his concentration on the implications of the
subject proposed for the tapestry at
Coventry, a type of subject, as Sutherland
has said, so much more difficult to portray
than the violence of a Crucifixion.

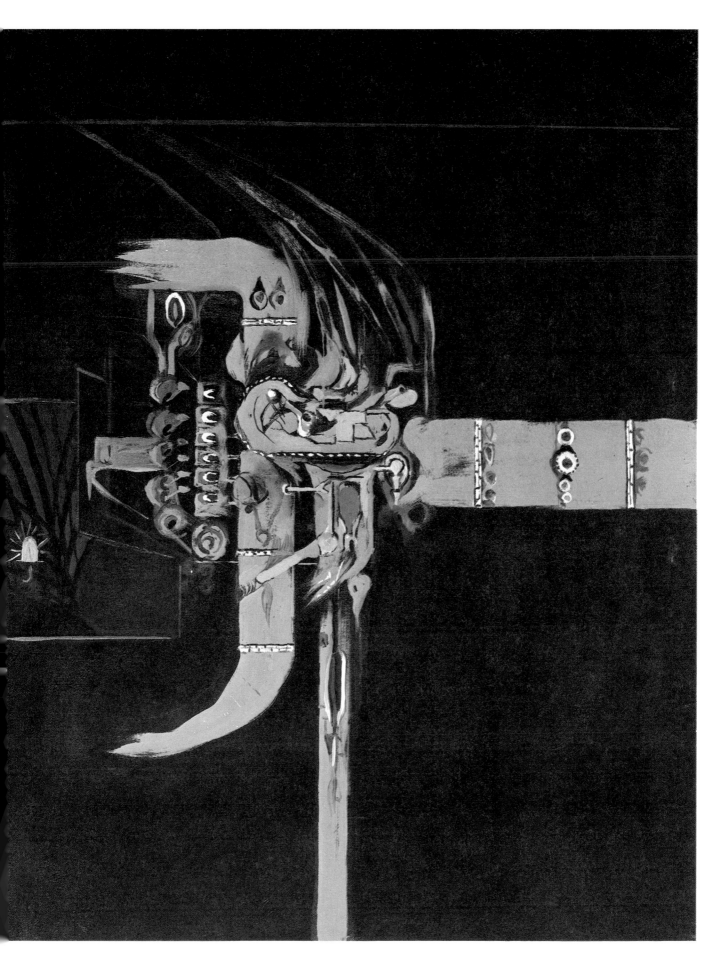

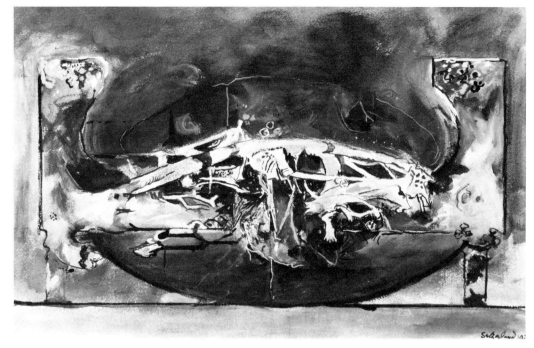

131. *Form in an Estuary*. Pen and ink, oil and gouache; 18.5 × 29.5 cm (7¼ × 11⅝ in.). Signed and dated 1970. Private collection, London

132. Photograph of a wrecked boat on the shore, Pembrokeshire (Giorgio Soavi)

In 1967 Sutherland went back to Wales for the first time in over twenty years: from then on he returned there every year, and most of his subsequent imagery derived from the studies he made in Pembrokeshire. His gouache sketch of a boat form is a paraphrase of a wreck he had found on the beach, and the proud bow of this wreck became the framework – repeated on both sides of a design to make a U-shape not unlike that of his *Fountains* (Plate 125) – for a number of paintings of this period. The large-scale *Poised Form in a Landscape* (Plate 133), based on the complex interlocking forms of a gnarled oak tree he loved drawing, a subject which, with variations, he painted more than once, seems to possess something of the power and rhythm of an engine in motion.

133. *Poised Form in a Landscape.* Canvas; 116.9 × 170 cm (46 × 66⅞ in.). Signed and dated 3 August 1969. Private collection, Milan

134. Photograph of a gnarled oak tree, Pembrokeshire (Giorgio Soavi)

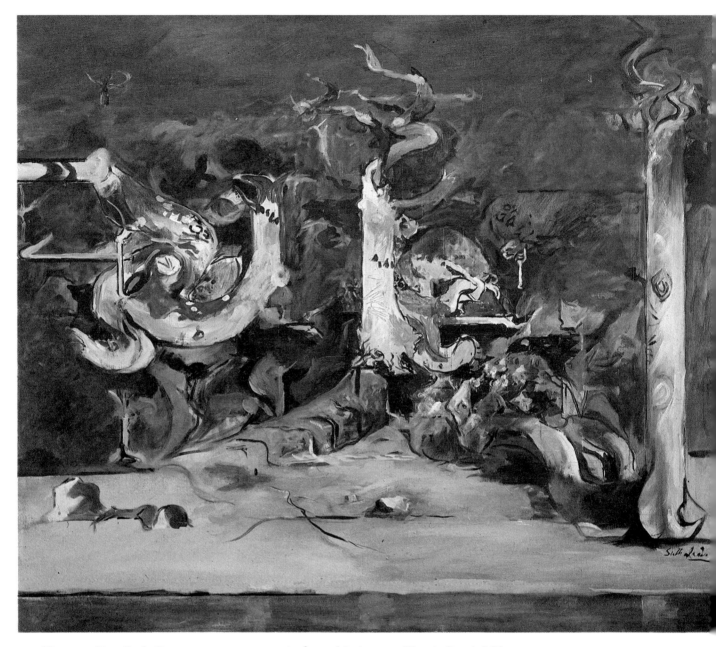

135. *Trees on a River Bank*. Canvas; 94.9 × 109.9 cm (37⅜ × 43¼ in.). 1971. Giorgio Soavi, Milan

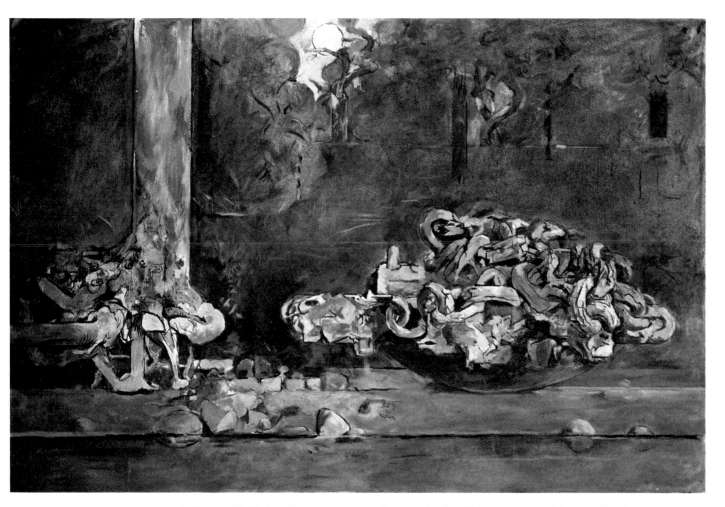

136. *Forest with Chains*. Canvas; 112.1 × 167.7 cm (44⅛ × 66 in.). 1971–2. Private collection

Sutherland found that, psychologically, he became more and more concerned with symmetry and control as he got older. But he remained a 'romantic' as well as a 'classical' artist, and these two canvases of broadly similar subjects sum up the diversity of his approach to the problems of composition in his work of the last ten years. The first picture is rhythmic and full of motion, the forms correspondingly undefined, the technique loose. The second, based on a watercolour sketch later published in *Graham Sutherland Sketchbook*, in which the 'chain' forms are complex and three-dimensional but well defined and integrated into an overall shape as controlled as a conglomerate (see Plate 137), is firm in structure and clear in spatial development. 'The hunk of chains which I came across [on the beach near Benton Castle: they were quite small] was of interest for me as a formal mass of coalescing shapes interwoven and cemented together by time and damp.' A simplified version of this canvas was painted for the Gallery at Picton. See also p. 40.

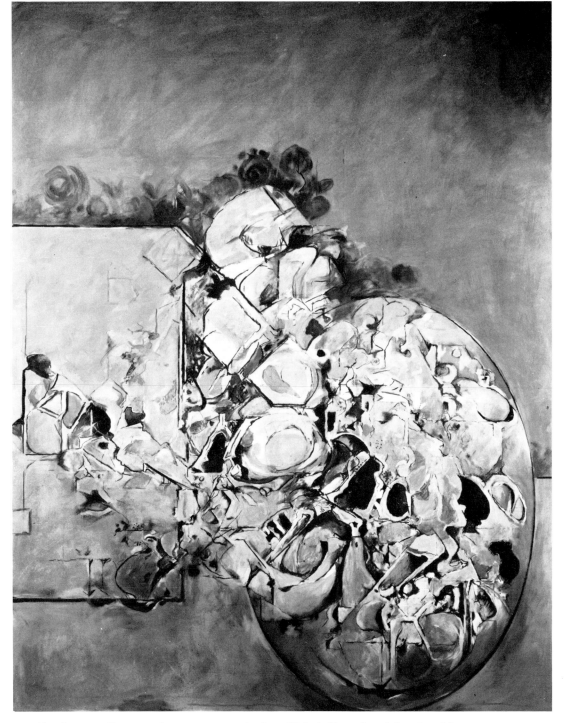

137. *Conglomerate*. Canvas; 181.7 × 143.4 cm (71½ × 56½ in.). Signed and dated 11 May 1970.
Ownership unknown

One of the best teachers at Goldsmiths' taught Sutherland as a student that the ideal to strive for in
a composition is the maximum variety which does not disrupt unity. This is a lesson which he
always remembered. 'Bach is my favourite musician . . . I am conscious that to such great tight knit
architecture I owe more than I can ever realise.' Nowhere did Sutherland test this theory more fully
than in his *Conglomerates*, pictures inspired by the intricate forms and varied colour of a large rock face
he had discovered lying on the ground. The contours bounding these complex forms, oval in some
pictures, circular in others, suggest the outline of the rock face. See also p. 40.

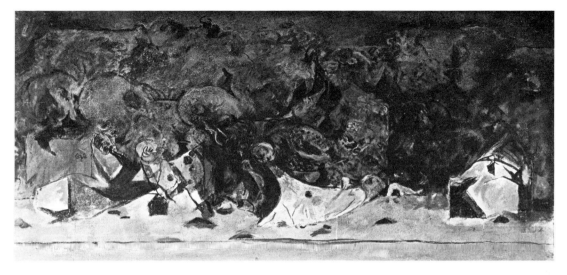

138. *Estuary*. Canvas; 80 × 172.8 cm (31½ × 68 in.). 1969. Private collection, Milan

This rhythmical composition was derived from a scene along the estuary of Milford Haven, with its reddish rocks and sand and dense woodland behind. Comparison should be made with Sutherland's similar compositions of the early 1950s, based on the rocks and stones he had found at Tourettes-sur-Loup, where the forms are not enveloped in movement but retain a separate existence.

139. Photograph of banks along the Milford Haven estuary (Giorgio Soavi)

140. *Landscape with Stones and Grasses*. Canvas; 47.6 × 92.1 cm (18¾ × 36¼ in.). 1953. Myron O'Higgins, New York

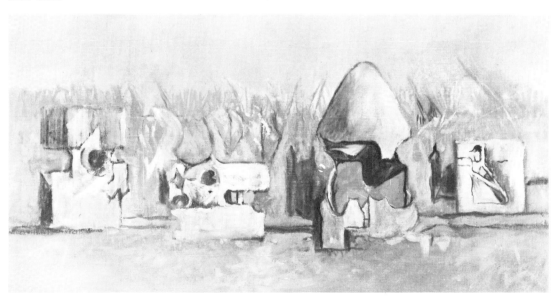

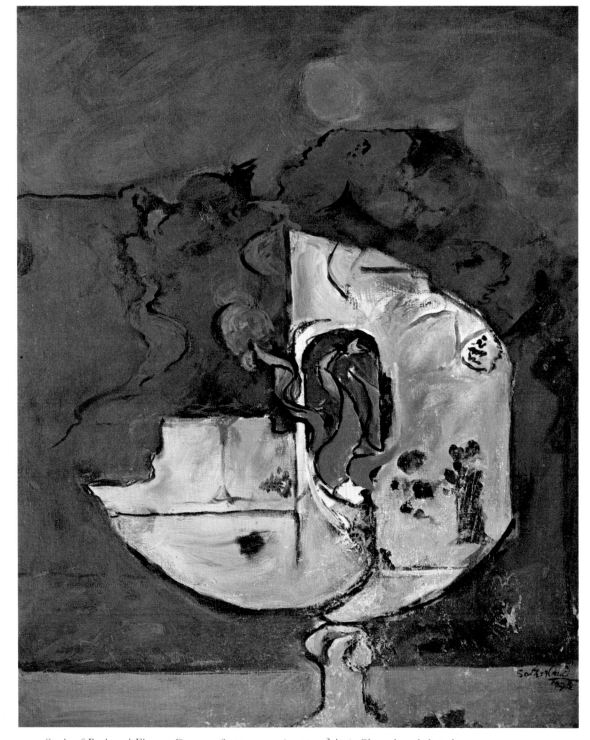

141. *Study of Rock and Flames*. Canvas; 61 × 50 cm (24 × 19¾ in.). Signed and dated 1975.
Private collection, Turin

In this picture Sutherland has created a monstrance out of rock forms he had sketched at Sandy
Haven. The motif of flames darting out of the centre of this construction harks back to his studies of
the steel furnaces of Swansea in 1942 (Plate 56). The design, with the deep greens of the landscape
licked by flames, is more elaborate than that of the version at Picton, also painted in 1975.

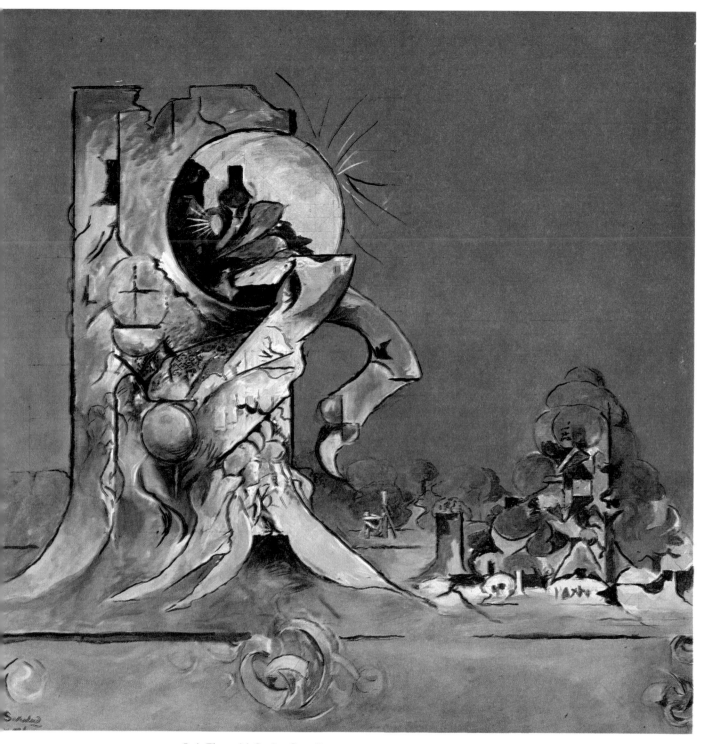

142. *Oak Tree with Setting Sun*. Canvas; 134 × 135 cm. (52 × 53 in.). Signed and dated 8 September 1976. Private collection, Turin

The oak tree which is the subject of this picture Sutherland has transformed into an image in which the sun is seen in the interstices of the branches, glistening like a jewel. The tree, though enlivened with touches of green, is conceived as a flattened form, the sky is a pinkish red, and the canvas is thinly and smoothly painted, elements which contribute to produce an effect of rich and decorative pattern. This treatment may be contrasted with that of the similar tree form in *Blasted Oak* of 1941 (Plate 42).

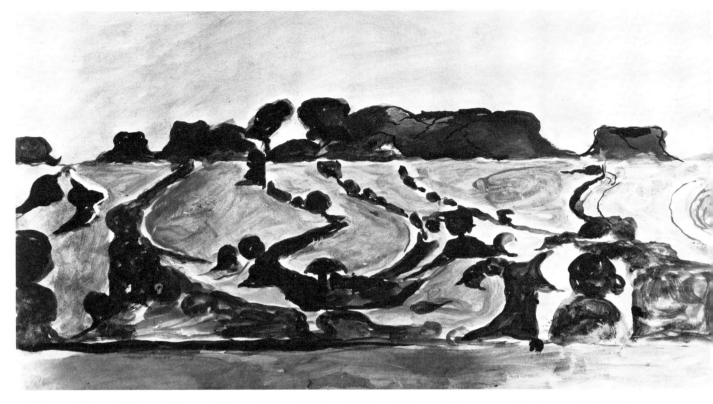

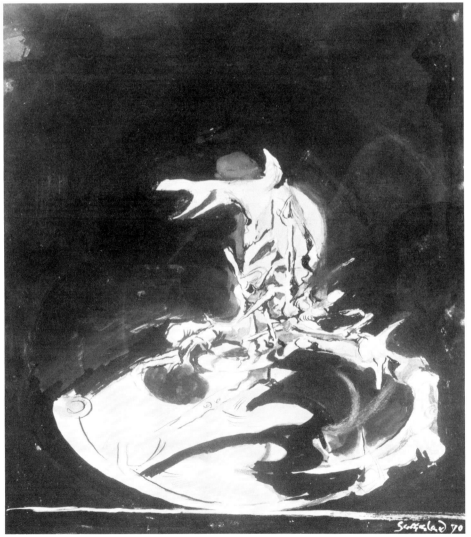

143. *Landscape with Fields I.*
Watercolour and gouache; 36.8×68.9
cm ($14\frac{1}{2} \times 27\frac{1}{8}$ in.). Signed and dated
1974. Private collection, Milan

144. *Formes d'Epines.* Pencil, pen and
ink and gouache; 34.9×30.8 cm
($13\frac{1}{4} \times 12\frac{1}{8}$ in.). Signed and dated
1970. Ownership unknown

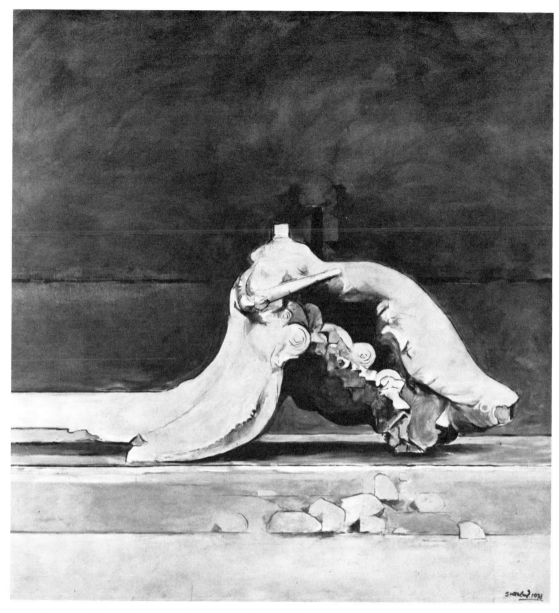

145. *Undulating Form*. Canvas; 178 × 172 cm (70 × 67¾ in.). Signed and dated 1973. Private collection, Milan

Two sketches, and an important finished canvas for which Sutherland had a particular regard, that demonstrate the artist's preoccupation with a sense of movement in his later work. In *Landscape with Fields I* the low walls of black stone seem to ripple through the fields of waving corn, while *Formes d'Epines* is a vigorous study of thorn forms which, in composition, recalls the rotating motion of *Midsummer Landscape* (Plate 38) of thirty years earlier. The tonality of *Formes d'Epines*, yellow in the lights, dark brown in the shadows and background, anticipates the colour scheme for the aquatints of *Bees*. *Undulating Form* is a large, finely balanced composition in which the motion is much gentler. The forms, painted in subtly modulated tones of yellow, are poised against a brownish background enlivened with tints of black, and contained by stabilizing verticals (not visible in the reproduction).

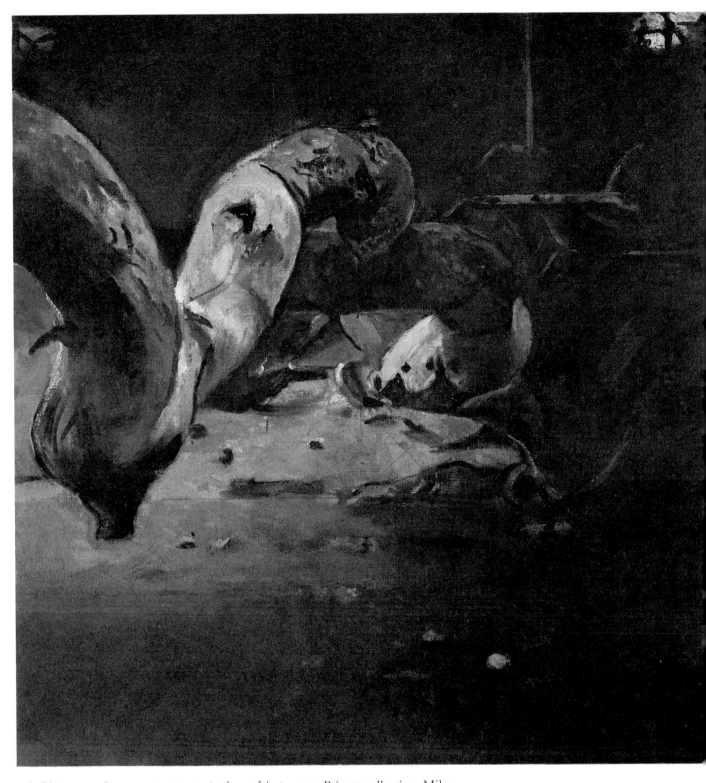

146. *Picton 1972*. Canvas; 52 × 50 cm (20¼ × 19⅝ in.). 1972. Private collection, Milan

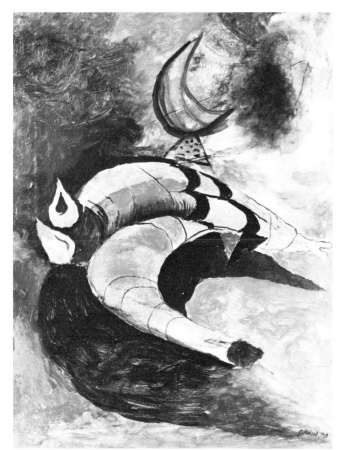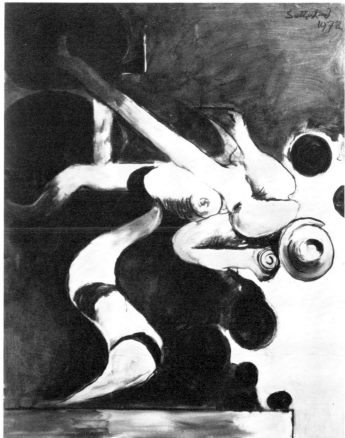

147. *Fallen Tree Against Sunset*. Canvas; 67.3 × 50.8 cm (26½ × 20 in.). Signed and dated 1940. Darlington Art Gallery

148. *Thrusting Form II*. Canvas; 100.3 × 81 cm (39½ × 31⅞ in.). Signed and dated 1972. Ownership unknown

The rhythmical, convergent shapes of Sutherland's *Thrusting Form*, an image which suggested to him the movements of a diver and prompted his etching and aquatint with that title published the following year, recall his well-known *Fallen Tree Against Sunset* painted over thirty years before. The differences between the style of 1940 and the style of 1972 are instructive. The forms in the early work have a weight and sense of inner strength which place them in the category of such 'presences' as *Green Tree Form* (Plate 39), and they are set against richly worked reddish-black shadows and a similarly treated sky clearly romantic in feeling. In the more recent picture Sutherland had quite different intentions: the handling is mellifluous, and the looser, less substantial tree and root forms have been energized into flowing rhythms which interlock in a more complex, perhaps more cerebral, invention. *Picton 1972* is perhaps the most subtle and deeply satisfying of Sutherland's rhythmical compositions of this period. In this evening scene the tree forms derived, as so often, from his favourite oak (Plate 134), beautifully placed in the canvas, are gently lit and occupy a shallow space, but they seem to spring out against the greys modulating from beach to background, a stifling gloom only relieved by an opening in the branches at the top of the canvas.

149. *Beetles I*. Pen and ink and watercolour; 56.5 × 76.2 cm (22¼ × 30 in.). Dated 14 March 1965. Ownership unknown

150. *The Caterpillar*. Colour aquatint; 37 × 28.5 cm (14⅝ × 11¼ in.). Published as No. 8 in *Apollinaire: Le Bestiaire ou Cortège d'Orphée*, 1979

Insects and animals inspired some of Sutherland's finest work in the last fifteen years of his life. In 1968 he completed a *Bestiary* composed of twenty-six colour lithographs, in 1977 he published fourteen colour aquatints of *Bees*, and in 1979 a further *Bestiary*, comprising seventeen colour aquatints, based on poems by Apollinaire. All three series demonstrate the extraordinary fertility which Sutherland continued to display in his invention when confronted with the mysteries of organic life. His crisp drawing of beetles is an example of his remarkable ability, the fruit of a lifetime of observation, to suggest the natural characteristics of the subjects he was portraying. In addition to these qualities, the aquatints display to the full those beautiful effects of resonant colour and delicate transparency which it is possible to achieve in the medium as it has been developed by Eleonora and Valter Rossi, who supervised the printing of the *Bees* and with whom Sutherland etched the Apollinaire plates. See also p. 38.

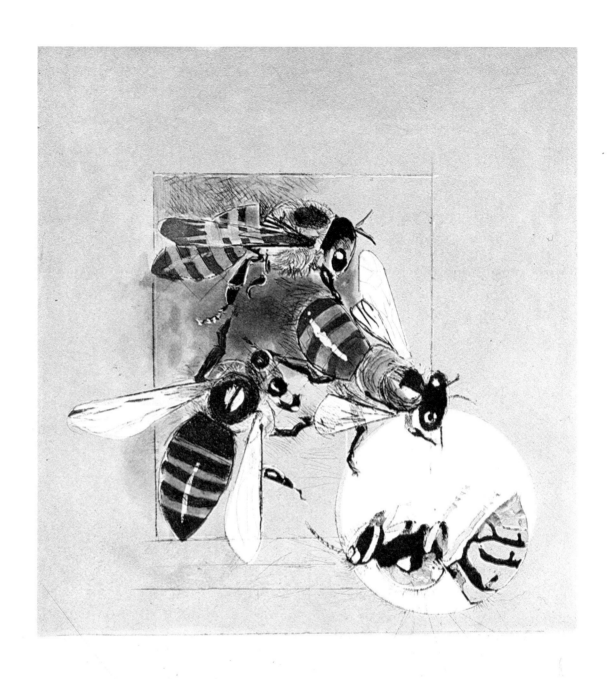

151. *Expulsion and Killing of an Enemy*. Colour aquatint; 40 × 31.5 cm (15¼ × 12⅜ in.). 1976. Published as No. 13 in *Bees*, 1977

152. Final Study for the *Portrait of Arpad Plesch* (1890–1974). Canvas; 67.3 × 65.1 cm (26½ × 25⅝ in.). Signed and dated 13 December 1961 – 20 March 1962. Madame Arpad Plesch

There are elements in many of Sutherland's portraits which can be linked with the European tradition. The pose of Arpad Plesch is reminiscent of a number of literary, theatrical and musical portraits by Reynolds and Gainsborough, while the introduction of the slim red volume, symbolic of the sitter's passion for collecting rare books, is a device familiar from the time of the Renaissance; the portrait of Lord Goodman irresistibly calls to mind the magnificent Ingres of Monsieur Bertin. But to say this is to say the obvious, that the range of compositional options open to a portrait artist is not great; and the comparisons confirm rather than deny Sutherland's originality, for his artistic solutions derive solely from his confrontation with the personality and physical presence of each individual sitter, and are infinitely subtle, as a study of his preparatory sketches shows. Plesch's powerful personality is underlined by the firm horizontal of the left arm on the library steps and by the strength of his hands, upon which Sutherland has laid particular stress. In the case of Lord Goodman, whereas Ingres has emphasized the bulk of his sitter's frame by means of the contour of the chair back, Sutherland has done so by the choice of a square format, the disposition low on the canvas, the three-quarter view, and the gigantic sleeve, tapering along the forearm, stabilizing his design with a system of verticals and horizontals in which even the flap of the pocket plays a vital part.

153. *Portrait of Lord Goodman* (born 1913). Canvas; 95.9 × 95.9 cm (37¾ × 37¾ in.). 1973. Tate Gallery, London

154. J.-A. D. INGRES: *Portrait of Louis-François Bertin*. Canvas; 116.2 × 94.9 cm (45¾ × 37⅜ in.). Signed and dated 1832. Musée du Louvre, Paris

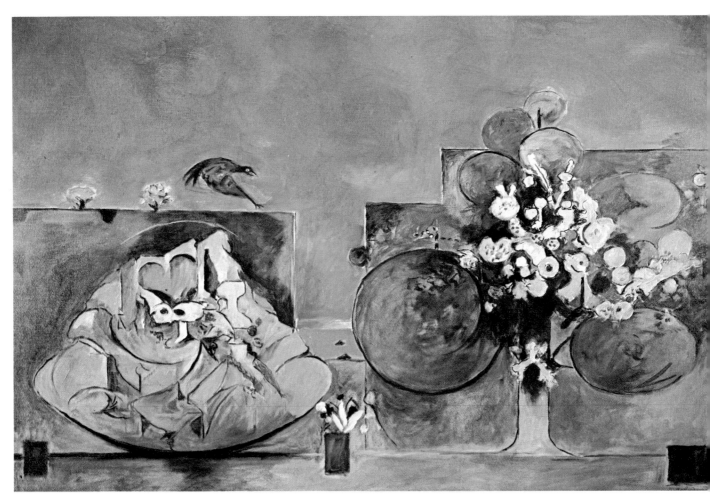

155. *La Primavera*. Canvas; 112 × 168.5 cm (44⅛ × 66⅜ in.). Signed and dated 1975. Private collection, Turin

La Primavera is an asymmetrical but carefully balanced design in clearly defined planes, far less complex than the *Conglomerates*. In this harmony of greens and whites Sutherland has fused two subjects, a rock of which he had made studies, and a hawthorn tree in full bloom he had seen near Sandy Haven (the bird depicted he actually saw on this occasion). The gap in the wall, with the sea beyond, was suggested by an old gateway in a stone wall, and the lowering sky, softly painted and beautifully modulated, is indicative of spring rain. The composition is almost identical with the version at Picton, painted in the previous year. Sutherland called it 'one of my less complicated pictures', because of the lack of distortion.

156. *Road at Porthclais with Setting Sun*. Gouache on masonite; 37 × 36.7 cm (14½ × 14 in.). 1979. Private collection, Turin

In some of his later Welsh pictures Sutherland reverted to themes which had absorbed him in the 1930s. This scene with a winding road was a subject he had sketched in 1935 (Plate 8). The reds, pinks and yellows stand out boldly against the deeper tones in the middle distance, and both the tonality and the sweep of the road can be compared with *Mountain Road with Boulder* (Plate 40), though, perhaps unexpectedly, the scene is less distorted for pictorial ends than an earlier picture of the same scene, *Welsh Landscape with Roads* of 1936 (Plate 17). The design was a favourite with Sutherland, and he repeated it, usually with variations, quite often during the 1970s. An oil dated 1975 is at Picton. This gouache, one of his most beautiful renderings of the subject, was also one of the last works he painted. Perhaps this was fitting, for the picture is dominated by the sun, and Sutherland adored the sun as he adored the spring.

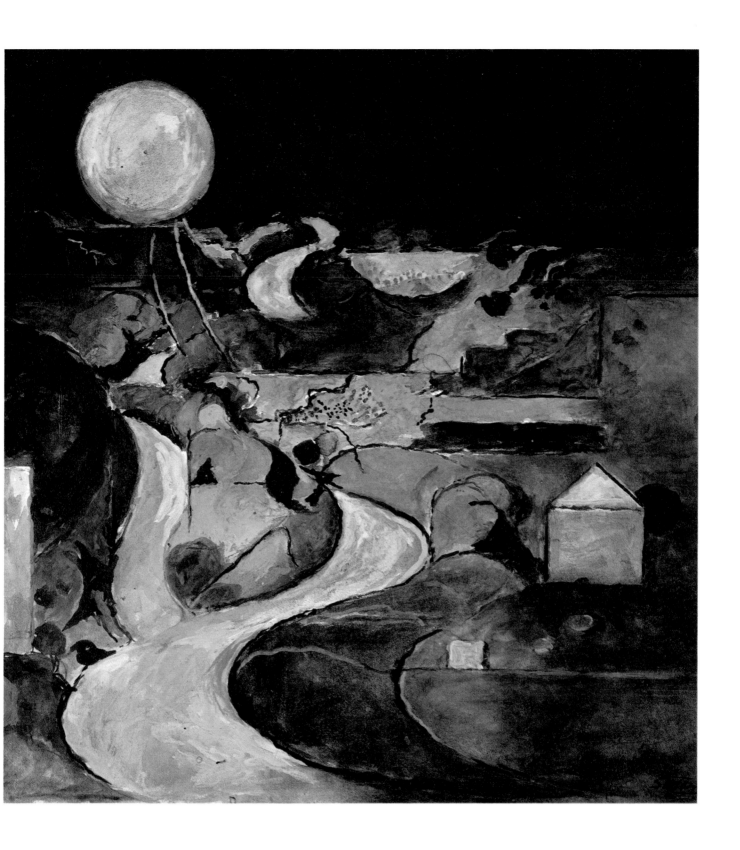

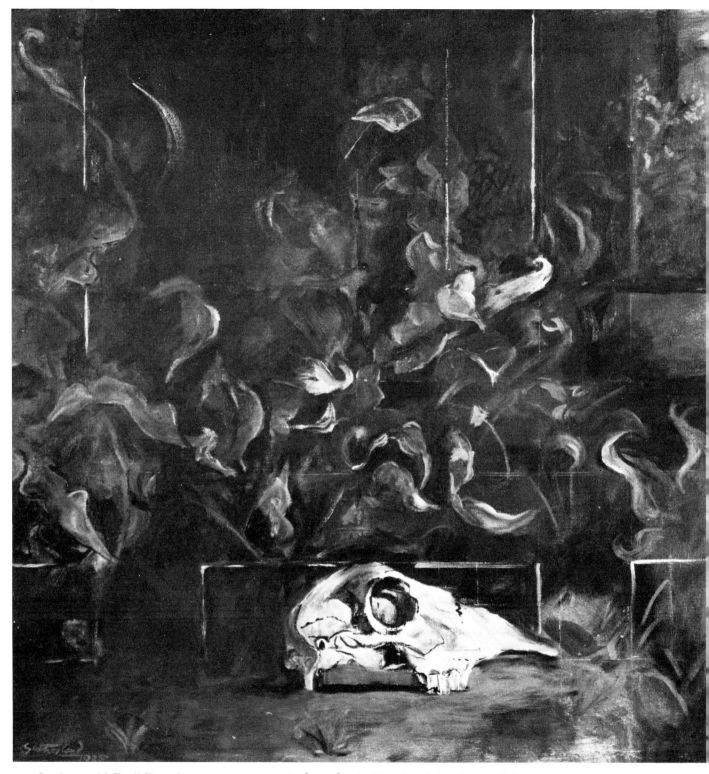

157. *Landscape with Fossil Form.* Canvas; 100 × 95 cm (39⅜ × 37⅜ in.). Signed and dated 1975. Private collection, Turin

In this picture the loosely painted foliage which seems to float against the grey-black background serves as a decorative foil for the strongly lit 'presence' on the shore.

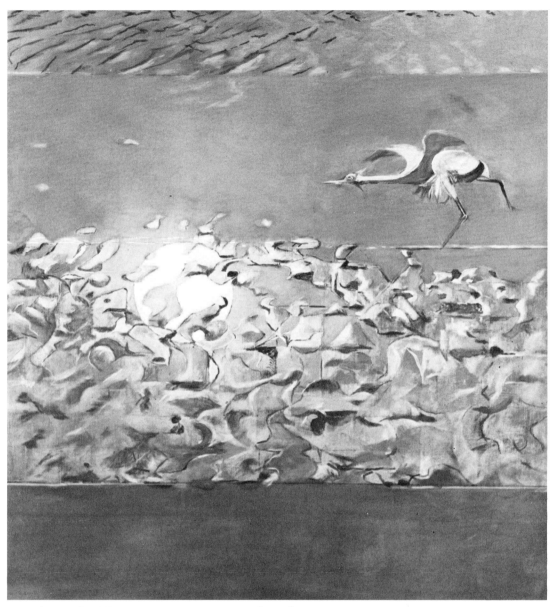

158. *Bird and Sand II*. Canvas; 140 × 135 cm (55⅛ × 53⅛ in.). Signed and dated 1977. Private collection, Turin

This design is a more sophisticated restatement of a theme Sutherland had first explored two or three years earlier in several canvases, one of which he executed for Picton. The genesis of the idea was the estuary of Milford Haven at low tide: rippling sand is seen at the top of the picture, and sand filled with black pebbles lower down. The two swans, which compose a complete circle of white shapes and stand out in a halo of reflected light, were derived from swans Sutherland had watched floating down the estuary when the tide came in. The work is beautifully balanced and softly painted, the canvas barely stained with colour. The grey tonality reflects the exact appearance of the estuary after the sun has gone in. 'The whole business of colour is a matter of mood and with me has been and is an emotional thing. If I have felt in recent years in some work that I prefer to work almost monochromatically, this is because the particular problem presented demands such treatment.'

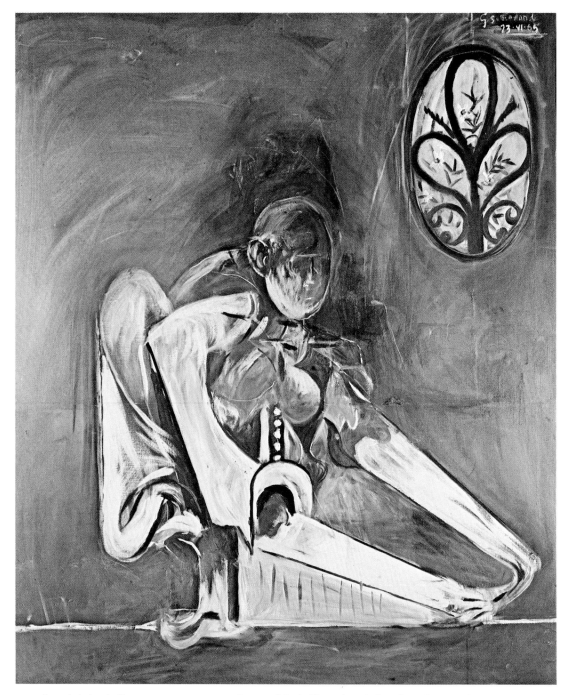

159. *Seated Animal.* Canvas; 145 × 122 cm (57 × 48 in.). Signed and dated 23 June 1965. Private collection, Milan

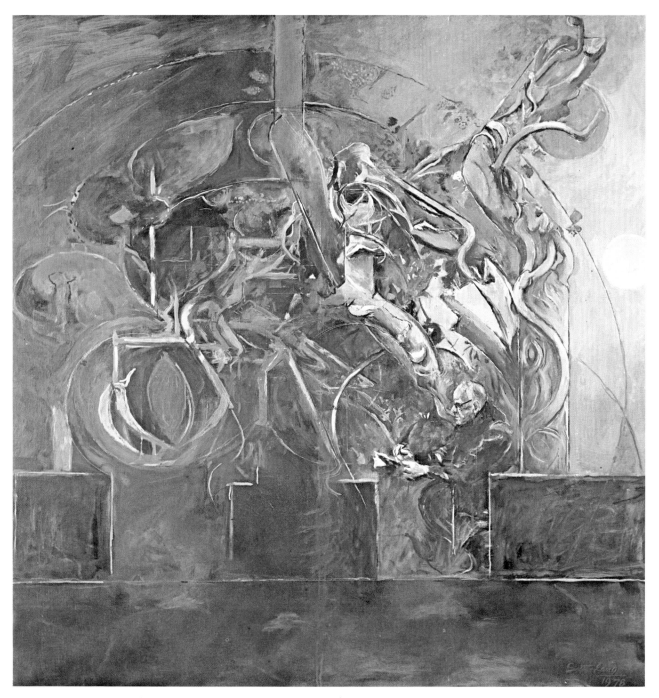

160. *The Thicket*. Canvas; 100 × 100 cm (39⅜ × 39⅜ in.). Signed and dated 1978. Private collection, Turin

Two of Sutherland's most moving pictures, images of darkness, concerned with the inescapability of *'la condition humaine'*. Painted at a time when he was especially preoccupied with correspondences between human, animal and mechanical forms, the sweeping brushwork modelling the forearms into elongated shapes reminiscent of some such implement as a chain-saw in the disturbing *Seated Animal* gives point to the air of deep concentration; the head, which is seen in mysterious shadow, was intended to represent himself. *The Thicket*, dark in tone, the sun blanched, is a tangle of fantastic and contorted shapes which, though based on an avenue of trees in Wales, is suggestive of the age-old fears of the forest and the ultimate mystery of nature. Sutherland's introduction of a portrait of himself sketching is an indication that the picture is imbued with private symbolism; he appears like a monk, dressed in a dark habit, but hunched and careworn, the colour drained from his face. In such a work as this there seems some justification for discovering that mood of pessimism which, in earlier years, he had disclaimed as 'outside my feeling'.

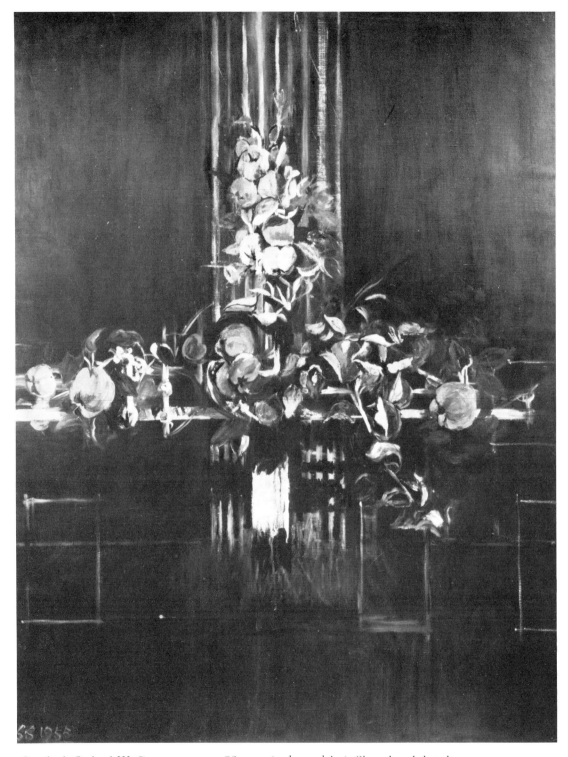

161. *Apple Orchard III*. Canvas; 112.1 × 86.7 cm (44⅛ × 34⅛ in.). Signed and dated 1955.
Private collection, England

Apple Orchard III was painted in Kent in 1955. 'The weather was particularly good & I became
interested in the swathes of fruit.' In contrast to this lyrical and balanced design, contortion and
dissonance are the keynote of his *Landscape with Indians*, painted in 1977, for which this is the large and
roughly painted sketch. For some time Sutherland had wanted to paint a landscape with figures. The
idea for this picture was suggested by a group of Indians in turbans who appeared one day in the

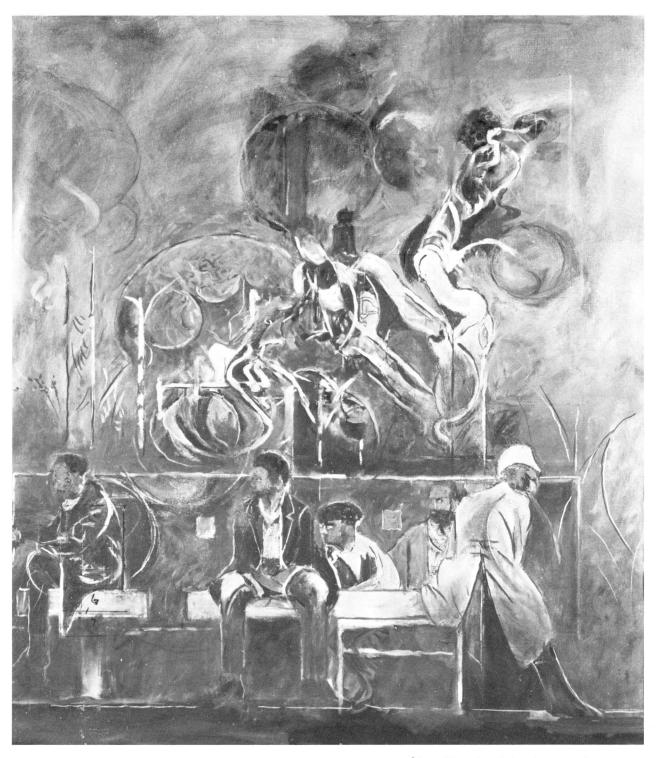

162. *Landscape with Indians*. Canvas; 109 × 100 cm (43 × 39⅜ in.). Signed and dated 1977. Private collection, Turin

estuary at Milford Haven; the innocent wanderers have been transformed into bandits, and the figure on the left is seen holding a shotgun while the figure on the right looks furtively over his shoulder. The scarlet shirts worn by two of the men provide enlivening colour. The background was derived from the same narrow path with overhanging boughs employed in *The Thicket* (Plate 160).

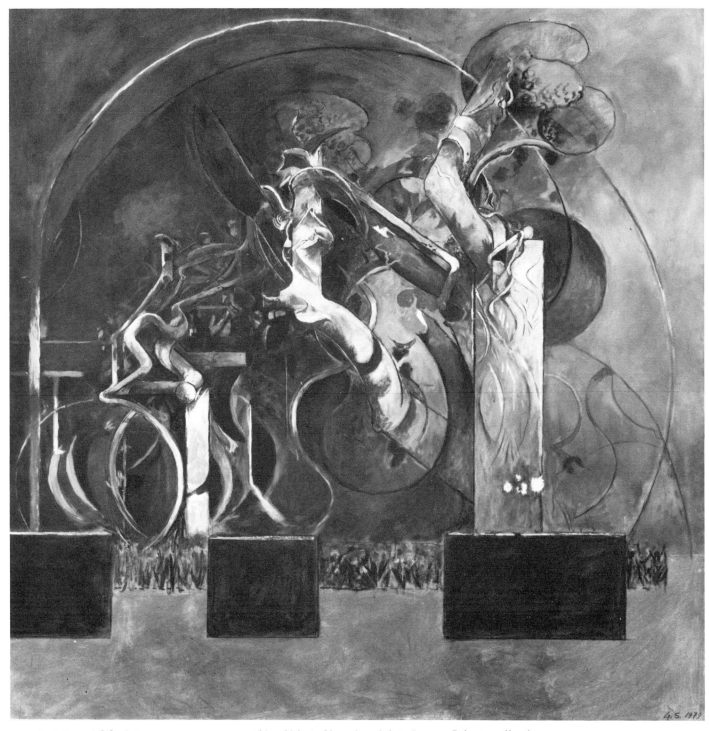

163. *Path through Wood*. Canvas; 173 × 173 cm (68 × 68 in.). Signed and dated 1979. Private collection, Turin

Path through Wood, a composition developed from *The Thicket* (Plate 160), is a mass of twisted and menacing forms emerging from darkness, contained within a framework of large concentric circles. The variety of greens which fill the canvas are relieved, as in so many of Sutherland's canvases, by areas of violet. As in *The Thicket*, there is little or no suggestion of depth or openness beyond, and the feeling is one of engulfment by mysterious, over-life-size shapes, predominant amongst which is a massive, thrusting tree form. Finished in April 1979, it was the last major canvas Sutherland painted.

BIOGRAPHICAL OUTLINE

1903 Born in London on 24 August, the son of a lawyer, later a civil servant

1912–14 Went to a preparatory school at Sutton

1913 First holiday in Dorset

1914–18 At school at Epsom College

1919–20 Apprentice at the Midland Railway Works at Derby

1921–6 Studied at Goldsmiths' College School of Art, University of London

1924–8 Shared lodgings at Blackheath with Milner Gray

1925 Finalist in engraving for the Prix de Rome
 Elected an Associate of the Royal Society of Painter-Etchers and Engravers
 First one-man exhibition of drawings and engravings, at the XXI Gallery

1926 Converted to Roman Catholicism

1927 Married Kathleen Barry on 29 December

1928 Went to live at Farningham, in Kent, subsequently moving to Eynsford (1930) and Sutton-at-Hone (1934)
 Second one-man exhibition at the XXI Gallery

1928–39 Taught at the Chelsea School of Art (engraving until 1932, then composition and book illustration)

1930 Began to paint, following the decline of the market for etchings and engravings

1934 First visit to Pembrokeshire, which he revisited every summer until the war

1936 Rented The White House at Trottiscliffe, in Kent

1938 First one-man exhibition of paintings, at the Rosenberg and Helft Gallery

1940 Second exhibition of paintings, at the Leicester Galleries

1940–5 Served as an official War Artist

1944 Commissioned by Canon (later Dean) Walter Hussey to paint a *Crucifixion* for St Matthew's Church, Northampton
 First visit to Paris, his base during his assignment to France as a War Artist

1945 Bought The White House at Trottiscliffe

1946 First one-man exhibition in New York, at Curt Valentin's Buchholz Gallery

1946–7 Taught painting at Goldsmiths' College

1947 First visit to the South of France; began to work there for several months every year
 First met Picasso and Matisse

1949 First portrait commission, from Somerset Maugham
 Appointed a Trustee of the Tate Gallery

1950	Commissioned to paint *The Origins of the Land* for the Festival of Britain
1952	Commissioned, on the instance of Sir Basil Spence, to design the great tapestry for the new Coventry Cathedral
	Retrospective exhibition in the British Pavilion at the Venice Biennale (an enlarged version was subsequently shown at the Musée National d'Art Moderne, Paris)
1953	Retrospective exhibitions in Amsterdam and Zürich, and at the Tate Gallery
1954	Resigned his Trusteeship of the Tate Gallery
	Painted the portrait of Sir Winston Churchill
1954–5	Retrospective exhibition circulated in Austria and Germany
1955	Bought La Villa Blanche at Menton
1960	Awarded the Order of Merit
1962	Consecration of the new Coventry Cathedral
	Received Honorary Degree of Doctor of Literature in the University of Oxford
1965	Retrospective exhibition at the Galleria Civica d'Arte Moderna, Turin
1966	Retrospective exhibition at the Kunsthalle, Basel
1967	Retrospective exhibition circulated in Germany and Holland
	Revisited Pembrokeshire, where he returned every year until his death
1968	Completion and publication of *The Bestiary*
1972	Elected Honorary Fellow of the American Academy of Arts and Letters
1973	Appointed Commandeur des Arts et des Lettres, France, and Honorary Fellow of the Accademia di San Luca, Rome
1974	Awarded the Shakespeare Prize, Hamburg (the first artist to be so honoured)
1976	Opening of the Graham Sutherland Gallery at Picton Castle in Pembrokeshire
1977	Retrospective exhibition of portraits at the National Portrait Gallery, London
	Aquatints of *The Bees* exhibited at Marlborough Fine Art, London
1979	Retrospective exhibition of war drawings exhibited at the Palazzo Reale, Milan
	Aquatints *Apollinaire: Le Bestiaire ou Cortège d'Orphée* exhibited at Marlborough Fine Art
1980	Died in London on 17 February

BIBLIOGRAPHICAL NOTE

The primary sources are Sutherland's own statements and writings. Those regarded by the artist as the most important have been gathered together by Roberto Tassi, and published in *Graham Sutherland: Parafrasi della Natura e Altre Corrispondenze*, Parma, 1979. An English translation is planned, but for the time being the reader must be referred to the original places of publication. The following are the principal: Graham Sutherland, 'A Trend in English Draughtsmanship', *Signature*, July 1936, pp. 7–13 (an essay concerned with the approach to their subject-matter characteristic of 'subjective', as opposed to 'objective', artists, and illustrated by reference to Blake (chiefly), Palmer, Turner, Paul Nash and Henry Moore); Graham Sutherland, 'Graven Images: Line Engraving and the Illustrated Book', *Signature*, July 1937, pp. 28–34; *Henry Moore on Sculpture*, ed. Philip James, London, 1966, pp. 76–83 (transcript of part of a radio discussion in 1941 between V.S. (now Sir Victor) Pritchett, Sir Kenneth (now Lord) Clark, Henry Moore and Sutherland, as printed in *The Listener*, 13 November 1941); Graham Sutherland, 'Welsh Sketch Book', *Horizon*, April 1942, pp. 225–35 (reprinted in *Sutherland in Wales*, the Picton Castle Trust and the National Museum of Wales, London, 1976, pp. 11–15) (a deeply felt description of the Pembrokeshire countryside which made him a painter); 'Modern Art Explained by Modern Artists: Part 1', *The Artist*, March 1944, pp. 17–18 (Sutherland in conversation with R. Myerscough-Walker) (not published in Tassi); Letter to H. P. Juda, dated Trottiscliffe, 10 August 1950, printed in Melville (see below); Graham Sutherland, 'Thoughts on Painting', *The Listener*, 6 September 1951, pp. 376–8 (one of the artist's most important statements); statement dated 4 December 1951, printed in Felix H. Man (ed.), *Eight European Artists*, London, n.d. (= 1954) (not published in Tassi); *Sutherland: Christ in Glory in the Tetramorph*, ed. Andrew Révai, London, 1964, pp. 26–83 (a full discussion between Sutherland and Révai which explores every aspect of the genesis of the Coventry tapestry) (one section only published in Tassi); Noel Barber, *Conversations with Painters*, London, 1964, pp. 43–53 (the most extended, most autobiographical and most valuable of Sutherland's general statements) (not published in Tassi); Graham Sutherland, *Druckgraphik und Zeichnungen mit dem vollständigen Bestiarium*, catalogue of an exhibition at the Kunsthalle, Nuremberg, November 1969 – January 1970 (*Interview with Graham Sutherland* by Dr Elisabeth Rücker and Michael Mathias Prechtl); 'Images Wrought from Destruction', *The Sunday Telegraph Magazine*, 10 September 1971, pp. 27–8 (open letter to Edwin Mullins describing his experiences as a War Artist); *The English Vision*, catalogue of an exhibition at the William Weston Gallery, London, October 1973 (introduction by Sutherland describing his training and early career as

an etcher) (not published in Tassi); *The Sutherland Gift to the Nation*, booklet accompanying an exhibition at Marlborough Fine Art, London, March–April 1979 (excerpt from *The Nature of Poetry & Painting*, a speech delivered by Sutherland when awarded the Shakespeare Prize in Hamburg, 1974); *Graham Sutherland*, catalogue of an exhibition at the Galleria d'Arte Narciso, Turin, February–March 1976 (conversation with Paul Nicholls which includes a list of the art and artists Sutherland most admired); *Portraits by Graham Sutherland*, catalogue of an exhibition at the National Portrait Gallery, London, June–October 1977, pp. 17–28 (conversation about his approach to portraiture between Sutherland and the present author); *Sutherland: Disegni di Guerra*, catalogue of an exhibition at the Palazzo Reale, Milan, June–July 1979 (commentary by Sutherland on his work as a War Artist) (not published in Tassi). To these should be added the principal films on Sutherland in which the artist has given interviews: *Graham Sutherland*, BBC Television film in association with the Arts Council, directed by John Read, 1954; *Painter at Work: Sutherland in France*, ABC Television film, written and directed by Peter Newington, n.d.; *Graham Sutherland*, BBC Television film, produced by Margaret McCall, 1968; *Graham Sutherland*, RAI Rome Television film, written and directed by Pierpaolo Ruggerini, 1969; *Sutherland in Wales*, BBC Wales Television film, written and produced by John Ormond, 1977; *Graham Sutherland*, private film directed by Adriano Viale, 1977; ITV Television film, transmitted on the *South Bank Show*, 1979.

The first book on Sutherland to appear was by his friend, the critic Edward Sackville-West, in the Penguin Modern Painters series, 1943 (revised edn., 1955). This sensitive appraisal was followed by an equally revealing essay describing the workings of Sutherland's imagination by Robert Melville, *The Imagery of Graham Sutherland*, the introduction to a volume illustrating Sutherland's works of 1946–50 by H. P. Juda, London, 1950. Douglas Cooper, *The Work of Graham Sutherland*, London, 1961, is a penetrating, fully documented and detailed study, written with the full co-operation of the artist; this is by far the most valuable work on Sutherland and will not be superseded; there are about 400 illustrations (15 in colour). The volume in *The Masters* series is by Andrew Révai (1963) (the similar volume in the series *I Maestri del Colore* (1966) is introduced by Luigi Carluccio). Francesco Arcangeli, *Graham Sutherland*, Milan, 1973 (English edn., New York, 1975) is invaluable for its 222 (230) illustrations (about half of which are of works executed subsequent to the appearance of Cooper's book), and especially for its 113 (117) colour plates. Giorgio Soavi, *The World of Graham Sutherland*, London, 1973 (Italian edn. Turin, also 1973), is an attractive pictorial biography including photographs of many of the sources for Sutherland's paintings. Roberto Sanesi, *Graham Sutherland*, Milan, 1979, contains previously unpublished works among its 119 illustrations (23 in colour).

Most publications of the last decade have concentrated on particular aspects of Sutherland's work. The graphic work was first catalogued by Felix Man, *Graham Sutherland: Das Graphische Werk 1922–1970*, Munich, 1970; Roberto Tassi, *Graham Sutherland: Complete Graphic Work*, London, 1978, is fully and magnificently illustrated, with 122 colour plates, but does not supersede Man; Sutherland's most recent aquatints, the *Bestiary* based on Apollinaire, are illustrated in the catalogue published for their exhibition at Marlborough Fine Art, London, 1979. A facsimile anthology from four sketchbooks used between 1968 and 1972 was published by Marlborough Fine Art as *Graham Sutherland Sketchbook*, London, 1974. About half the portraits are catalogued and reproduced in *Portraits by Graham Sutherland*, 1977 (see above). 171 of the war drawings, mostly unpublished works from Mrs Sutherland's collection, are catalogued and reproduced in *Sutherland: Disegni di Guerra*, 1979 (see above).

Full bibliographies to date, including exhibition catalogues, are contained in Mel-

ville, Cooper, Arcangeli and Tassi. Neither of the latter two, however, list the Tate Gallery catalogue by then published (1964), which contains meticulous entries incorporating previously unpublished information supplied by the artist.

Works in preparation include a *catalogue raisonné* in the Rizzoli *Classici dell'Arte* series and a biography by Roger Berthoud.

ACKNOWLEDGEMENTS

The publishers would like to thank all the private owners and museum authorities who have kindly allowed works in their collections to be reproduced. Every effort has been made to trace the present owners of the works illustrated. We should also like to thank all those who have helped us by supplying photographs, and to acknowledge our special indebtedness to Marlborough Fine Art, David Breeden, James Kirkman, Pierpaolo Ruggerini, Giorgio Soavi and Gianni Tinto in this respect.

The following are acknowledged for specific photographs:

The Ambassador Editions, London: Pl. 105 (and back of jacket)

David Breeden, London: Pls. 72, 122, 125

Christie's, London: Pl. 35

Clarke-Crisp Collection Dance Archive, London: Pl. 41

P. & D. Colnaghi & Co. Ltd, London: Pl. 1

Courtauld Institute of Art (Witt Library), London: Pls. 15, 42, 86

Electa Editrice, Milan (photos: Sergio Anelli): Pls. 47, 53

Linda Gras, New York: Pl. 117

James Kirkman, London: Fig. 12; Pls. 2, 10, 16, 25, 32, 34, 43, 46, 58, 70, 80, 81, 92, 99, 100

Lefevre Gallery, London: Pl. 124

London Transport Executive: Fig. 4

Marlborough Fine Art (London) Ltd: Pls. 13, 18, 44, 45, 46, 54, 60, 62, 79, 123, 129, 130, 133, 136, 137, 144, 148, 149, 150

The Joint Shell-Mex and B.P. Archive, London: Fig. 3

Sotheby's, London: Pl. 23

2RC Editrice, Rome: Pl. 151

The Victoria and Albert Museum, London: Pls. 4, 6, 24

Woodmansterne Publications Ltd, Watford (photo Nicholas Servian): jacket illustration (front)

The Coventry Cathedral Tapestry is reproduced by permission of the Provost and Council of Coventry Cathedral.

The works of Picasso (Pl. 76) and Matisse (Pl. 118) are © SPADEM, Paris.

The works reproduced as Pls. 17, 36, 39, 52, 71, 88, 94, 101 and 153 are © The Tate Gallery, London. All other works by Sutherland are © COSMOPRESS, Geneva, and ADAGP, Paris.

INDEX OF WORKS